Tom Mackie's
Landscape Photography Secrets

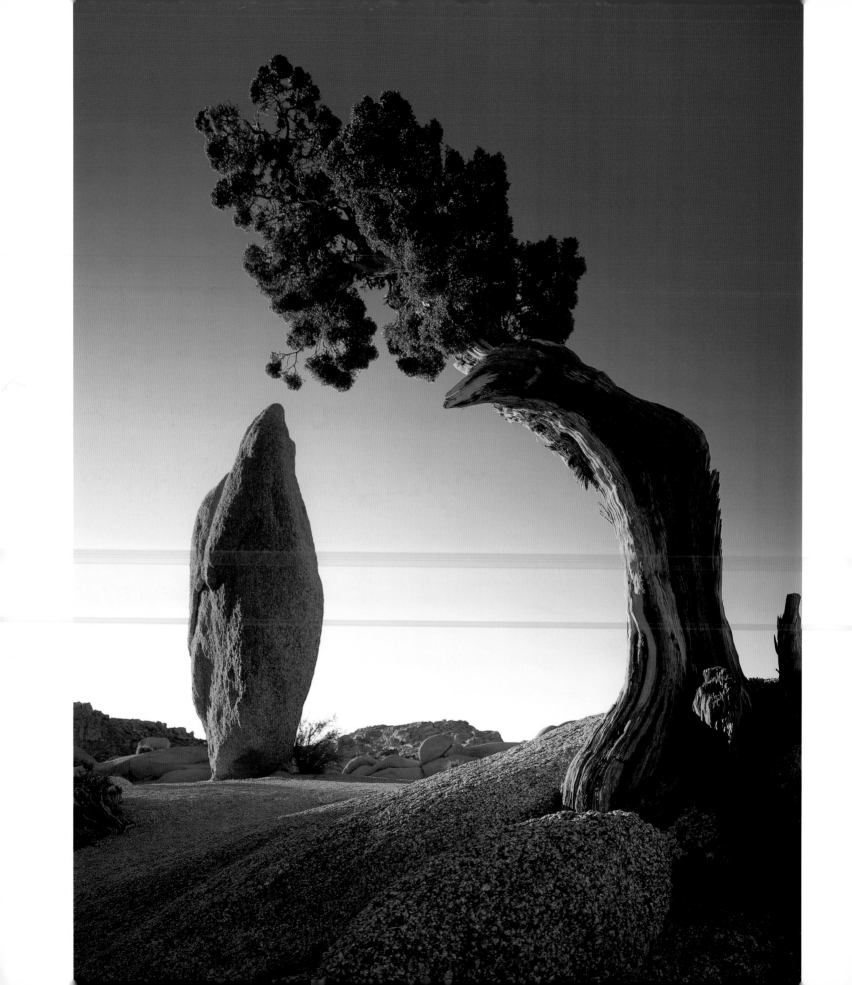

Tom Mackie's
Landscape Photography Secrets

Tom Mackie with Daniel Lezano

D&C
David and Charles

To my mom, who supported my choice of career in photography when most kids were getting real jobs.

A DAVID & CHARLES BOOK

David & Charles is a subsidiary of F+W (UK) Ltd.,
an F+W Publications Inc. company

First published in the UK in 2005
First paperback edition published in the US in 2005

Distributed in North America
by F+W Publications, Inc.
4700 East Galbraith Road
Cincinnati, OH 45236
1-800-289-0963

A catalogue record for this book is available from the British Library.
ISBN 0 7153 2296 6 hardback
ISBN 0 7153 2302 4 paperback (USA only)

Printed in Singapore by KHL Printing Co Pte Ltd
for David & Charles
Brunel House Newton Abbot Devon

Visit our website at www.davidandcharles.co.uk

David & Charles books are available from all good bookshops; alternatively you can contact our Orderline on 0870 9908222 or write to us at FREEPOST EX2 110, D&C Direct, Newton Abbot, TQ12 4ZZ (no stamp required UK mainland).

(PREVIOUS PAGE)
STANDING STONE & JUNIPER TREE, JOSHUA TREE NATIONAL PARK, CALIFORNIA, USA
Visiting locations at various times of the day unleashes a variety of possible compositions under different lighting conditions. I had photographed this area several times before but only in the evening. On this occasion the first rays of morning light revealed this lone juniper tree framing an unusual standing stone. Camera: Wista Field 4x5; lens: 90mm Schneider; filter: Cokin yellow/blue polarizer; film: Fuji Velvia 50; exposure: 1/2 sec @ f/32.

(OPPOSITE)
DOUGLAS FIR TREE IN WALL STREET, BRYCE CANYON NATIONAL PARK, UTAH, USA
No other format works better with this scene than the panoramic. This unique Douglas Fir tree growing out of this gorge is a great example of forced growth with the tree reaching for the sunlight. I had my friend and fellow photographer, Rod Edwards, stand in the shot to reinforce the sheer scale of the image. Camera: Fuji 617 panoramic; lens: 90mm; film: Fuji Velvia 50; exposure: 8 sec @ f/32.

CONTENTS

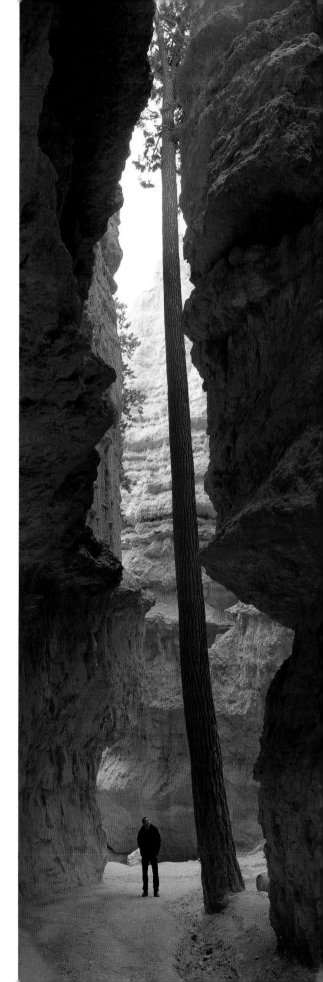

INTRODUCTION

This book is as much about solutions as secrets. Every type of landscape has different aspects about it that require particular solutions to enable the photographer to capture an image that communicates his or her intentions.

What I find so appealing about working in the landscape, compared to other areas of photography, is that it contains such a diverse range of geography, each with its own unique characteristics. When photographing in two completely different environments, for example deserts and coastline, the same fundamental photographic principles apply to both, but each one has its own individual qualities that require a special line of approach. Yes, you could say one common feature they both contain is sand, but each environment has a completely diverse effect that portrays each landscape as one distinctive place from the other.

As light is the most important aspect in photography, the correct use of light in a specific type of landscape is a very important consideration. For example, if the photographer wishes to show the lush, intricate details of a forest interior, the solution is to use soft, diffused lighting to bring out these features. Understanding how various landscapes react to a range of lighting situations can be best accomplished by immersing oneself in the landscape.

This book is divided into various types of landscapes: urban, rural, coastal, mountains, forests, deserts, water and gardens. In terms of the first type, the dictionary definition of a landscape is 'all the visible features of an area of land'. An urban landscape can be just as challenging as a wild, untamed scene when creating the image and can be highly stimulating visually when viewing a contemporary composition. When arranging a natural composition, look for graphic shapes and colours within the scene to create a composition. The only main difference in an urban scene is that the shapes are more defined.

We live in a 'quick fix' society where everything we do has to be done right now; this is especially true regarding the impact digital technology has had on photography. Many people are misguided in thinking that their photography will improve if they switch from film to using a digital camera. While digital photography definitely has its place and is a great learning tool because of the instant results, it is not responsible for creating great images – it is the person who pushes the shutter who decides which angle to shoot from, which lens to use and which lighting conditions to employ. Tripping the shutter takes a fraction of a second, but getting the best from a scene takes an intimate understanding, which results from spending time in the landscape.

CRASHING WAVES, ARUBA, LESSER ANTILLES, CARIBBEAN
I wanted to create the feeling of action, so I set the tripod-mounted camera close enough to the rocks to fill the right side of the frame with the waves. This enabled me to position the yachts in the upper third of the frame. Camera: Pentax 6x7; lens: 45mm; filter: polarizing filter; film: Fuji Velvia 50; exposure: 1/4 sec @ f/16.

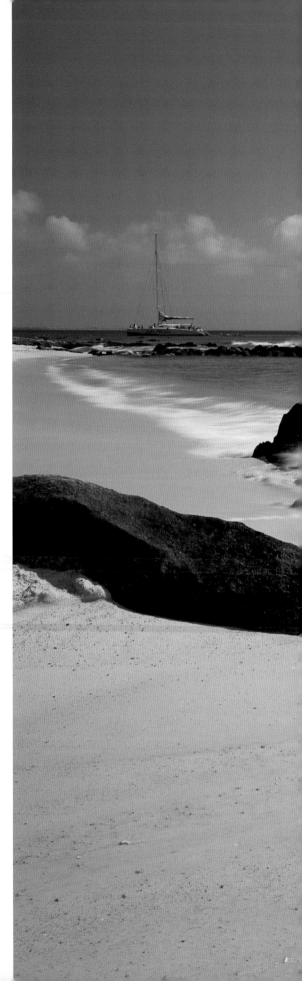

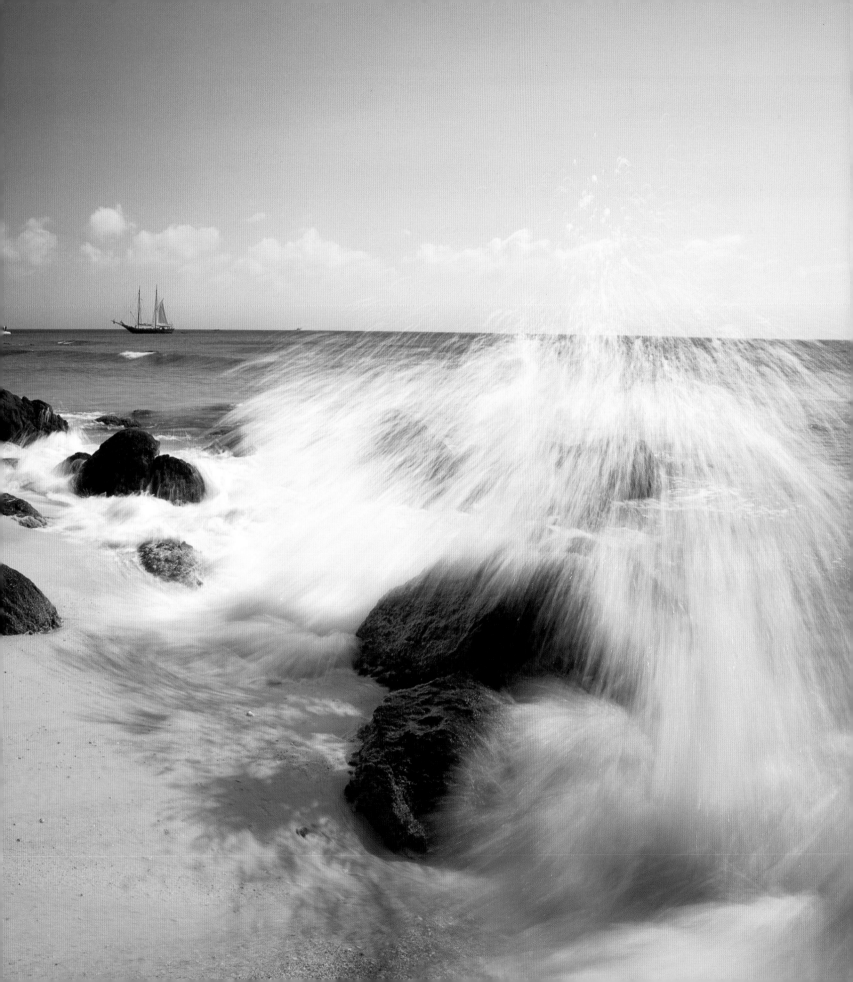

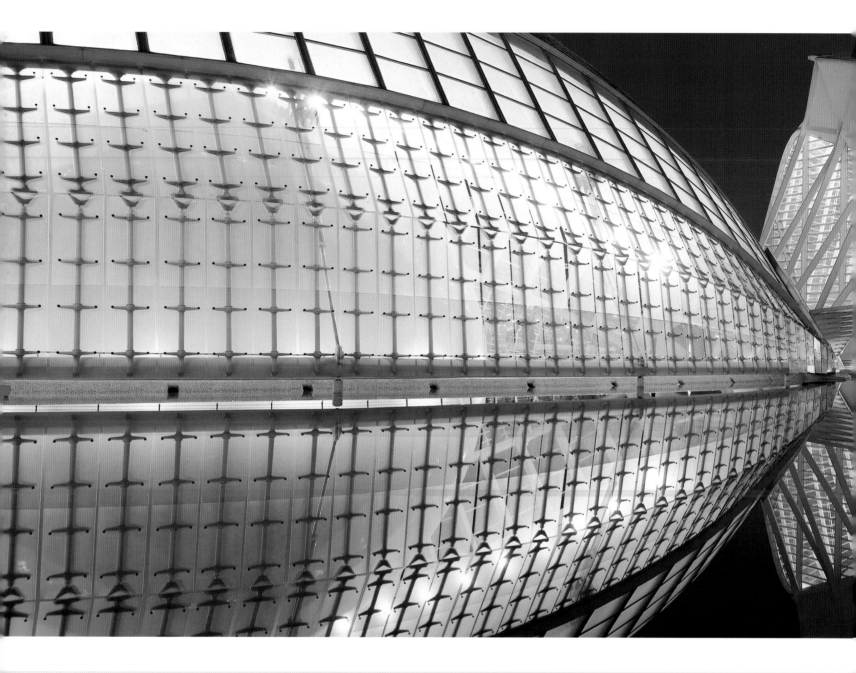

THE CITY OF ARTS AND SCIENCES, VALENCIA, SPAIN

The futuristic shapes of Santiago Calatrava's complex reflecting in a surrounding pool lend themselves
ideally to a panoramic format. The illuminated building's geometric design stands out prominently
against the night sky. The reflections tend to be better at night as the air is usually still. Camera:
Fuji GX617 panoramic; lens: 90mm; film: Fuji Velvia 50; exposure: 8 sec @ f/22.

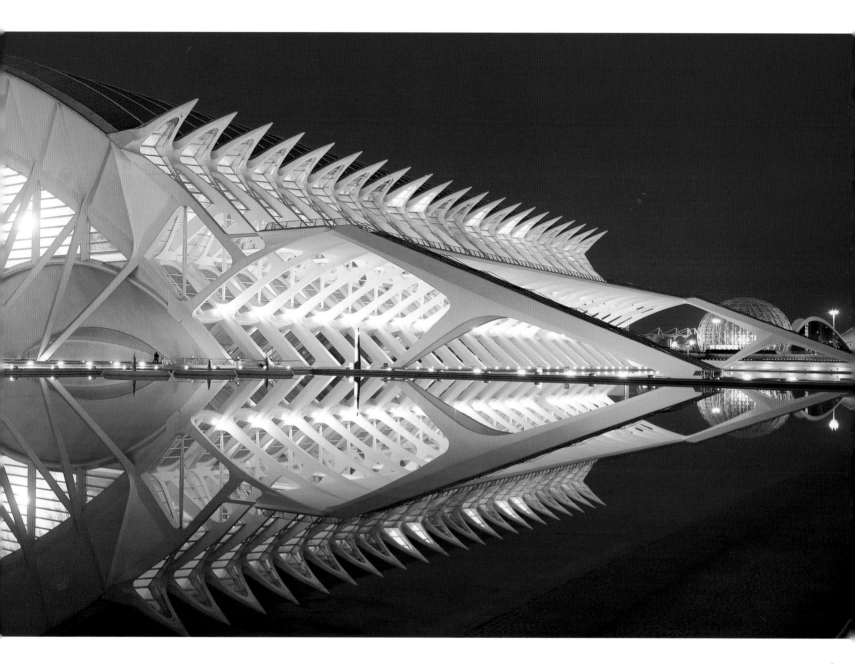

URBAN LANDSCAPES

Unless you live in the middle of nowhere, it is more than likely that you have easy access to an urban landscape – although most of us think in terms of such a landscape being called just a town or a city, that is not how you should think of it. A good working definition of an urban landscape is one that is made up almost wholly of building structures, whether whole or part of a building, or a cross-section of buildings in a general scene.

From a photographer's point of view, built-up areas offer huge potential for spectacular imagery both during the day and at night. Think of your city or town as an urban landscape, and your mind will start picturing the various office buildings, homes, churches and architectural endeavours as potential photographic subjects.

THE CITY OF ARTS AND SCIENCES, VALENCIA, SPAIN

Shadows that travel across a building usually detract from the image, but you should always look to use them to your advantage. Here, the afternoon shadows became part of the shot and created interesting lines and shapes that benefitted the overall result. Camera: Wista Field 4x5; lens: 150mm Schneider; filter: polarizing filter; film: Fuji Velvia 50; exposure: 1/4 sec @ f/22.

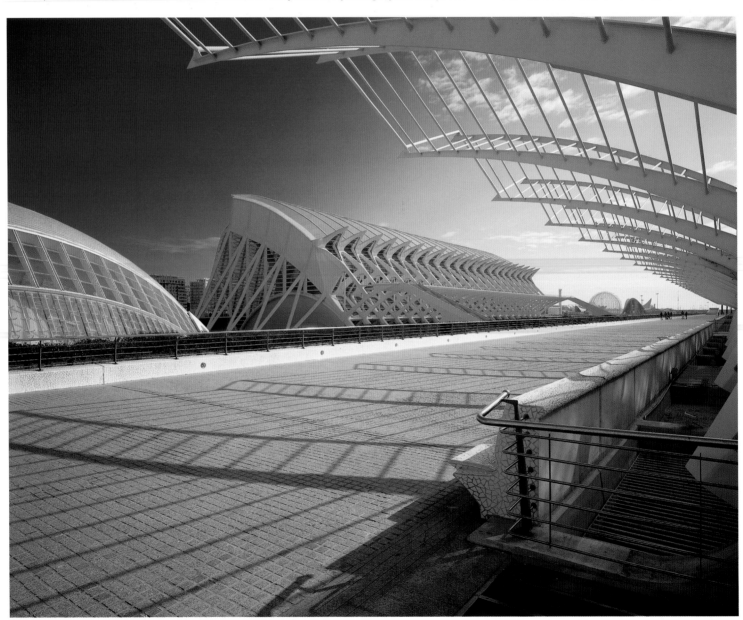

Lighting considerations

While the two vistas are physically very different, aim to think about lighting an urban landscape in the same way as you would a rural scene, although it is important to note that there are some major differences.

For example, when shooting an urban landscape, you shouldn't be thinking about heading to a location in time to capture it in early morning or late afternoon light, as low shadows can potentially spoil the scene. At these times of day, the low position of the sun means you might find you have strong, unsightly shadows cast across buildings. The secret in this instance is to move around and make full use of the shadows, both as part of the subject and to bring out detail and form.

When you are looking at an urban landscape, look particularly for line, shape and colour, and examine how each of these components interacts with each other. With a group of buildings that are close together, pay particular attention to the shadows and how they are cast from one building to another.

In addition, it's best to study the weather conditions (see over) and judge whether you can spend time working at the image; alternatively, if the light looks as if it is about to fade, you need to work quickly by grabbing the shot and then concentrating on taking further images. It is often the case that as long as you have captured the image you wanted, any additional ones are a bonus.

While midday isn't the appropriate time to shoot rural landscapes, as the scenery looks flat, you'll find that this type of light is suitable for architectural images. Some buildings have very bold, strong colours, such as the Children's Science Museum in Dubai, on this page and overleaf, which looks great in strong overhead lighting.

CHILDREN'S SCIENCE MUSEUM, DUBAI, UNITED ARAB EMIRATES

The strong overhead lighting emphasizes the colour and design of this remarkable structure. I used a telephoto lens to isolate these highly graphic shapes against the vivid blue-and-red building. By making a slight adjustment of viewpoint, I was able to create two different images of the same subject. Camera: Pentax 6x7; lens: 200mm; filter: polarizing filter; film: Fuji Velvia 50; exposure: 1/2 sec @ f/22.

CHILDREN'S SCIENCE MUSEUM, DUBAI, UNITED ARAB EMIRATES

Isolating sections of a building with a telephoto lens can often be more powerful than the building as a whole; I love images like this. There is a conscious approach when creating such images: I balanced the red and blue dominant colours in the frame by selective cropping with a 200mm lens. The outer red colours in the frame are similar in shape when inversed, which helps to hold the image together. A polarizing filter helps to saturate the colour. Camera: Pentax 6x7; lens: 200mm; filter: polarizing filter; film: Fuji Velvia 50; exposure: 1/2 sec @ f/22.

LANDSCAPE SECRETS

The ultimate aim is to treat buildings as you would any other type of landscape or even portrait – consider your subject and think about how you can use the lighting to produce the most flattering effect and bring out the details that matter most.

Weather considerations

The great thing about photographing buildings is that you can get very good results even when the weather conditions are terrible. For instance, if it's raining and the light is so low that you're forced into using a long exposure, then you have the opportunity of using the texture and movement of the clouds as an attractive backdrop.

Many landscape photographers see bad weather as effectively ruining their day – however, if you're out and conditions take a turn for the worse, you can always consider shooting detail shots of buildings instead. Don't forget that in addition to shooting the exteriors of buildings, you also have the possibility of shooting interiors.

In my experience, Fuji Velvia is the best film for adding punch on days when the quality of the available lighting is murky or flat; despite advances in technology I still prefer shooting to film over digital capture, and the quality of this film is in a league of its own, and cannot be matched by even the best-quality digital results.

Finding a composition

When you're considering how to frame the subject, always try to play to the architect's intentions and look for lines, shapes or patterns that add to the composition. In addition, always bear in mind that a strategically placed figure can sometimes add to the image – this can be a companion, or you can ask passers-by. Try different viewpoints and angles, and change lenses so you can vary the extent of your crops.

The ultimate aim is to treat buildings as you would any other type of landscape or even portrait – consider your subject and think about how you can use the lighting to produce the most flattering effect and bring out the details that matter most.

SPIRAL STAIRCASE, RAVELLO, ITALY

When shooting landscapes on the Amalfi Coast in Italy, the weather was poor so I went in search of suitable interiors. I framed the design of the stairs in a hotel on a panoramic camera. Camera: Fuji GX617 panoramic; lens: 90mm; film: Fuji Velvia 50; exposure: 10 sec @ f/32.

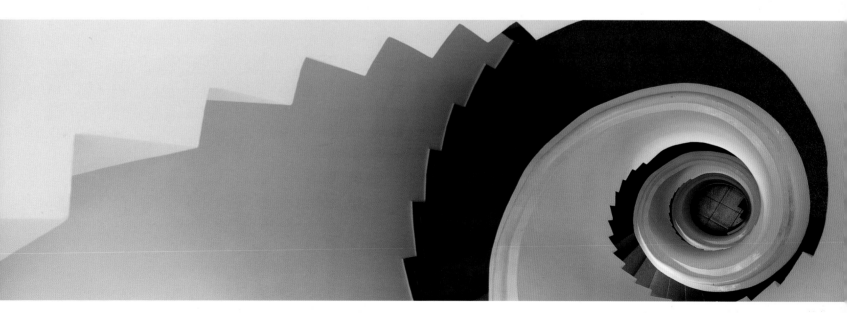

Materials and styles

When photographing details, it's important to consider how light interacts with the components of the building and the materials used in its construction. For instance, the architect Frank Gehry uses titanium in many of his structures (see opposite), and because this material reflects light differently during the course of the day, the building takes on varying appearances and colours.

Sometimes you may encounter buildings where the architect has broken away from convention in their design: instead of typically straight walls, the structure is curved without a straight line in sight and appears completely space-age. In this instance, even though you may be faced by a totally unique shape, you should still be on the lookout for interesting viewpoints and methods that allow you to create strong compositions.

THE SAINSBURY CENTRE, NORWICH, ENGLAND
Lines feature predominantly in this structure, designed by Sir Norman Foster, so I emphasized this by using a short telephoto lens to compress the perspective. The extensive glass windows on the right of the shot provided natural light and cast shadows across the floor that added to the overall composition. Camera: Wista Field 4x5; lens: 210mm Schneider; film: Fuji Velvia 50; exposure: 1 sec @ f/22.

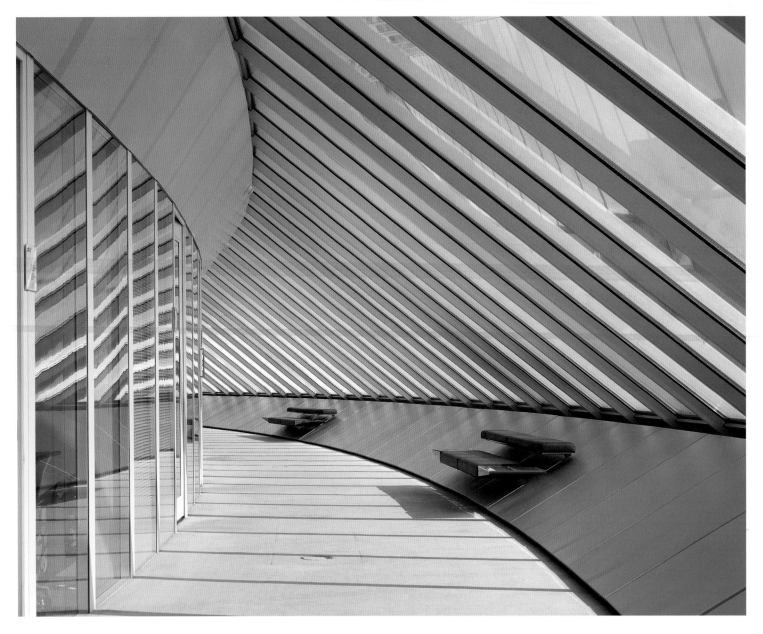

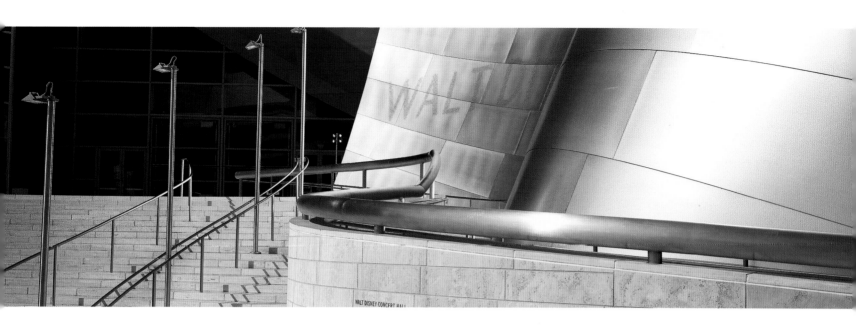

Look out for buildings with mirrored windows, in particular modern buildings that are near older structures or churches to contrast nicely.

To reiterate, the same basic principles that you'd use when photographing rural landscapes apply when shooting buildings. Look at the graphic components of your subject – mentally strip away the details and see how the straight lines and curves work to create a wonderful image. When you compose a picture in this way, you may seem to be adopting a very simplistic approach, but frequently this can result in a very strong image.

Overcoming problems

There are various problems to overcome when shooting urban landscapes. A very common one is discovering an unsightly object, such as a building crane in the frame; other objects that detract from the image can be cars and power lines. Today you can remove such objects in Photoshop after scanning or downloading the image, but you can minimize the problem in-camera: with a moving crane, wait until it faces directly towards or away from you and choose an angle that puts it behind another structure in the scene so it has only minimal impact on the image. Then you can do some housekeeping to tidy up the shot.

Don't worry about moving objects out of the scene – I have removed huge green wheelie bins, signs and even delivery vans (with the help of the driver, of course).

Use a tripod whenever possible in an urban scene, as you'll always notice something coming into the frame that you don't want to include, such as people, power lines or cars. By having the camera mounted, you can fine-tune your framing but also wait until the unwanted elements leave the shot. In addition, when using a lead-in line in the frame that is close to the lens, you require good depth of field and a tripod allows you to select as small an aperture as needed.

One problem experienced by many photographers is that they choose to cram in as many elements as possible and end up filling the frame and ruining the result – the image

DISNEY CONCERT HALL, LOS ANGELES, USA

Photographing part of a building can sometimes give far more interesting results than shooting the building as a whole. Breaking down the image into very basic components, so that you're looking at graphic shapes, colour and design, often creates a more interesting composition. In this image, the building, designed by Frank Gehry, plays a secondary role in the overall composition as the main focus is on the handrail, lamps and steps. The aim of this shot is to show off the architect's intentions and bring what he designed into print in as creative a way as possible. Camera: Fuji GX617 panoramic; lens: 90mm; filter: polarizing filter; film: Fuji Velvia 50; exposure: 1/2 sec @ f/22½.

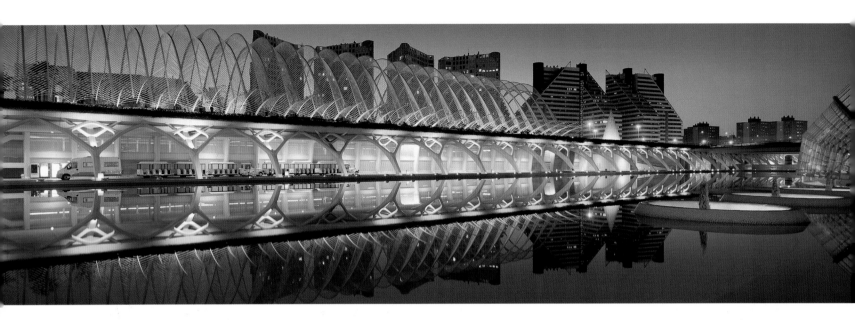

THE CITY OF ARTS AND SCIENCES, VALENCIA, SPAIN

The remnants of the setting sun added a pleasant backdrop to this skyline. I waited until there was around a 1-stop difference between the sky and the reflection and based the exposure between the two readings. Camera: Fuji GX617 panoramic; lens: 90mm; film: Fuji Velvia 50; exposure: 5 sec @ f/22½.

loses impact because the viewer's eye scans the scene looking for a point of focus to settle on, but fails. The old adage 'less is more' really rings true in this situation.

Reflections are another thing to watch out for – if you're shooting a building surrounded by water, make sure you head out early. The wind is usually much calmer in the early morning, so your reflections will be more defined, while the lighting is also better. You can expect to encounter similar characteristics of light in the evening.

Look out for buildings with mirrored windows, in particular modern buildings that are near older structures or churches to contrast nicely. You can use parts of the buildings that reflect other parts – scan for shapes that break up the conformity of the building. I use a polarizer when I want to remove any reflections that reveal the building in great detail.

Reconnaissance and planning

As we've seen, the time of day has a major influence on how buildings appear in your photographs, so it's important to spend time wandering around potential scenes – be

prepared to spend an entire day walking around a location and noting down how the direction of light plays on the subject. Don't be too concerned that you may not have taken a single photo – by planning your next day's photography, you are ensuring that the shots you take have a much higher success rate.

If you're heading for a city centre, Sunday mornings are best because the financial districts are devoid of activity; you are thus less likely to have people and cars appearing in your shots. Aim to get there before people head for a place of worship or go shopping, and you can get a couple of hours of photography without many distractions.

You can find something to photograph in an urban landscape at any time of day or night, and if you wander around a city or town as I have suggested and take notes, you will improve the number and variety of shots you

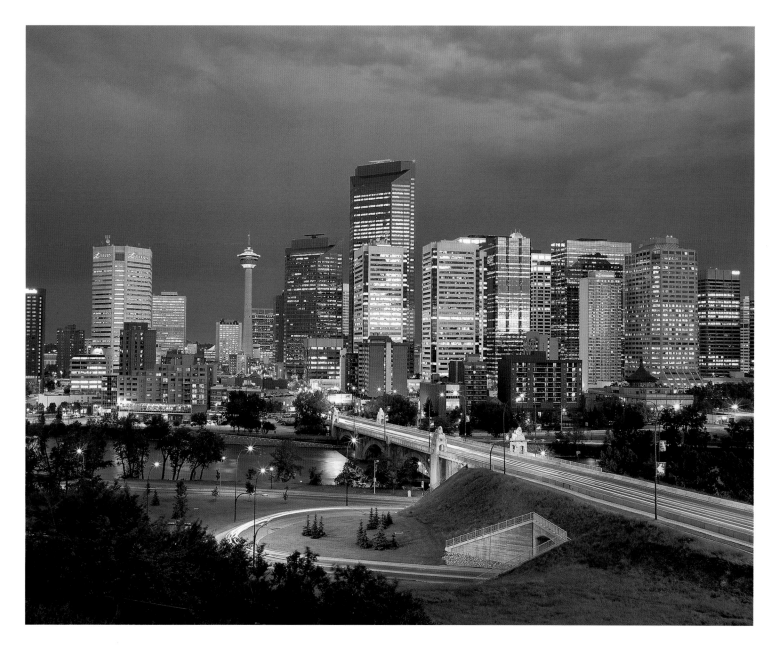

can take in a day. You'll be able to set out to a city you've studied in advance and know where to head to catch the beauty of the morning light. (It's worth bearing in mind that during the winter, the sun is relatively low in the sky, and the lower angle provides warm light for much of the day.) As the sun rises and the light becomes flatter, you can head to certain places that you have already visited and use a telephoto lens to shoot details.

Urban photography by night

With night photography the amount of time you have when the level of light in the sky and the buildings are at their optimum is limited. Once this short period has passed, you may as well forget it, as you are only likely to capture a pure black sky. If the difference in exposure between sky and buildings is 2 or 3 stops difference the sky will be too light, while waiting until the sky is darker than the foreground will result

SKYLINE AT NIGHT, CALGARY, CANADA

I spent the day driving around Calgary searching out various viewpoints, and chose to shoot from an elevated park overlooking the city from the west. The plan was to have a brilliant evening sky reflecting in the mirrored buildings, but it was overcast. The road on the right provided streams of car lights leading into the composition. Camera: Pentax 6x7; lens: 135mm; film: Fuji Velvia 50; exposure: 1 min @ f/22.

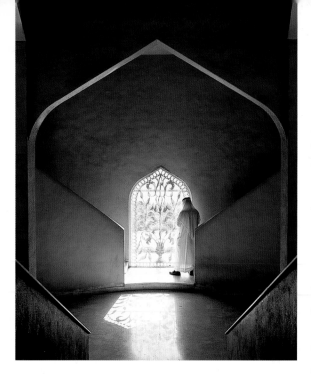

(ABOVE) SHARJAH, UNITED ARAB EMIRATES
The highlights on the Arabic arch and handrails help to draw the eye to the window and frame the scene. Exposure was crucial to get enough detail on the interior and not overexpose the window design. I based it on the tone on the wall to the left of the window and bracketed the exposure Camera: Pentax 6x7; lens: 75mm shift; film: Fuji Velvia 50; exposure: 4 sec @ f/22.

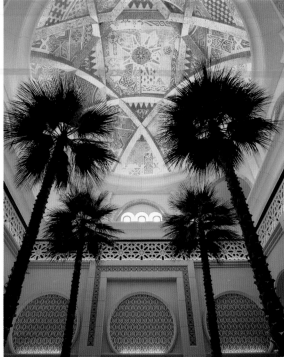

in the sky recording as a solid black. If shooting at night and recording your images on film, make sure to try Fuji Velvia, as long exposures of several seconds on this film have a way of creating unusual and attractive colour casts (usually magenta/blue), which can bring added interest to the sky.

During long exposures, you might run into reciprocity problems, so you will need to bracket. Reciprocity is a phenomenon where the film's sensitivity is reduced, due to the long exposure time, so you need to give an extra amount of exposure to ensure the image is correctly recorded. In general it's best to take a spot reading from the buildings and the sky and when you reach a 1-stop difference, you can expose for the building and then overexpose in 1-stop increments.

Artificial lighting can look amazing on buildings at night, especially if there's a mix of interior and exterior lights that results in the scene being lit in a variety of colours. This usually looks wonderful on the final result, so if you're shooting digitally, it's worth avoiding making automatic compensation for this unusual shift in colour temperatures.

Urban interiors

When shooting interiors, many photographers prefer to work with natural light, in other words making full use of sunlight coming through windows and doors; introducing artificial lighting often takes away from the natural character of the scene.

When shooting with film, be aware that the colour temperature of artificial lighting is different to that of daylight, which means that your images may exhibit a colour cast: tungsten gives off a warm, orange glow, while fluorescents produce a sickly green cast. On digital cameras, colour casts can be compensated for by selecting the appropriate White Balance setting.

If your interiors include windows, find out when the light that comes through them is at their strongest, as this will help your exposures. However, be cautious of including windows in a frame, as the difference in brightness means that they bleach out and prove

(RIGHT) STAIRCASE TO MOSQUE, DUBAI, UNITED ARAB EMIRATES
I thought this unusual zigzag staircase would make a good composition, but there were a lot of distracting elements around the stairs and no central point of focus that weakened the image. I asked my driver to stand at the top of the stairs, thus utilizing the Rule of Thirds, and eliminated the distracting elements by using a telephoto lens. Camera: Pentax 6x7; lens: 200mm shift; film: Fuji Velvia 50; exposure: 1/15 sec @ f/16.

(LEFT) ROYAL MIRAGE HOTEL, DUBAI, UNITED ARAB EMIRATES
The palm trees added an unusual perspective and patterns against the golden ceiling of the reception area. I chose an angle that spaced the silhouettes of the palms so as not to merge with one another. Camera: Pentax 6x7; lens: 45mm; film: Fuji Velvia 50; exposure: 4 sec @ f/22.

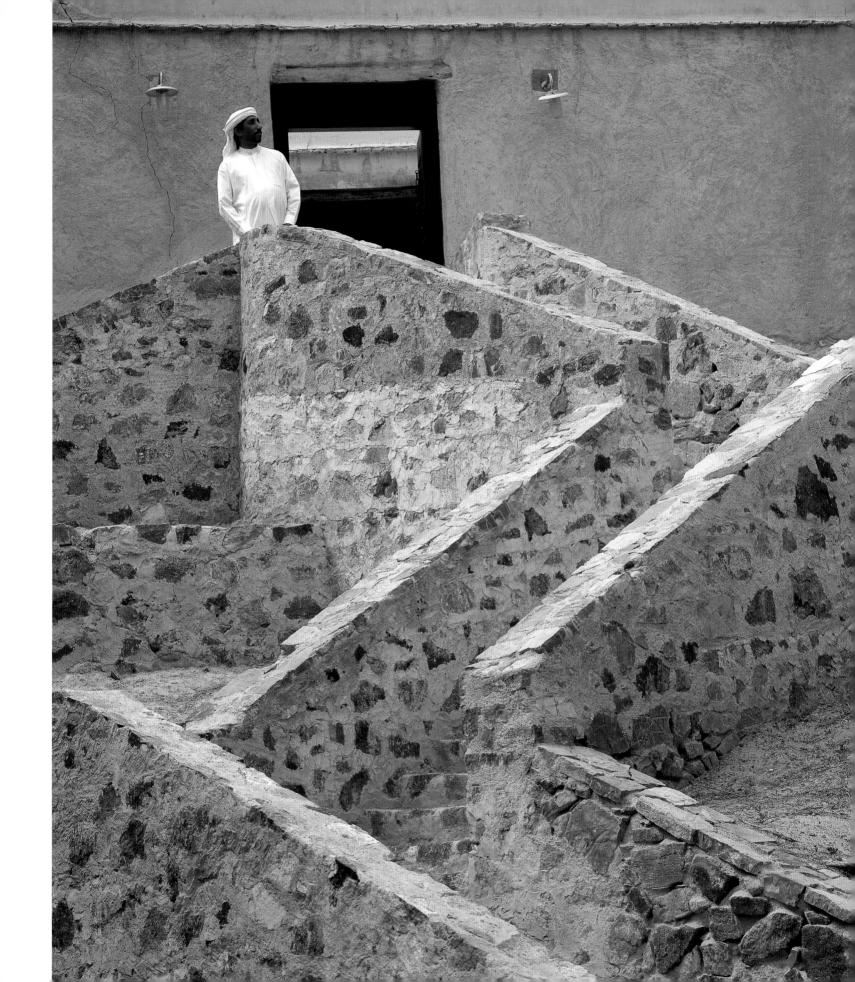

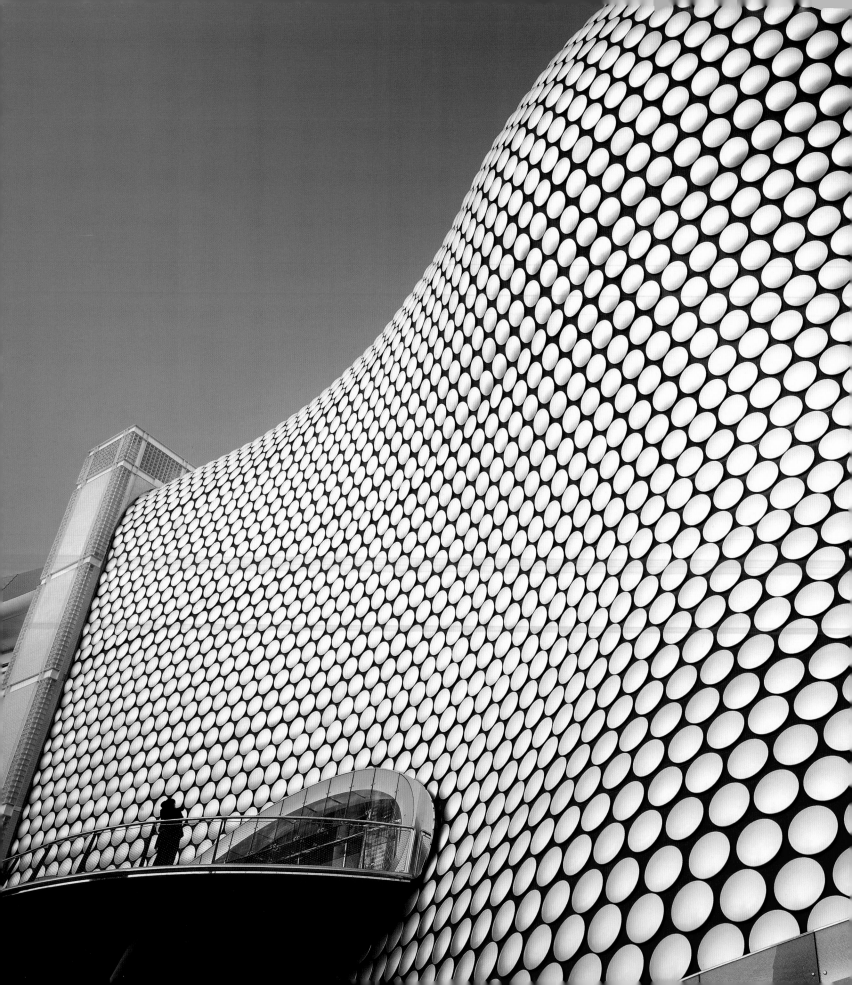

SELFRIDGES BUILDING, BIRMINGHAM, ENGLAND

With this building, having a reference for scale was very important because the structure was so unusual and didn't have any known factor to indicate size. Fortunately, I was able to incorporate a couple of people in the lower left corner of the frame. The image above is merely an abstract interpretation of the structure – without a sense of scale or human presence, it is more difficult to indicate what the viewer is looking at, yet it is more creative. Camera: Wista Field 4x5; lens: 75mm Nikkor; filter: polarizing filter; film: Fuji Velvia 50; exposure: 1/4 sec @ f/22.

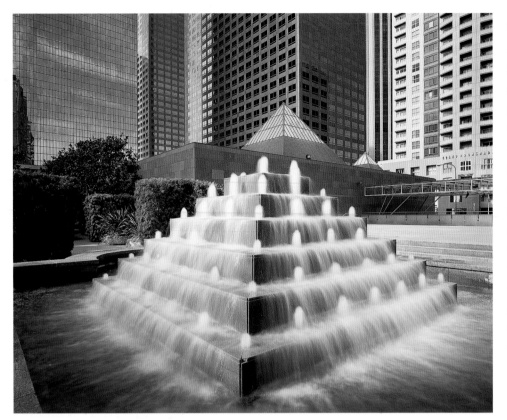

WATER CASCADE, MUSEUM OF CONTEMPORARY ART, LOS ANGELES, USA

I previsualized how a long exposure would create a soft, silky effect, with the water cascade set against the structured design of the buildings in the background. I chose an angle that would include the same pyramid shapes on top of the building as with the fountain. Lens choice was an important consideration, to keep the size relationship between all of the elements to a set scale: a 210mm short telephoto lens enabled me to crop tightly into the buildings and maintain the scale; with a wide-angle lens, the elements in the background would appear further away and distracting areas of sky would be included. Camera: Wista Field 4x5; lens: 210mm Nikkor; filter: polarizing filter; film: Fuji Velvia 50; exposure: 1 sec @ f/32.

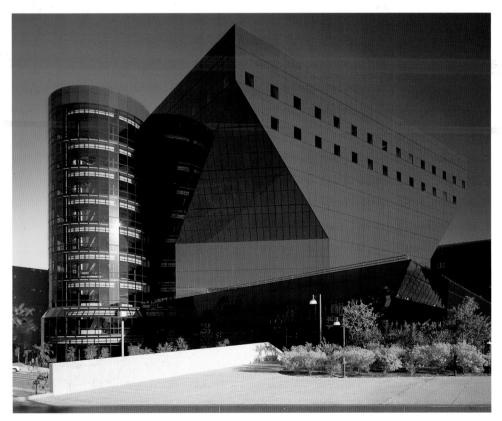

PACIFIC DESIGN CENTER, LOS ANGELES, USA

Including minor details such as the red kerb can have a major impact on the final result. I included the kerb in this image because I felt it provided a stronger base or anchor to the composition and complemented the blue, green and yellow in the scene. Sidelighting helped to show the geometric form of the structure. Camera: Wista Field 4x5; lens: 90mm Schneider; filter: polarizing filter; film: Fuji Velvia 50; exposure: 1/2 sec @ f/22½.

incredibly distracting – wait until a cloud covers the sun, as this will act as a huge diffuser, producing a bright, soft light. Remember that light colours advance and dark colours recede, so your eye is always drawn to the brightest areas of the scene.

Naturally lit interiors can often be improved by warming them up slightly with an 81A or B filter. This has the effect of neutralizing the cool colour cast in shadow areas, and gives an overall feeling of warmth.

Other lighting considerations

When photographing a building as a whole, you may prefer to choose a three-quarter angle so that the side and front of the building can be seen. This gives the building more dimension and form – but does it matter which three-quarter angle, left or right, to show?

Definitely; for example, if the sun is lighting the building from the front left side and it is shot from the left three-quarter angle, this will produce a flatly lit building with no modelling. If shot from the right three-quarter angle, the front of the building is lit and the right side is in shadow, providing more texture and modelling.

Lens choice

A good lens of choice for urban images is a telephoto, as this allows you to pick out details. A good variety of lenses also enables you to capture buildings in different ways.

A PC (shift) lens allows you to control perspective and converging verticals – where buildings appear to lean backwards – although

the latter is easily corrected in Photoshop. This digital option shouldn't be overlooked, as there are likely to be occasions where conditions mean that you are forced to take pictures where the buildings suffer from converging verticals, the result of tilting the camera upwards to include the whole building in the frame. The obvious way to avoid this is to keep the film plane parallel to the building by either moving further away or shooting from a higher vantage point.

For interiors, the wider the lens the better: ultra-wide-angle zooms, such as a 17–35mm, are incredibly versatile, and another favourite is a 15mm super-wide. Bear in mind that using a wide-angle means that architectural features will invariably appear smaller in the frame.

Permission

Seeking permission to photograph buildings is very important – always ask permission if you are on private property or if you are inside a building. Also bear in mind that even if you're in a public area, some things cannot be photographed: these include government and military buildings and airports. Some countries are stricter than others, so make sure you check your facts, and if you spot any security personnel, always ask their permission.

L'UMBRACLE, THE CITY OF ARTS AND SCIENCES, VALENCIA, SPAIN

The panoramic format used in a vertical position was ideally suited to accentuate the patterns of the structure. I shot just after midday so the shadows created by the arches ran laterally across the path. At this time of day the sky also polarized nicely to contrast with the white arches. Camera: Fuji GX617 panoramic; lens: 90mm; filter: polarizing filter; film: Fuji Velvia 50; exposure: 1 sec @ f/32.

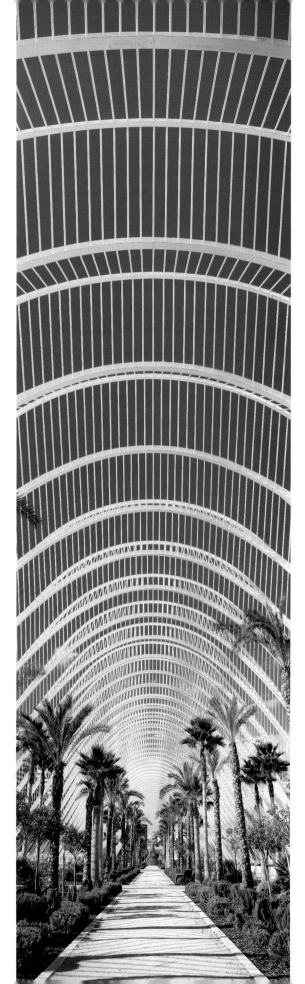

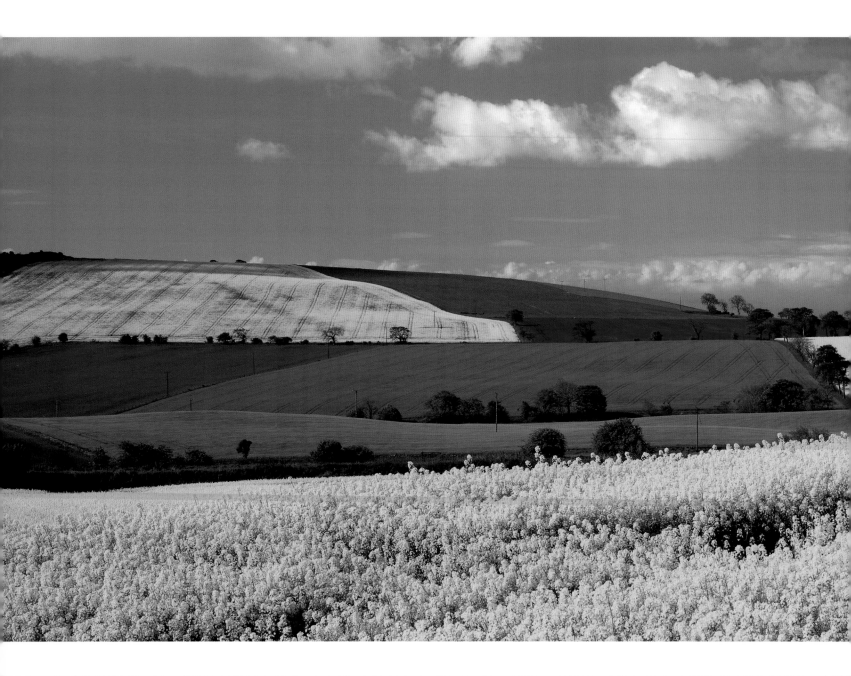

FIELDS OF OILSEED RAPE, NEAR ABERCROMBIE, SCOTLAND

When photographing fields of tall crops, it can be difficult to gain any feel of expansiveness.
To overcome this, I shot from the top of my motorcaravan. A polarizing filter increased saturation
and separation between the clouds and blue sky. Camera: Fuji GX617 panoramic; lens: 90mm; filter:
polarizing filter; film: Fuji Velvia 50; exposure: 1/4 sec @ f/22.

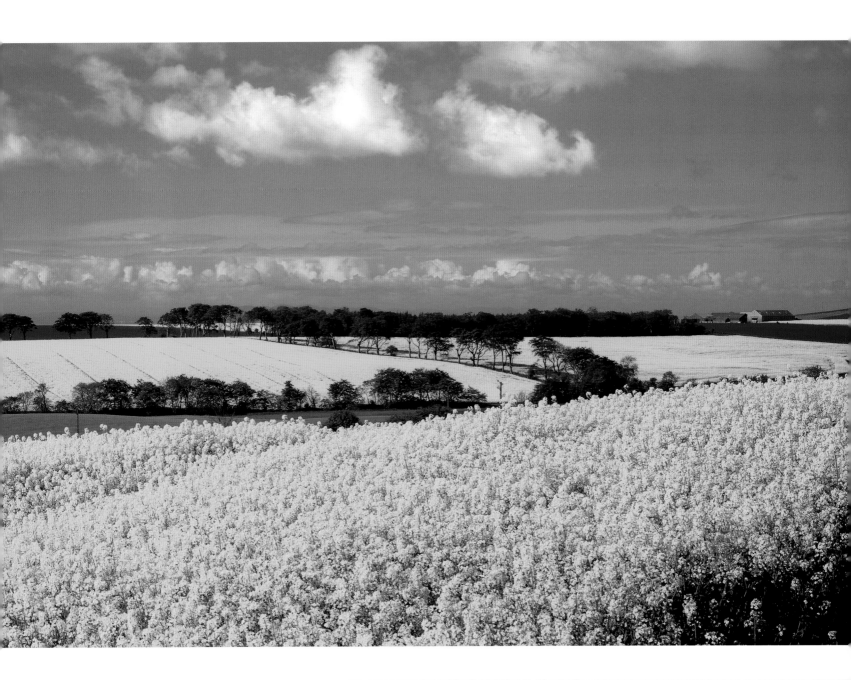

RURAL LANDSCAPES

While the planet becomes populated at an ever-increasing rate, there is no doubt that even the industrialized countries of the Western world still have a huge variety to offer in the way of rural landscapes that, in global terms, are on our doorsteps – let alone the possibilities and opportunities offered to photographers by inexpensive flights and foreign travel.

Even though there may be greater expanses of sky, water and flat land in rural landscapes than can be found in urban environments, you should still be looking for the same elements in both situations – shapes, colours and patterns; however, capturing the different light and dealing with vast expanses and open spaces bring their own, unique aspects to rural landscape photography.

SUNLIGHT STREAMING THROUGH TREE SURLINGHAM, NORFOLK, ENGLAND

Mist is a very evocative element in a landscape; the best way to get the full effect is through backlighting. The sun, partially behind the tree, created streams of light through the branches. Exposure was crucial, so I took spot readings from the sky to the left of the tree. Camera: Wista Field 4x5; lens: 150mm Schneider; film: Fuji Velvia 50; exposure: 1/15 sec @ f/22½.

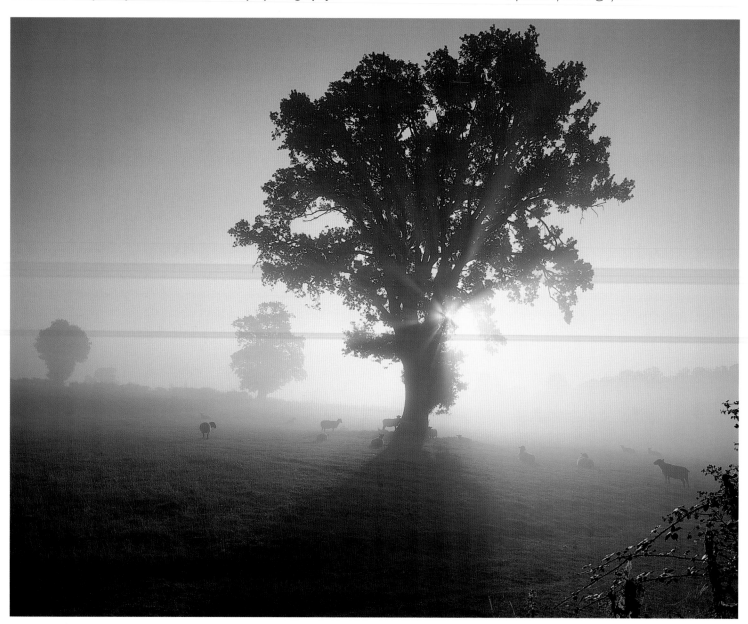

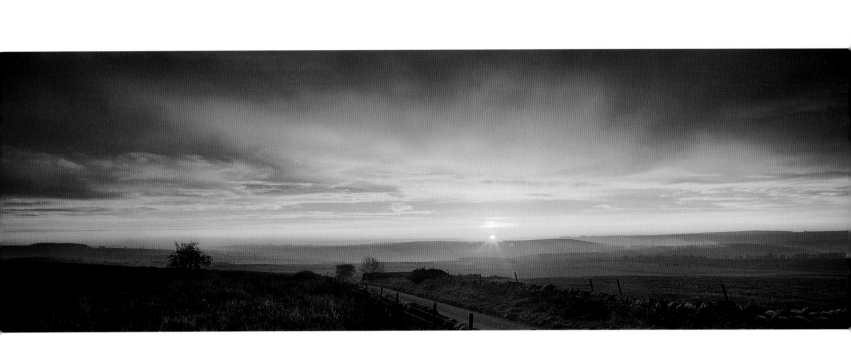

When planning when to visit rural landscapes, it's worth considering which season is best for your particular purposes. Different locations suit particular times of the year, so you want to ensure you're not visiting at the wrong time.

Seeking out locations

Dedicated landscape photographers spend a lot of time and effort studying potential locations and working out the best time of year to visit them. Inevitably they discover that they return again and again to certain areas.

To sound a personal note, the Lake District is not only my favourite region in the UK, it is probably also the number one location in the country for landscape photographers. It has everything a photographer could wish for – mountains, lakes, glacial valleys and waterfalls. Every aspect of the landscape is packed into a small area, and it is still possible to take great pictures even in bad weather. In rain or fog, rather than concentrating on wide, sweeping views, it is possible to visit some of the many waterfalls or shoot in woodlands or caves.

When searching for good potential landscapes, it's worth visiting an area within a 50 mile (80km) radius of where you're staying. Travel around and try to spot potential scenes and even individual elements, such as a lone tree in a field. If you're lucky, the weather and lighting will be on your side so that you can start taking pictures there and then. If conditions aren't great, as is all too often the case, mark the location on a map and plan to revisit it at a more suitable time.

It's easy to fall into the trap of taking hundreds of pictures of scenes because the lighting is nice and the general scenery has great potential. What you should be doing on reconnaissance is studying a scene and looking to make elements in the frame work together so that the composition is a success. Look for line, texture and patterns in the scene – I always look for strong shape and colour, and if I'm shooting on a particularly bad day, I look around for strong elements and shapes that could make a shot. Landscape photography is like fishing – you're never know whether you're going to catch a whopper or come home empty-handed.

SUNRISE OVER BIG MOOR, PEAK DISTRICT NATIONAL PARK, ENGLAND

This was one of those mornings when everything happens at once and there is not enough time to capture every shot. The valley behind me was covered in low mist, but I opted to shoot the colourful sunrise first and take my chances with getting the mist in the valley later. I used a 3-stop split ND grad filter to balance the exposure of the sky with the foreground. As the sun rose higher in the sky, I quickly moved to capture the warm light on the rocky outcrops. The mist had partially cleared, but I still managed to capture two different atmospheric scenes within 20 minutes. Camera: Fuji GX617 panoramic; lens: 90mm; filter: Lee 0.9 hard ND grad; film: Fuji Velvia 50; exposure: 1 sec @ f/22.

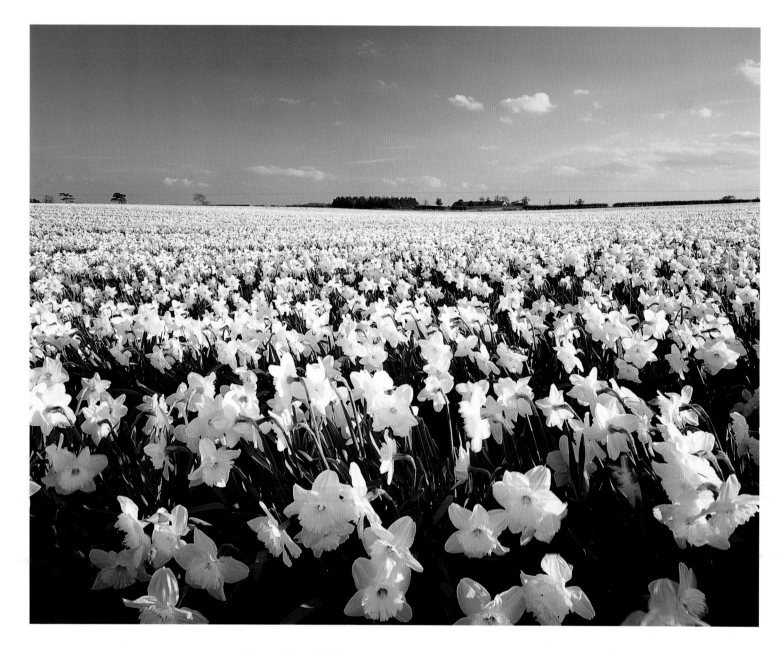

FIELD OF DAFFODILS, TROWES, NORFOLK, ENGLAND

After gaining permission from the farmer, I chose a position with the sun to one side and slightly backlit – this seemed to make the flower heads radiate with light, portraying the concept of spring freshness. I spot-metered off the sky to obtain a neutral value. Camera: Wista Field 4x5; lens: 90mm Schneider; filter: polarizing filter; film: Fuji Velvia 50; exposure: 1/2 sec @ f/22½.

The different seasons

When planning when to visit rural landscapes, it's worth considering which season is best for your particular purposes. Different locations suit particular times of the year, so you want to ensure you're not visiting at the wrong time. The seasons play a big part in choosing where you are going to go and at what time of year, so make sure you research each area properly and make note of any unusual features.

At the start of the year in winter I head for a northern area, such as Scotland or the Lake District in the UK, as I know these locations may be covered in snow.

In February I know that snowdrops will be appearing in woodlands, so I plan to head for areas where I can photograph them. Each season has its own merits, with spring offering a bountiful number of flowers, such as crocuses, daffodils, snowdrops, tulips and

bluebells; and in summer you have gorse, thrift and so on. In the United States, April brings a profusion of wild flowers such as owlsclover, lupins, goldfields and California poppies, to the high desert areas of California. It's advisable to arrive early in the morning when the air is cool and still, before heat thermals bring up the wind – when you are using a wide-angle with a beautiful array of flowers as the foreground, there is nothing worse than flowers blowing around. By planning ahead, you are maximizing the potential for great images.

Each season sees a change in the colours of the trees, with springtime bringing a really fresh green as leaves first appear, through the bright, hazy colours of summer, while autumn delivers glorious reds and gorgeous bracken.

Summer is the worst season to photograph rural landscapes. The landscape may be filled with greens, but is devoid of other colours as many of the flowers have gone, while haze deteriorates the blue of the sky and often requires a blue grad filter to add colour. The days are also long, so you have to wake up very early (4.30–5am) to shoot sunrise and stay out late to capture a sunset.

However, there are some wonderful flowers to be found in summer, in particular English poppies, which appear around June and July all over Britain. At the same time, expansive fields of sunflowers grace the landscapes of Tuscany, Provence and Andalusia, as well as patterns of lavender fields in Provence.

When shooting any type of flower, it's important that you ensure that the foreground is filled with flowers in their peak condition – any wilted examples in the foreground will detract from the final image.

My favourite season, along with most other landscape photographers, is autumn, especially during the period when the season crosses from autumn to winter. Earlier, September sees the start of the harvest season and results in the harvest moon, when particles in the air lead to an orange-coloured moon.

FIELD OF POPPIES, COTSWOLDS, ENGLAND

In my book *Photos with Impact*, I photographed a single tree in a field of oilseed rape. When I returned the next year to present the landowner with a calendar that featured the picture, he told me of a field of poppies nearby. Local people know their area much better than you and can point out great locations. Camera: Fuji GX617 panoramic; lens: 180mm; filter: polarizing filter; film: Fuji Velvia 50; exposure: 1/2 sec @ f/22½.

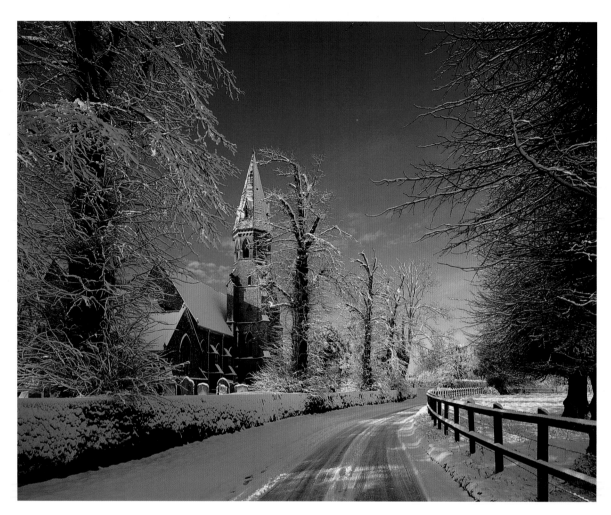

CHURCH AND LANE IN WINTER, FRAMINGHAM PIGOT, NORFOLK, ENGLAND

Fresh snow on trees tends to be short-lived – the slightest wind or rise in temperature, and it's but a memory. I used the lane and fence as lead-in lines and placed the church between two trees. A polarizing filter deepened the blue sky and made the snow-covered trees stand out. Camera: Wista Field 4x5; lens: 90mm Schneider; filter: polarizing filter; film: Fuji Velvia 50; exposure: 1 sec @ f/22.

Even if you've visited a location several times before, it's always worth revisiting, as each time you do, you'll discover that the lighting is different and you find new ways to photograph it.

In winter one I love to shoot hoar frost, which is fairly uncommon and looks wonderful in pictures. The right conditions to look for the night before are sub-zero temperatures with mist or fog. However, it is essential for the skies to clear by morning to leave a brilliant blue sky to contrast with the hoar frost.

Whatever the season, it's important to read weather forecasts, as this can help you plan what to shoot the following day. Following weather patterns and understanding them is very important, particularly in a mountainous area or near the coast, where weather patterns can vary dramatically.

Doing your homework

Just as for urban locations, doing research is extremely important in finding locations. You can visit locations recommended by other photographers, but if you do, you can guarantee that whatever scenes you record will have been captured by many others. You can only input your own unique style of photography to create something different. To find potential new locations, read books, study maps and dedicate time and energy to finding the best locations. To find new places with great potential, it's a good idea to visit bookshops and research in magazines (particularly travel magazines).

CHURCH RUINS AND TREE, SURLINGHAM, NORFOLK, ENGLAND

This is one of my favourite trees and features in many of my photographs. Here I used the church ruins to frame the tree. I used a polarizing filter to make the hoar-frost-covered tree stand out against the blue sky. Camera: Wista Field 4x5; lens: 90mm Schneider; filter: polarizing filter; film: Fuji Velvia 50; exposure: 1 sec @ f/4.5.

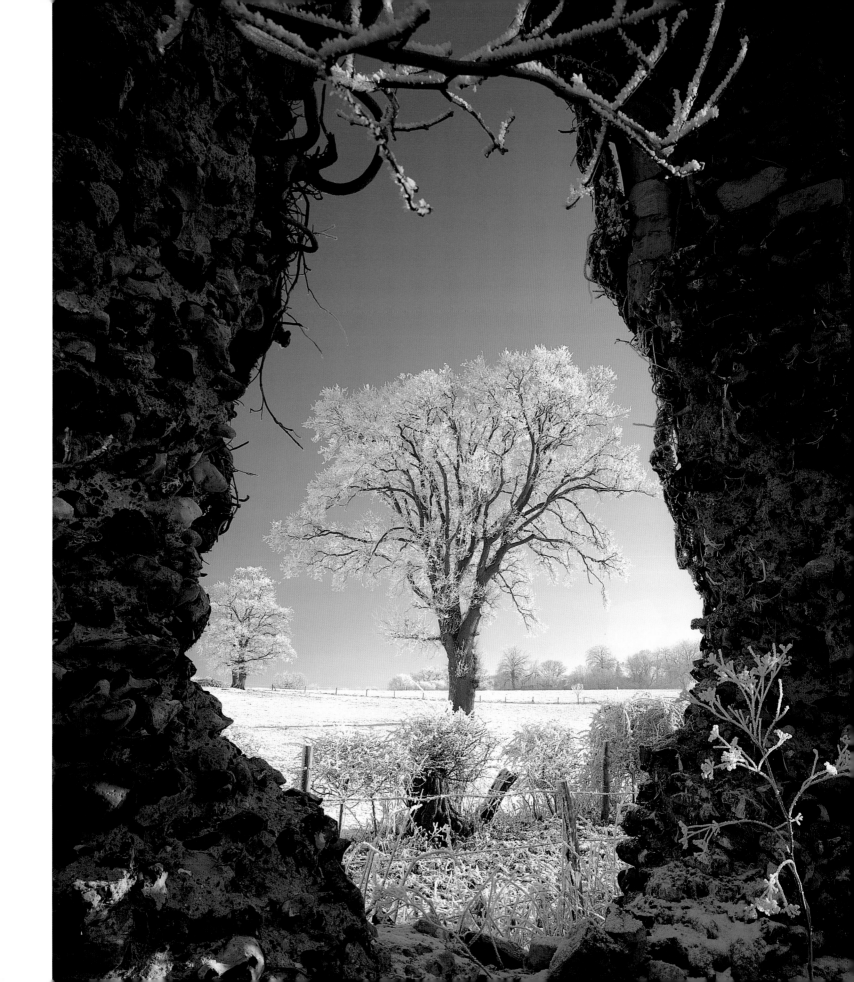

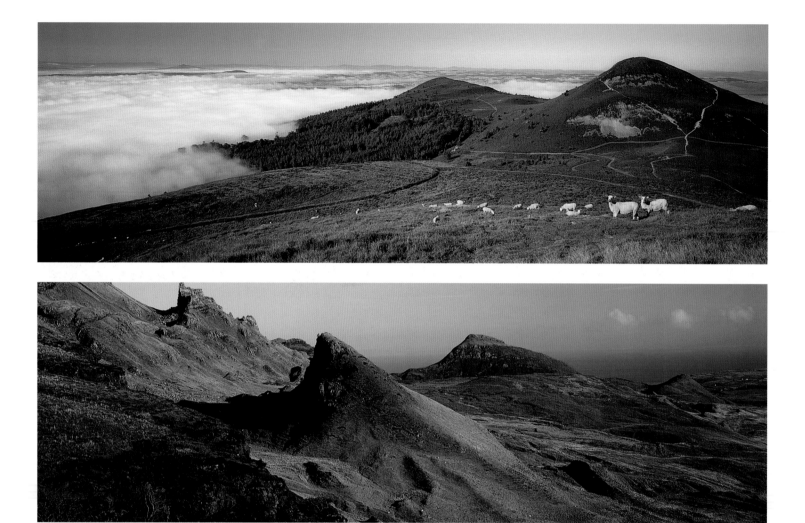

(TOP) MORNING MIST AROUND EILDON HILLS, MELROSE, SCOTLAND

With one clap of my hands the sheep's heads jerked up, and I hit the shutter. Camera: Fuji GX617 panoramic; lens: 180mm; filter: polarizing filter; film: Fuji Velvia 50; exposure: 1/2 sec @ f/22½.

(ABOVE) THE QUIRANG, ISLE OF SKYE, SCOTLAND

This strange volcanic landscape is a Mecca for landscape photographers. In autumn the bracken turns from green to a deep russet. Camera: Fuji GX617 panoramic; lens: 180mm; filter: polarizing filter; film: Fuji Velvia 50; exposure: 1/2 sec @ f/22½.

Revisiting scenes

Don't ever think that because you've shot a particular view or scene once, you can cross it off your locations list, never to return to it. Even if you've visited a location several times before, it's always worth revisiting, as each time you do, you'll discover that the lighting is different and you find new ways to photograph it.

Make a list of various subjects and locations in your area, detailing their specific attributes and noting down potential conditions for each place. A particular location might be suitable for a sunrise or sunset, a fresh snowfall, backlit trees, reflections and so on. Then when conditions are right you can return to these.

With misty scenes, I often like to include a tree with a distinctive shape in the frame. There is one very close to my home that fits the bill perfectly – while in clear conditions the general landscape isn't perfect, when the mist rolls in it makes for a stunning shot. So it pays to note details like this, as you'll find some locations are best suited to particular conditions.

Shooting into mist

On the subject of mist, it's well worth trying to shoot into the sun when the air is misty, as the shadows cast by branches dissect the brightly lit mist with dark lines of shadow. When shooting into the light, you must be able to

expose the frame correctly, most effectively using a spot reading with a handheld meter. Learning where to take your readings from comes from trial and error and experience.

When ground mist and fog cover low-lying areas of the valleys, you will benefit from being up high on outcrops so that you can take full advantage of the conditions. Because you have a clear view, you're able to capture fantastic results, especially when the light is at its best, such as at sunrise.

Finding strong components

It's important to balance components in the scene so that one side isn't heavier than the other in terms of subject matter and focal points. Every landscape lends itself to different compositional tools, whether it's the Rule of Thirds, lead-in lines or S-shapes. If you spot a stone wall that's the perfect lead-in line, arrange the composition so that there is something in the background for the eye to settle on, such as a church, a barn or a tree.

FARM NEAR TOTNES, DEVON, ENGLAND
The rich, red earth of Devon contrasted nicely with the green and golden fields. With the sun at a right-angle to the camera, these were perfect conditions for full polarization to make the clouds stand out. Camera: Wista Field 4x5; lens: 150mm Schneider; filter: polarizing filter; film: Fuji Velvia 50; exposure: 1/2 sec @ f/22½.

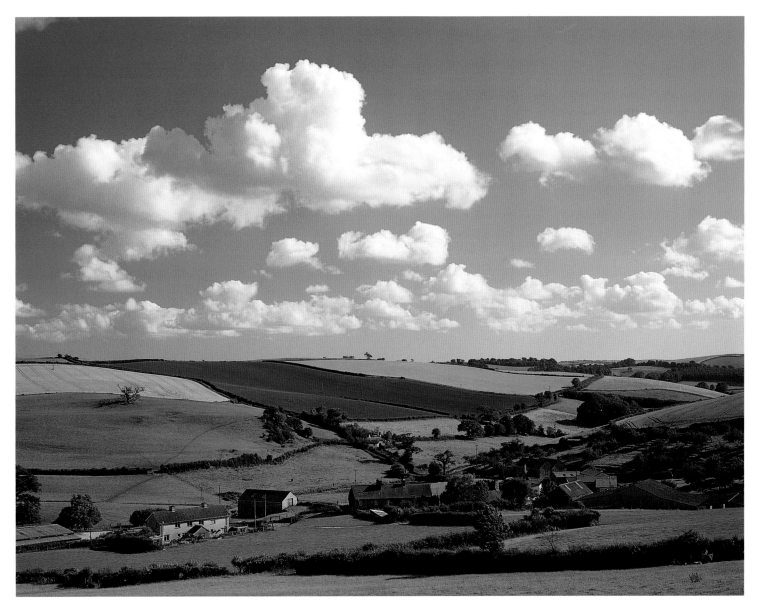

SUNSET OVER LANDSCAPE, ZAHARA DE LA SIERRA, SPAIN

Photographing hilltop villages in Andalusia is ideal for obtaining views over the expansive landscape. This village was positioned perfectly to obtain a high angle that included the village and the setting sun. To balance the extreme exposure range I combined a Lee 0.6 and a 0.9 ND grad along with a sunset filter to add warmth to the overall scene, and exposed for the tiled rooftops. Camera: Fuji GX617 panoramic; lens: 180mm; filters: Lee 0.6, 0.9 hard ND grads, sunset filter; film: Fuji Velvia 50; exposure: 8 sec @ f/32.

Primarily what you're trying to do is tell a story, guide the viewer's eye through the picture and make it an interesting journey for them. To this end, look for strong lead-in lines that draw your eye into the scene – a road, a river, a fence or a track, for instance. Then find suitable angles that give you the best viewpoint – high viewpoints can often give you a better view of the vista.

If you have a tree as your main focal point, ensure that when you position it in the frame, half of it doesn't intersect the horizon, as the shot won't be as successful.

Using manmade objects

It's important to look for elements that catch the viewer's attention – often these can be something simple, such as a subject with a strong shape.

Straw bales, for instance, are extremely graphic subjects that cry out to be shot creatively. They are, however, a subject with which you need to take care, as there is a right and wrong way to photograph them. You need to shoot from the correct angle and make sure they're positioned against the scene to the best

possible effect. You'll normally find several positioned in the same field, so try and balance them out throughout the frame. Look for bales without the hessian wrap or black plastic around them – string is far more attractive. Bales look best just after they have been wrapped up – their colour starts to dull once they have been left in the field for a few days.

Other manmade features that bear repeated photography are mills and turbines – with strong patterns and shapes playing a key role in a strong composition, these subjects are suitable for creating memorable images.

Excluding manmade objects

In contrast, there are plenty of manmade objects that crop up in rural landscapes and that you have to try your best to exclude (although this isn't always possible). Apart

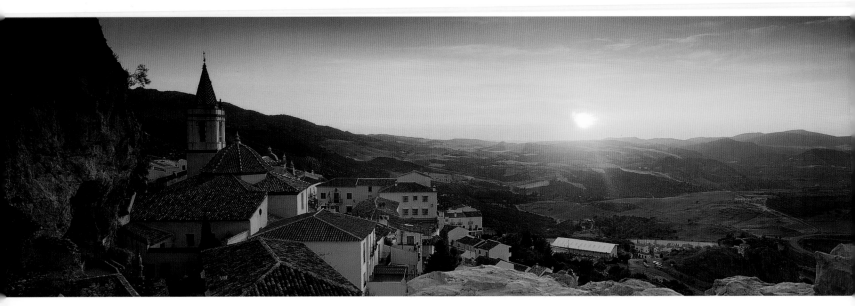

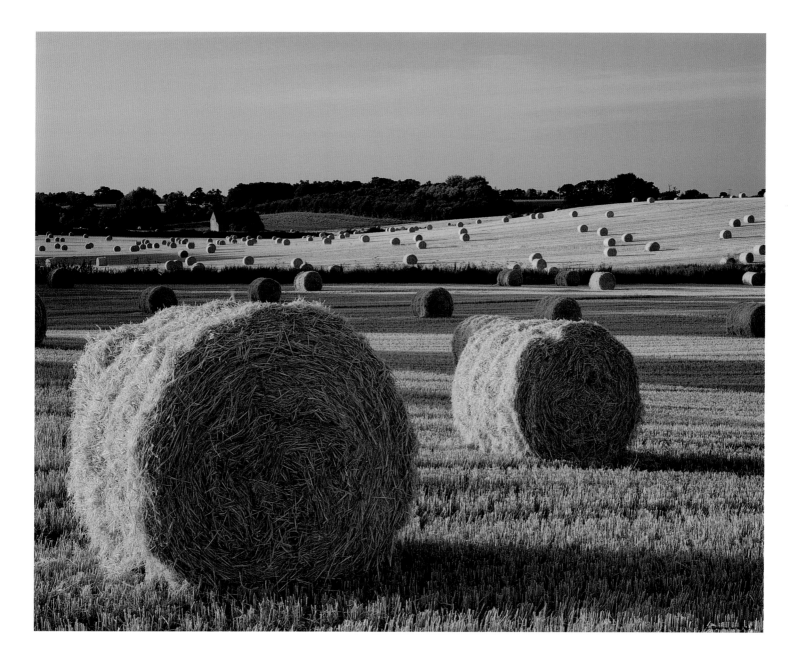

from removing obstacles in Photoshop, there are ways to make these objects less apparent: pylons and power lines are the most common, and all you can do is try and adopt an angle that excludes them from the frame.

If this isn't possible, changing focal lengths can help. For instance, imagine you have rolling farmland with power lines going straight through it. If you use a normal focal length lens, the sizes of objects within the scene will appear as they do to the eye. But shoot with a wide-angle lens and the obtrusive objects are pushed further away.

Varying formats

If you are thinking of selling you work through stock libraries, it's advisable to get an upright and horizontal shot for every scene you shoot, simply from a marketing point of view. If you can shoot a vertical (portrait format) image,

EVENING LIGHT ON STRAW BALES, SURLINGHAM, NORFOLK, ENGLAND
The dark circular shapes of the bales made an interesting compositional element. I positioned two prominent bales to balance the foreground space, and to enhance the warm evening light I used a warm polarizing filter. Camera: Wista Field 4x5; lens: 150mm Schneider; filter: Tiffen warm polarizing filter; film: Fuji Velvia 50; exposure: 2 sec @ f/32.

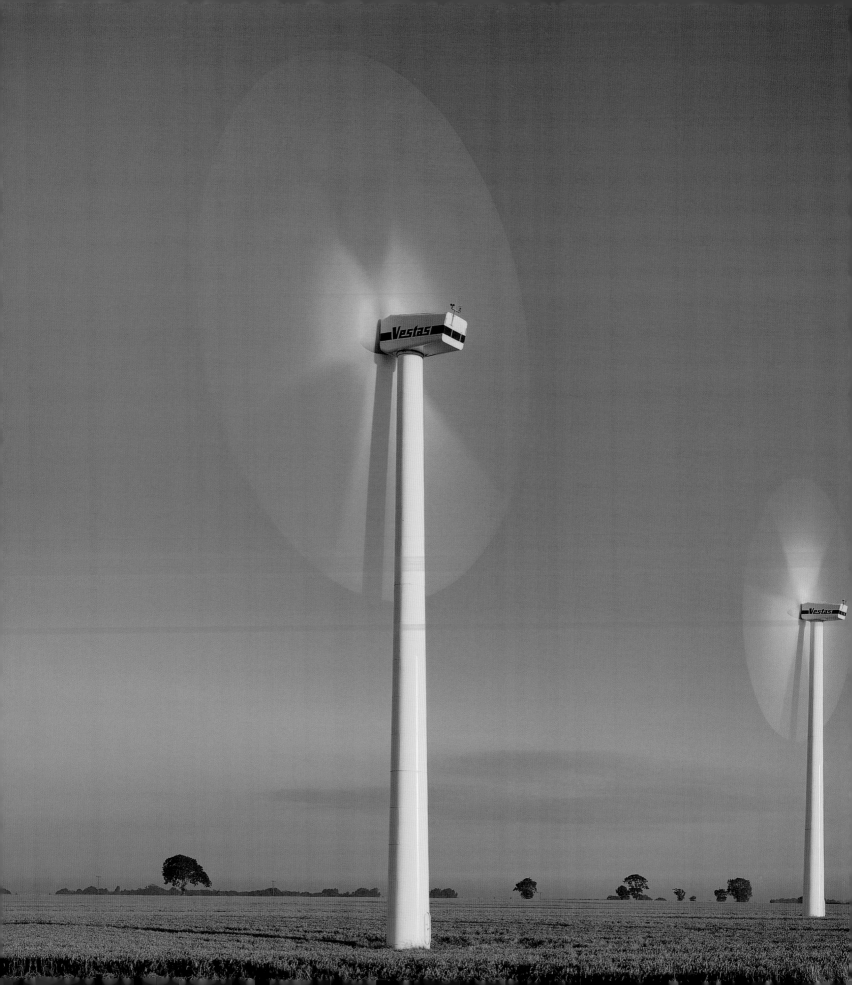

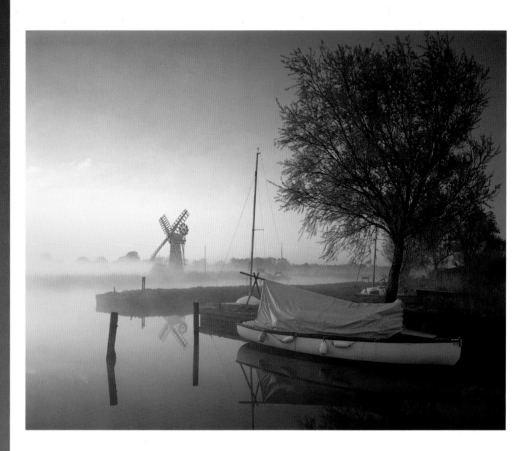

(ABOVE) THURNE MILL IN MIST, NORFOLK, ENGLAND

Here is a 'traditional' windpump in the landscape in direct comparison to the wind turbines at left. But what we consider traditional now must have seemed like a blot on the landscape to many people back then, much in the way that people now think of the modern wind turbines. When photographing either the modern or traditional structures, the placement of the sails is important to the final result – the turbines in a line would not have the same effect if any of the sails had been facing a different direction. Conversely, the sails of traditional windmills or windpumps photograph better when they are at a three-quarter angle to the camera so the fantail can also be seen. Camera: Wista Field 4x5; lens: 90mm Schneider; filter: polarizing filter; film: Fuji Velvia 50; exposure: 4 sec @ f/22½.

(LEFT) WIND TURBINES, WINTERTON, NORFOLK, ENGLAND

Patterns and shapes are important elements in landscape photography, and manmade structures, such as this set of turbines, make ideal subjects. I chose a slow enough shutter speed to blur the motion of the turbines; this made the image more interesting by adding motion. I used a yellow/blue polarizer to enhance the warmth of the early morning light. Camera: Wista Field 4x5; lens: 150mm Schneider; filter: Cokin yellow/blue polarizing filter; film: Fuji Velvia 50; exposure: 1/4 sec @ f/22½.

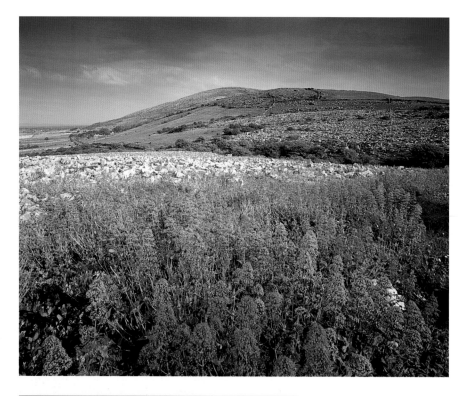

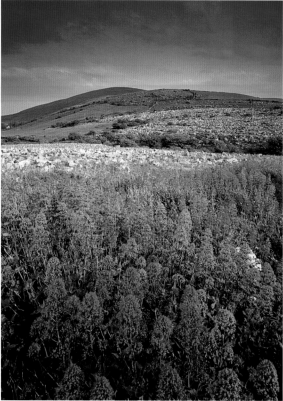

A hard-edged graduate filter is fine to use when your horizon is relatively flat. However, if it's irregular, due to trees, hills and so on, a soft-edged grad is a far better choice.

you can use it for a magazine, brochure or book cover, while a horizontal format is more suitable for use across a spread in a book or magazine. Some scenes work both ways, some don't, but by having both it increases the marketing potential for that image.

Panoramic images need you to look at a subject in a completely different way, requiring you to adopt 'letterbox viewing'. Many scenes won't work with this format, and using a panoramic on a scene for the sake of it is not recommended practice; it's better to compose the elements of a scene to fit the given format.

The choice of lens often depends on the weather that you're working in. Fit a wide-angle if the sky is fantastic, and as the sky deteriorates, use longer focal lengths.

Using filters

There are two filters in particular that are perfect for rural landscapes – the polarizer and the ND graduate. I use polarizing filters for the majority of my rural landscapes because they boost the colours and help the clouds stand out in the sky. Polarizers also reduce reflections from foliage and, by doing so, saturate the colours.

The ND grad is a vital accessory for rural landscapes, as you have to compress the exposure latitude between the foreground and sky. There are three main strengths – 0.3ND (1 stop), 0.6ND (2 stops) and 0.9ND (3 stops). Choose the strength you need based on the range of the scene and the effect you are looking for; you may find that you use one particular filter more than the others.

A hard-edged graduate filter is fine when your horizon is relatively flat. However, if it's irregular, due to trees or hills, a soft-edged grad is a far better choice. Use the depth of field preview to stop down the lens as this allows you to see the effect of the grad and judge whether it needs to be raised or lowered for the most effective result.

RED VALERIAN, THE BURREN, CO. CLARE, IRELAND

Not all compositions afford both horizontal and vertical orientations, but whenever possible I try to shoot both. This is useful for marketing purposes – for example, the horizontal might suit calendars or books, while the vertical is an ideal format for magazine covers. Camera: Wista Field 4x5; lens: 75mm Nikkor; filter: polarizing filter; film: Fuji Velvia 50; exposure: 1/2 sec @ f/32.

Exposure

Photographers all have different ways of exposing when using ND grads, but taking a reading through the filter with a spot meter gives a fairly accurate result. There may be times when you only want to use a section of the filter, so by taking a reading at that point you can get a more accurate reading.

Take care when you have strong differences in the exposure values of elements in the frame, such as a field of bright oilseed rape. Look for mid-tones in the scene – green foliage is a good guide, as long as it isn't in intense sunlight or deep shade. In most situations expose properly for the sky and the rest of the scene will fall neatly into place.

If it's windy, look for scenes with vegetation swaying in the breeze. In this case, use an exposure time of around 1/2 sec to capture some movement.

DEW-LADEN SPIDERS' WEBS IN MIST, SURLINGHAM, NORFOLK, ENGLAND
Photographers create their best work in their own local area because they know and understand the landscape better than anyone else. This image is next to a wildfowl reserve where I walk my dog. I spotted these webs covered in dew one morning, and to highlight them I shot directly into the sun. Camera: Wista Field 4x5; lens: 90mm Schneider; film: Fuji Velvia 50; exposure: 1/4 sec @ f/32.

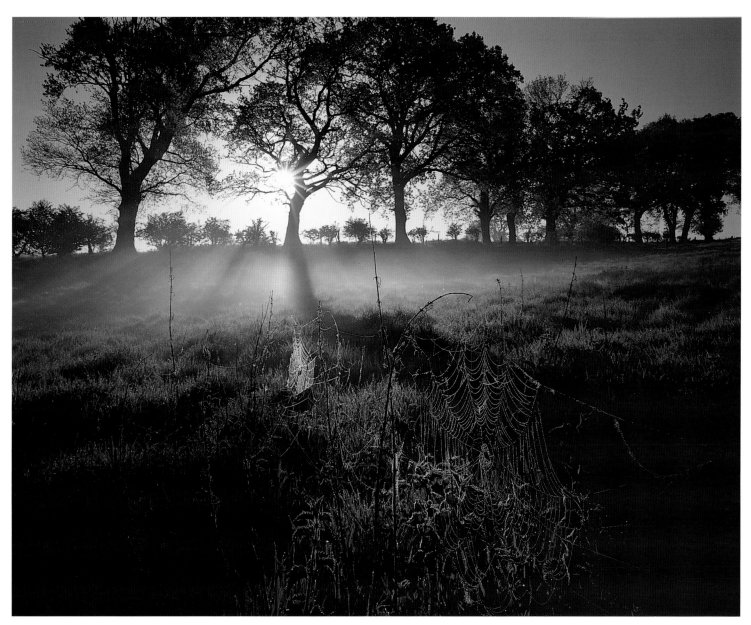

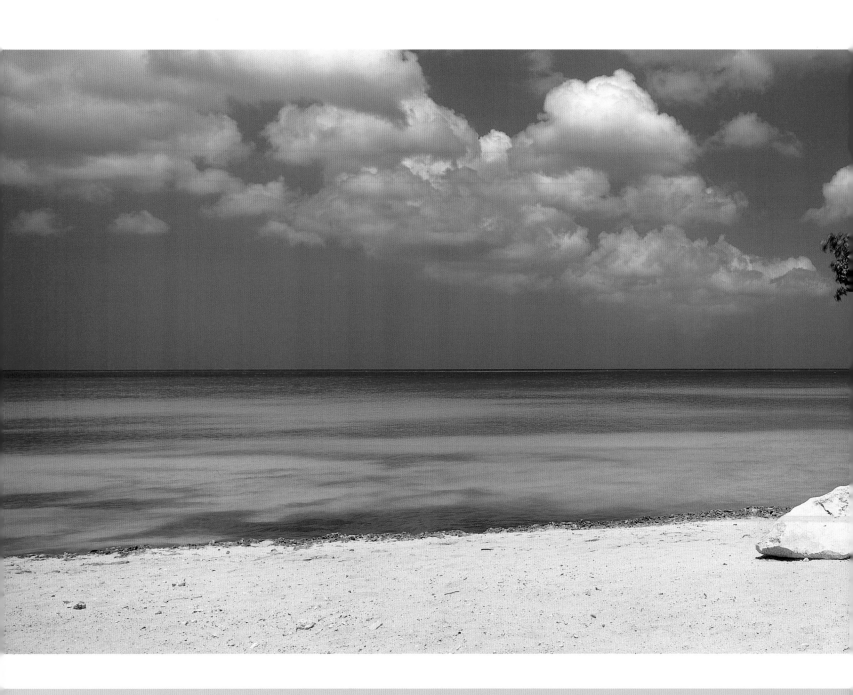

DIVI DIVI TREE, ARUBA, LESSER ANTILLES, CARIBBEAN

Even for a simple shot of a tree on a beach, I visited the spot at various times and found that midday light provided the best colour in the sea. A polarizing filter deepened the blue sky and removed reflections from the water's surface. Camera: Fuji GX617 panoramic; lens: 90mm; filter: polarizing filter; film: Fuji Velvia 50; exposure: 1/2 sec @ f/22½.

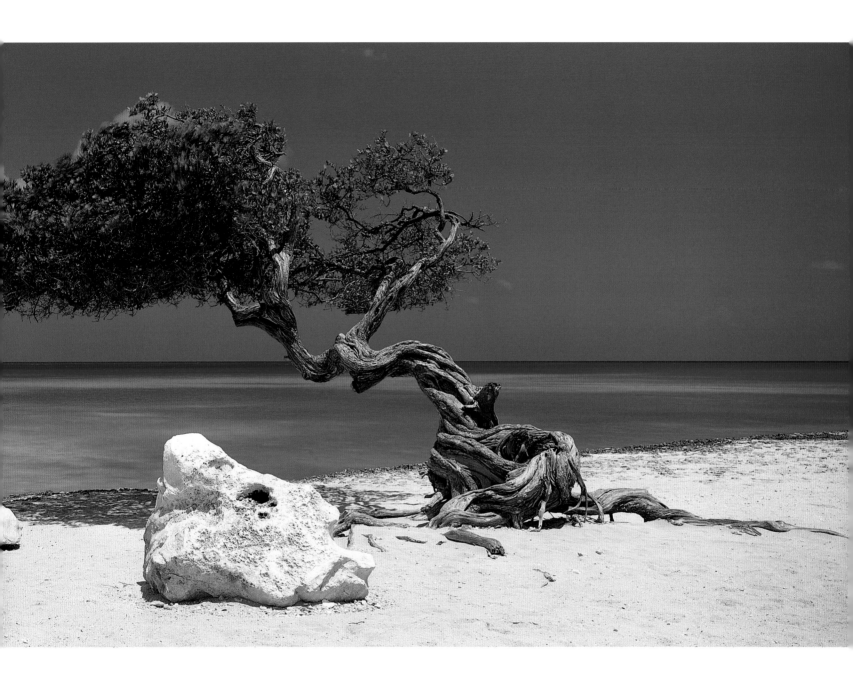

COASTAL LANDSCAPES

If you live on an island, such as any of the British Isles, you should feel very lucky, because no matter what direction you travel in, sooner or later you'll reach one of the most beautiful and unique type of landscapes, the coastline.

While for most people a visit to the beach means sunbathing, ice creams and relaxation, for the keen photographer, the opportunity to be beside the sea is one of unrivalled picture-taking potential. And even though your options for moving around to find the perfect viewpoint are limited by the boundaries of the sea itself, the diversity and natural beauty of the coast means it should not be too difficult to find suitable photo opportunities.

Take in the details

While a coastline is a very different proposition to other types of landscapes, you should approach it in much the same way as you would other types of location – but in terms of composition and viewpoint, it is largely dependent on what's happening in the sky. If there is an interesting cloud formation then I will compose to utilize the formation in the frame, but if the sky is void of interest then I concentrate on details of the coastline.

Don't only shoot wide vistas as the coast, in particular the beach, offers a wealth of potential for shooting details such as tide pools, rocks and sand patterns. This option is particularly attractive when the weather is too overcast for general views.

If the weather does take a turn for the worse and begins to get a little stormy, you're in luck, as this is the perfect weather condition for capturing larger, crashing waves against rocks or the shoreline. Even in extremely poor conditions, when colour in the scene has been washed away, try visualizing and shooting in black and white – features such as piers, sea defences, groynes and boulders have a graphic appeal that often looks better in black and white than in colour. Try a variety of techniques, in particular setting long exposures to capture the flowing waves around static elements such as rocks, groynes and piers.

THE DEIL'S HEAD AND STARFISH, NEAR ARBROATH, TAYSIDE, SCOTLAND
Foreground interest plays an important part of coastal scenes: I couldn't believe it when I found hundreds of starfish scattered on the rocks on this Scottish coastline. I used a front tilt on my 4x5 to ensure the foreground-to-background remained in sharp focus – this can also be accomplished by using the hyperfocal distance where you focus one-third of the way into the scene and stop the lens down to the smallest aperature. Camera: Wista Field 4x5; lens: 90mm Schneider; filter: polarizing filter; film: Fuji Velvia 50; exposure: 1/2 sec @ f/32.

SAND PATTERNS AT LOW TIDE, WELLS-NEXT-THE-SEA, NORFOLK, ENGLAND
Every time I photograph this coastline, I notice something different in the scene – sometimes small tide pools in the foreground, at other times interesting and attractive sand patterns. Coastlines are among the most transitory of scenes – every day sees something new. Camera: Fuji GX617 panoramic; lens: 90mm; film: Fuji Velvia 50; filter: polarizing filter; exposure: 1/2 sec @ f/22½.

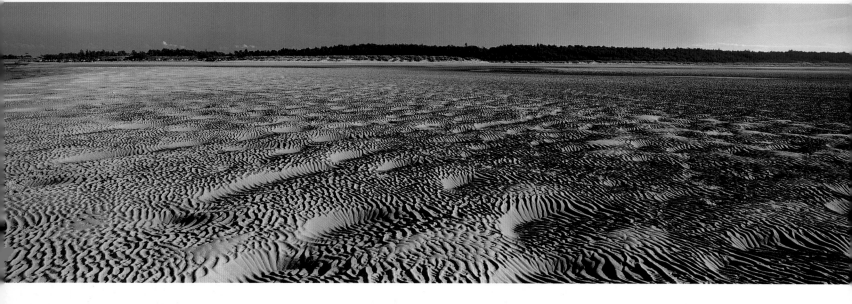

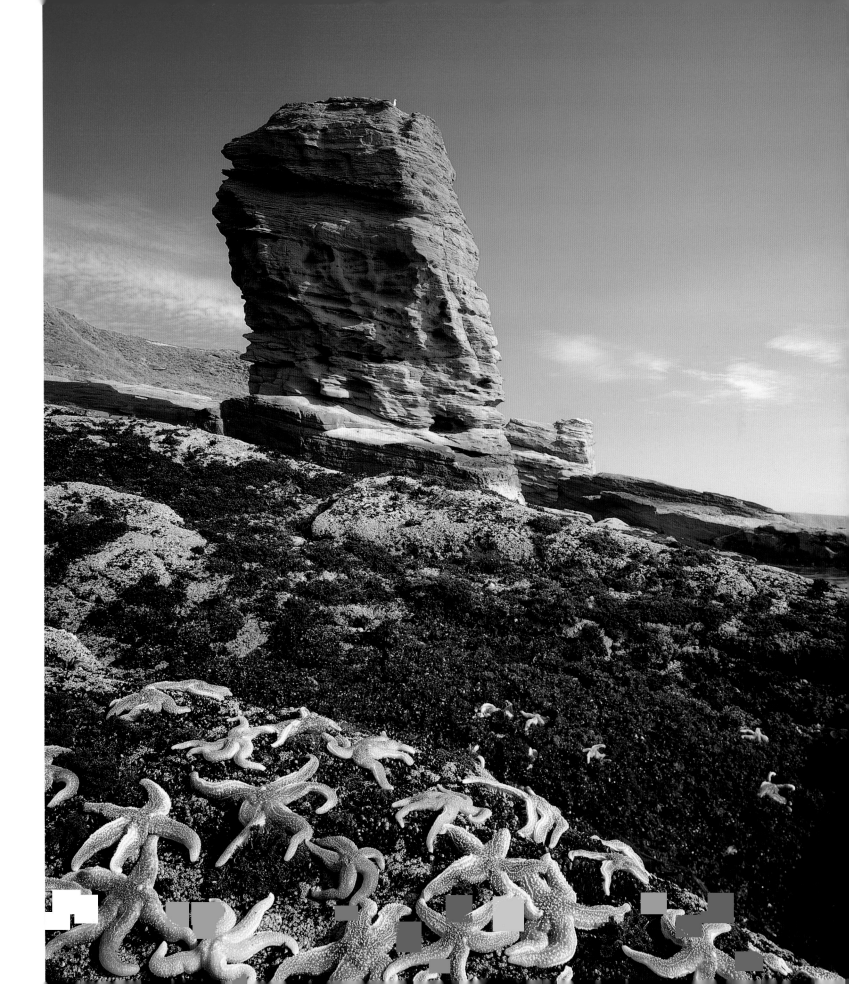

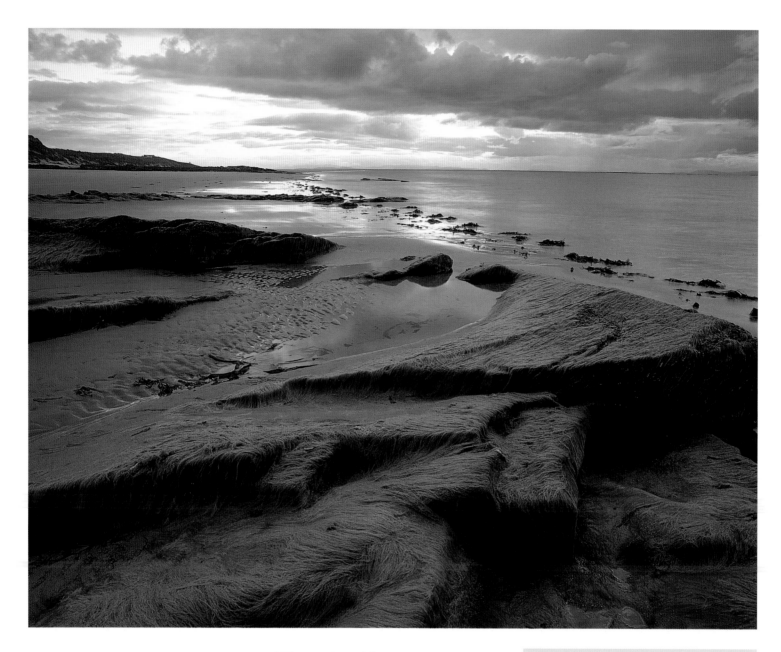

LOSSIEMOUTH BEACH, GRAMPIAN, SCOTLAND

The natural curve of the moss-covered rocks added a good foreground element. A polarizing filter removed the reflection from the moss, revealing a saturated green, contrasting with the stormy magenta sky. A grad was necessary to balance the exposure value of the sky with the foreground. Camera: Pentax 6x7; lens: 45mm; filters: Lee hard 0.9 ND grad, polarizing filter; film: Fuji Velvia 50; exposure: 1 sec @ f/22.

When the tide turns

A particularly pleasing aspect of photographing coastlines, in particular beaches, is that you start each day with a clean palette to work with because with each tide, the previous day's activities have been washed away.

The same coastline will never look the same from visit to visit. Each time the beach has new shells, flotsam, patterns in the sand, tide pools and various other elements that offer the

LANDSCAPE SECRETS

Features such as piers, sea defences, groynes and boulders have a graphic appeal that often looks better in black and white than in colour.

chance to capture new detail shots as well as general scenics – each new tide unleashes secrets that will disappear and be replaced by new revelations with the arrival of another tide.

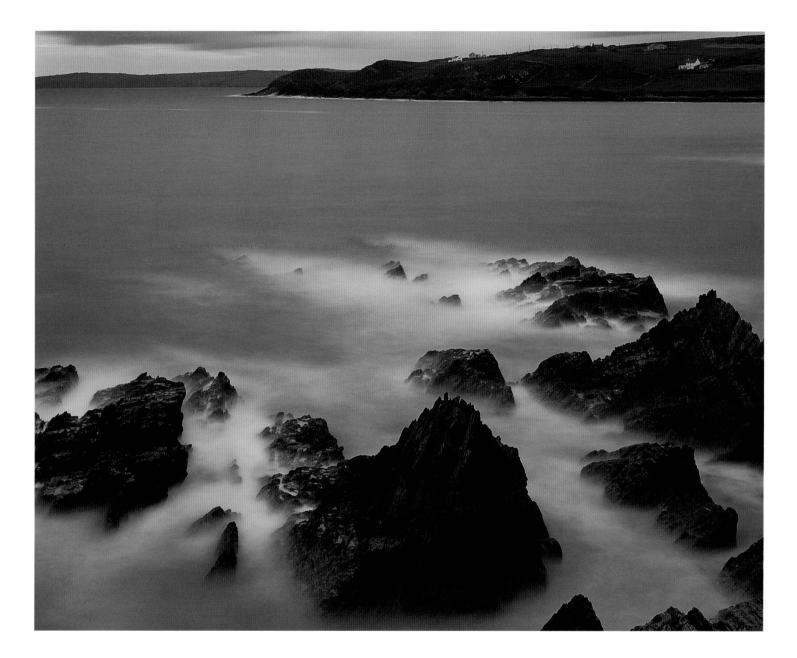

It's important to check tide times, as this allows you to plan in advance for the tide being in or out. There are various websites and teletext services offering this type of information, so you shouldn't have any real problems finding out times. If you want to shoot features on the coast, such as rocks jutting up through water during a long exposure at dusk or dawn, it's important to check that the tide is at the correct level.

Another tip that can make a big difference to your final result with coastal photography is when you are shooting within the breaking waves on the beach, make sure you firmly plant your tripod legs into the sand as the water is rushing in and out. Otherwise, you will find that during any long exposures you take, the whole tripod will sink into the sand. This will result in blurred images, and your horizons may also be on the skew.

ROCKY COASTLINE, DUNWORTHY BAY, CO. CORK, IRELAND

I spent two days in gale-force winds and rain, waiting for a break in the storm before the wind died down and the rain stopped long enough to make a few exposures. The sky was grey and lifeless, so I cropped most of it out. Camera: Wista Field 4x5; lens: 210mm Nikkor; filter: Lee 80B; film: Fuji Velvia 50; exposure: 2 min @ f/22.

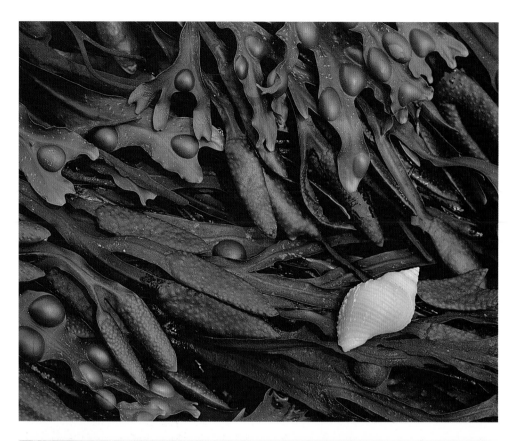

BLADDERWRACK AND PERIWINKLE, WEST RUNTON, NORFOLK, ENGLAND

The overcast conditions provided ideal soft lighting for close-up subjects. I placed the bladderwrack in a natural diagonal in the frame and, keeping the Rule of Thirds in mind, added the shell at an angle in the lower third. A polarizing filter removed the reflections, and saturated the colours. Camera: Wista Field 4x5; lens: 150mm Schneider; filter: polarizing filter; film: Fuji Velvia 50; exposure: 1 sec @ f/22.

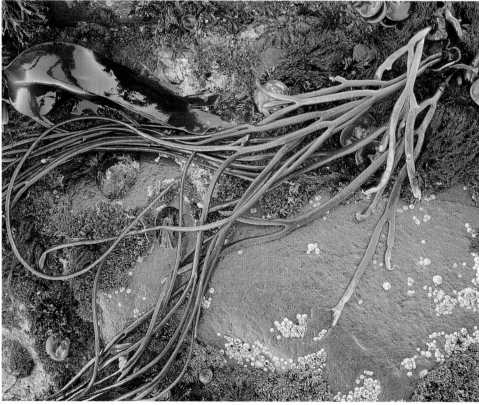

BOOTLACE SEAWEED AND ROCK DETAIL, NEAR CRASTER, NORTHUMBERLAND, ENGLAND

Sometimes when shooting details, you may come across subjects that are perfectly positioned. More often than not, though, you need to pick and mix subjects – look for sand with interesting patterns and use this as a backdrop on to which you can place a shell, a barnacle-covered piece of driftwood or any other suitable still-life subject. If you can't find any interesting shells on the beach, buy a selection and set up still lifes on the beach. Camera: Wista Field 4x5; lens: 150mm Schneider; film: Fuji Velvia 50; exposure: 1 sec @ f/22.

The changing seasons

As with all landscapes, seasons play an important role in the general appearance of the coastal scenery. Research when flowers are in bloom in coastal areas, and plan your visits for seasons when the flora and the colours of the headlands are fully in bloom, as this is when they are at their most colourful and there are the fewest instances of brown, dying leaves and plants. For instance, in the UK, I aim to visit the coastline in early May, when the pink blooms of thrift are present.

The general colour of the headland changes dramatically throughout the year: in most non-tropical places, winter sees headlands having a very drab, brown colour that's not at all appealing. But this all changes with the arrival of spring, when the coastline bursts into colour and the scene takes on a vibrancy and life that was missing only a few weeks earlier.

Protecting your equipment

It is absolutely essential that your gear is constantly protected from sea spray, however fine, as the salt in seawater can cause serious damage to equipment and accessories. Large, re-sealable plastic bags of the type sold at supermarkets are an effective and inexpensive way of protecting your camera.

Keep your camera inside the bag, as the salt in the air of an onshore breeze can otherwise prove very harmful to its electronics. The only part of the bag that should be open is the hole that's cut into it for the lens to poke through. A strong elastic band ensures that the plastic remains firmly in place around the lens side.

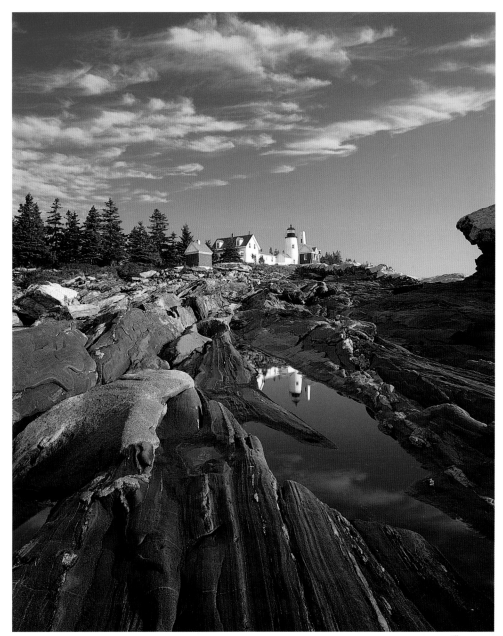

Many island locations, especially in the Caribbean, are subject to constant trade winds, in which case you need to constantly check the front lens element, as deposits of sea spray have an obvious adverse effect on the final image. Black plastic bin liners are also worth carrying in strong winds to store your gadget bag inside to prevent sand building up while the bag rests on the beach.

PEMAQUID LIGHTHOUSE, PEMAQUID POINT, MAINE, USA

This is a popular location for photographers as the interesting rock striations make lead-in lines to the lighthouse. The low angle chosen revealed the reflection of the lighthouse in the tide pool. Camera: Wista Field 4x5; lens: 90mm Schneider; filter: polarizing filter; film: Fuji Velvia 50; exposure: 1 sec @ f/32.

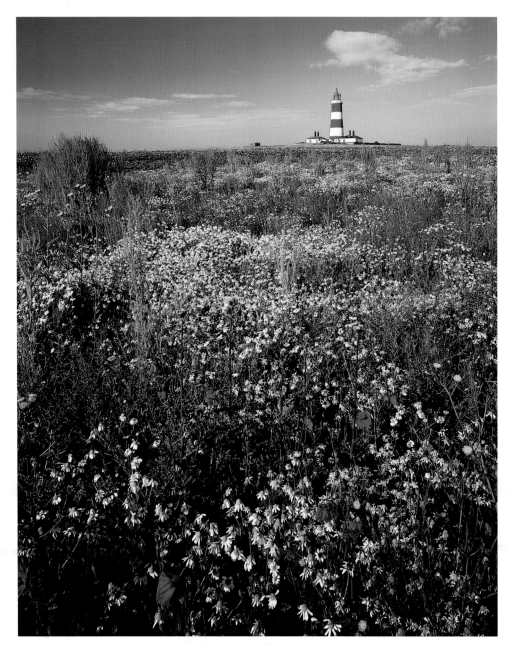

Cliffs can make for very dramatic images whether you're at the top looking down at the beach, or at its base shooting up at the strong lines and textures of the cliff face. Positioning yourself at a high vantage point and shooting a rugged coastline with rocks jutting out to sea can produce powerful and evocative images.

Pebble or shingle beaches often provide interesting pattern details, and are also great for shots of water lapping over the shore. These beaches are also a good subject for shooting into the light, as you can capture the highlights dancing off the surface of the pebbles.

When on the beach use wide-angle lenses more than any other focal length to exaggerate the foreground interest and the depth of the scene. Look for strong foreground interest – rock formations are a good choice, as are patterns in the sand. If you're including rocks in the foreground, try and shoot them while they're wet, as their colour and sheen will be far better than when they are dry.

When the tide is out you'll often find rock pools, which make excellent subjects for use as foreground interest. They're also teaming with life – sea anemones, crabs and other sea creatures cry out for you to fit a macro lens and shoot some detail and nature images. Beaches that are relatively featureless when the tide is in may offer far more potential when the tide is out, in the form of tidal pools and patterns and shapes in the sand.

HAPPISBURGH LIGHTHOUSE, NORFOLK, ENGLAND

When composing subjects like lighthouses, give prominence to the part of the scene with the most interest – here the wildflowers presented the best foreground, so the horizon is high in the frame and the lighthouse off to one side. Camera: Wista Field 4x5; lens: 90mm Schneider; filter: polarizing filter; film: Fuji Velvia 50; exposure: 1/2 sec @ f/32.

Looking for variations

There are a great many types of coastline, each presenting its own unique characteristics and with it, its own photographic challenges. With experience you will find that the nature of coastlines changes quite dramatically over a relatively short distance so, if you are prepared to do some walking, a day's photography can result in a real variety of pictures.

Using filters

I have all my lenses mounted with polarizers as they help to reduce highlight glare in strong lighting conditions. A polarizer is particularly essential for tropical beaches when the sun is very high in the sky. While in the tropics, I visited the same scene in early morning, at lunchtime and in the evening, and found that

the light was best in the middle of the day. This was because at this time the rays of light come down from overhead and really bring out the turquoise colour of the sea, especially when a polarizer is fitted.

When photographing yellow sandy beaches, particularly under overcast conditions, the sand tends to take on a cool colour cast. An 81-series or a coral filter will counteract this blue cast and put the warmth back into the sand.

Expose for atmosphere

The most atmospheric way to record waves is by shooting long exposures in the low light of early morning or late evening. An exposure of several seconds or even minutes is needed if you want decent depth of field, and this results in you capturing several successions of waves and recording the water as an ethereal mist.

LANDSCAPE SECRETS

If you are including rocks in the foreground, try and shoot them while they're wet, as their colour and sheen will be far better than when they are dry.

Sometimes you may want to freeze the action of water, say to capture the explosion of waves crashing against rocks, but often this gives the image a very static feel, and unless your wave has a nice shape, it doesn't look particularly good. Using an exposure of around 1/4 sec is slow enough to record a little movement in the wave but fast enough to freeze the action, and this is a better option.

When using long exposures, remember to shoot the tide when it is receding. If the tide is advancing, you will continually find yourself moving your tripod to avoid the approach of the water. If you can time shooting for when the tide is on the turn, you can make full use of the water's ebb and flow without distraction.

Capturing reflections

Another wonderful aspect of photographing coastlines is that it allows you to include reflections in the scene and add real depth to your images. Evening light is my favourite for reflections: the light is clear and often the wind is lighter, meaning water in rock pools is more likely to lack ripples and appear clearer

HOOK HEAD LIGHTHOUSE, CO. WEXFORD, IRELAND

I waited until evening when the light level was low enough to afford an exposure of several minutes. This allowed several passes of the light from the lighthouse and the sea recorded as an atmospheric mist. The dark, rocky coastline in the right-hand corner of the frame acts as a strong base and balances the overall image. Camera: Fuji GX617 panoramic; lens: 180mm lens; film: Fuji Velvia 50; exposure: 2 min @ f/22.

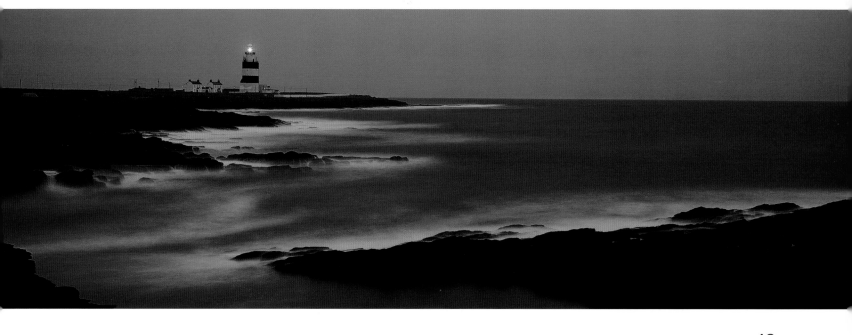

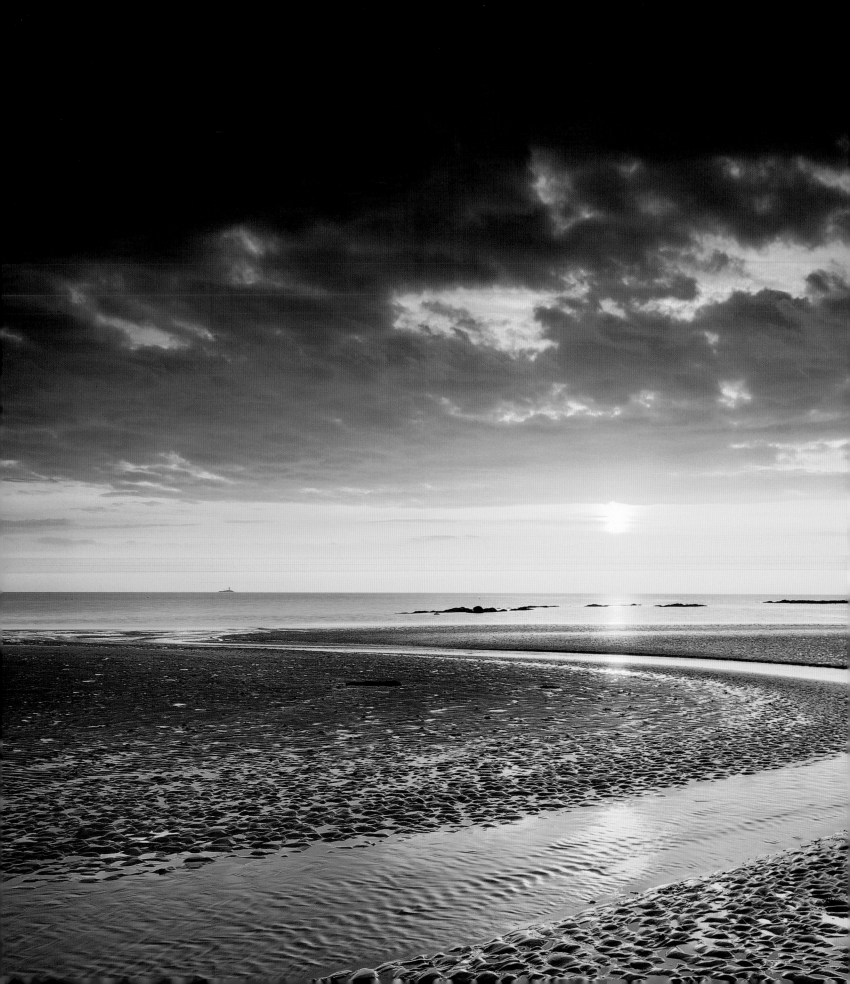

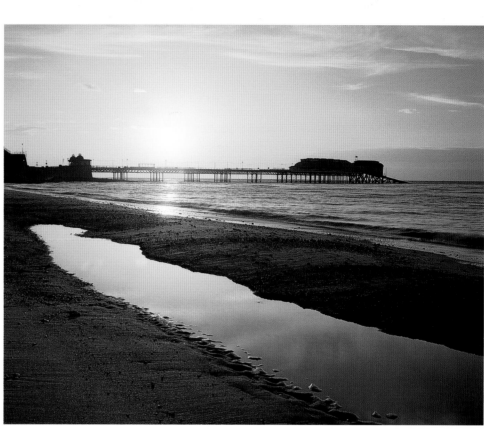

(ABOVE) CROMER PIER AT SUNSET, NORFOLK, ENGLAND

I was fortunate to have found this tide pool on the beach, as it reflected the evening sky and provided an ideal diagonal line leading to the pier; this invokes action into the scene. A sunset filter enhanced the overall colour. Camera: Wista Field 4x5; lens: 150mm Schneider; filter: sunset filter; film: Fuji Velvia 50; exposure: 1/2 sec @ f/32.

(LEFT) SUNRISE OVER BEACH, RUSH, CO. DUBLIN, IRELAND

I used the sweeping curve of the water channel to guide the viewer through the frame. Arriving at a correct exposure can be tricky – I took spot meter readings from the highlights in the sand in the foreground and from the sky just below the dark cloud. The exposure range was too extreme, so I placed a Lee hard 0.9 ND grad over the sky along with a Lee 4 coral grad over the top of the frame and a Lee 2 coral grad over the bottom part of the frame. Camera: Wista Field 4x5; lens: 90mm Schneider; filters: Lee hard 0.9 ND grad, 4 coral grad and 2 coral grad; film: Fuji Velvia 50; exposure: 1/4 sec @ f/22.

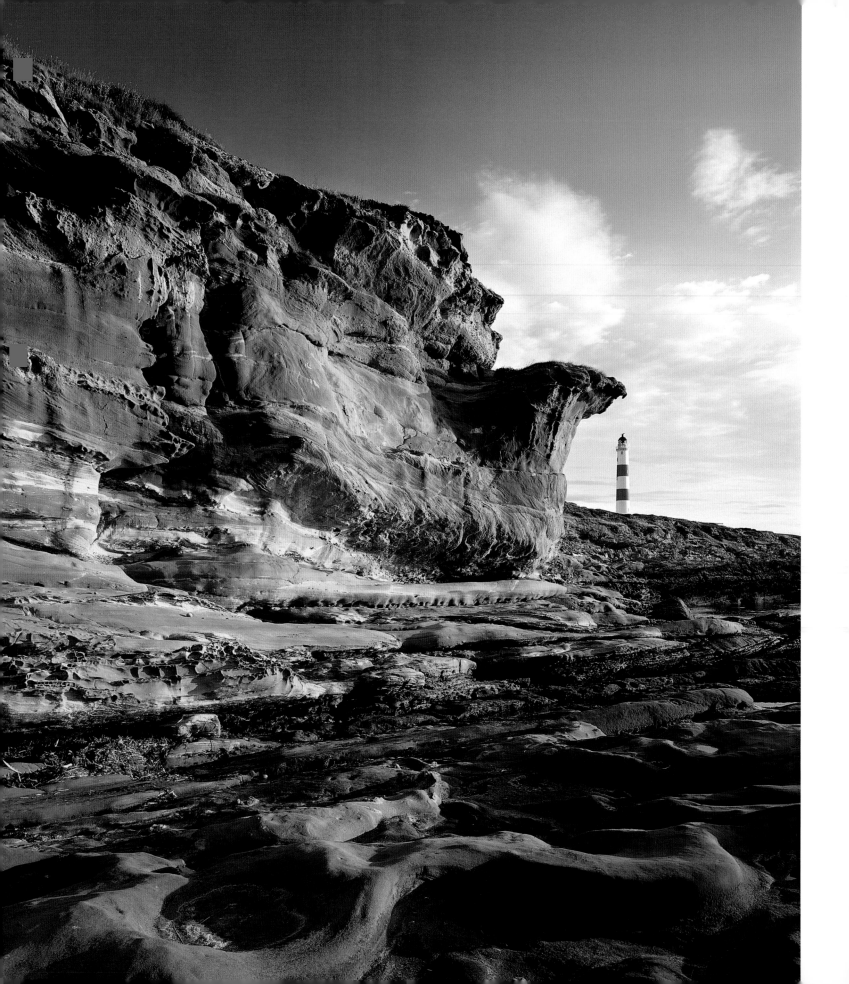

SANDSTONE CLIFFS AND LIGHTHOUSE, TARBAT NESS, SCOTLAND

I arrived at this lighthouse in the afternoon to scout for possible compositions and found these amazing sandstone cliffs. Unfortunately they face east and were not lit. So I set up the next morning before sunrise and waited for the first light to illuminate the cliffs. As the sun was at a right-angle to the camera, the scene polarized beautifully. Camera: Wista Field 4x5; lens: 90mm Schneider; filter: polarizing filter; film: Fuji Velvia 50; exposure: 1 sec @ f/32.

in the final image. Sunrise and sunset are both excellent times to capture reflections as you can fill the frame with orange hues and capture colour patterns in the waves.

The strongest compositions

Whatever type of coastline you're shooting, try and find a stretch that is curved or has a defined shape, as opposed to one that reaches into the distance in a straight line. Curved coastlines or those with exaggerated features offer far more interest and appeal than a flat, two-dimensional view of a bland, featureless coastline disappearing into the distance.

If you shoot the coastline straight on with the horizon perfectly intersecting the scene, this gives the illusion of a calm, peaceful scene. However, if you get closer and have the diagonal going across the frame, then you add an element of action and drama to the image.

Make sure you find a beach that has strong enough features to make it a strong composition. It's pointless going to a location with long stretches of sand and little else, as you will find it incredibly difficult to produce powerful pictures. It's far better to look for

coastlines with cliffs, groynes or other sea defences or sea stacks that allow you to work the elements into a wonderful final image.

Specialist equipment

A handy gadget that is worth investing in is the Flight Logistics Sun Compass – an inexpensive but invaluable aid for determining the position and time of sunrise and sunset for any location in the world. It's well worth acquiring one, as you will find sunrise and sunset are two of the best times to shoot coastlines and this gadget will ensure you don't miss them.

WHITESANDS BAY, DYFED, WALES

To really appreciate this beach a high viewpoint was needed. I used a small strip of foreground as a base and the waves entering the frame from the lower left corner direct the viewer through the composition. A polarizing filter not only increases colour saturation, but also removes the reflection from the water's surface so the waves stand out against the blue water. Camera: Fuji GX617 panoramic; lens: 90mm; filter: polarizing filter; film: Fuji Velvia 50; exposure: 1/4 sec @ f/22½.

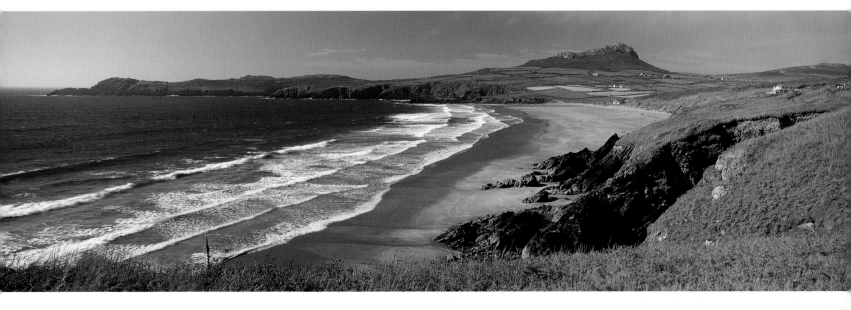

GLANGARRIFF HARBOUR, CO. CORK, IRELAND
The evening clouds reflecting in the harbour had potential for a composition, but it needed something in the foreground. The upturned boat filled the foreground with red, which complements the blue sky. I used a Lee hard 0.9 ND grad to compress the exposure range between the sky and foreground. Camera: Pentax 6x7; lens: 45mm; filters: Lee hard 0.9 ND grad, polarizing filter; film: Fuji Velvia 50; exposure: 2 sec @ f/22.

Favourite locations

In the UK, I love shooting the coastline of North Devon and Cornwall. Around Sandy Mouth and Pentire Head are many areas that have rocky outcrops and features that make for fantastic coastal photography.

Another area of the UK that doesn't get nearly enough credit for its coastlines is Wales, in particular the area of South Wales towards St Govan's Head and the Mumbles.

There is a splendid variety of beaches in a small area, from sandy beaches to rocky coastlines. Another area great for rocky features and dramatic images is the Marlows in Pembrokeshire, where the views on offer virtually guarantee great images.

Western Scotland has some amazing coastlines – some beaches have pristine white sands that almost make you believe you are in the Caribbean.

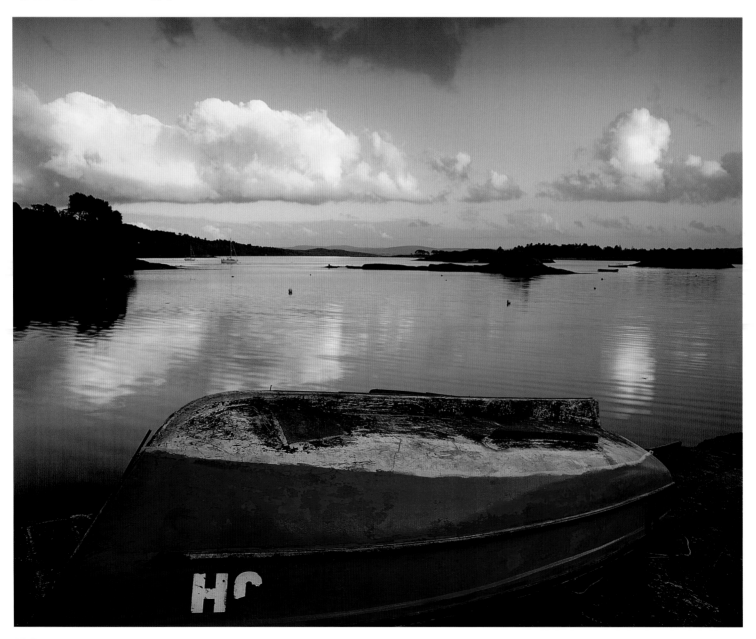

EVENING SKY REFLECTING IN THORNHAM HARBOUR, NORFOLK, ENGLAND

I shot both horizontal and vertical orientations on this tranquil harbour scene. At the time I thought the vertical format would be right for a book cover: evocative, bold colour and simple composition with plenty of space for titles and text. I used a Lee pink stripe filter on the horizon to enhance the colour even more. It's best not to stop down too much with this filter in order to achieve a smooth transition, as small apertures give a more defined edge in the transition. Camera: Wista Field 4x5; lens: 210mm Nikkor; filter: Lee pink stripe filter; film: Fuji Velvia 50; exposure: 1 sec @ f/16.

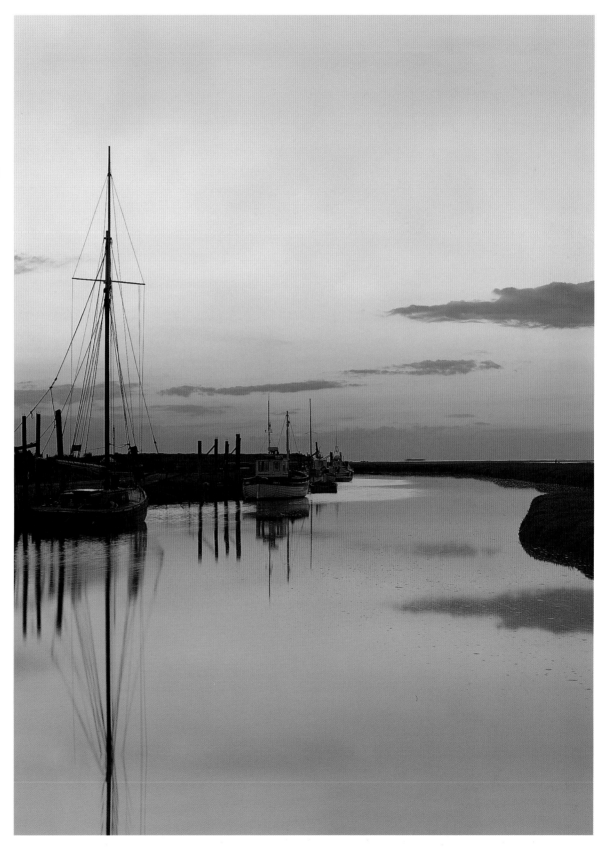

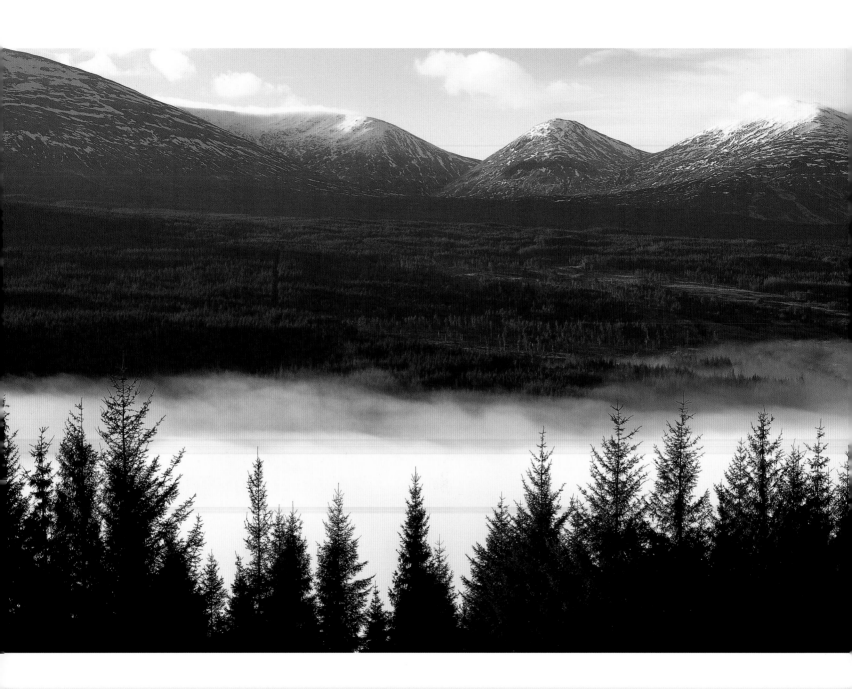

LOW CLOUD IN GLEN GARRY, HIGHLANDS, SCOTLAND

I'd like to say that I hiked five miles before sunrise to get this shot, but in fact I drove to a lay-by that overlooks this fabulous viewpoint. After making several compositions with the 4x5, I felt the panoramic format conveyed my intentions better. The silhouette of the pine trees gives a strong defined base to the composition backed by the low cloud. Camera: Fuji GX617 panoramic; lens: 180mm; filter: polarizing filter; film: Fuji Velvia 50; exposure: 2 sec @ f/22½.

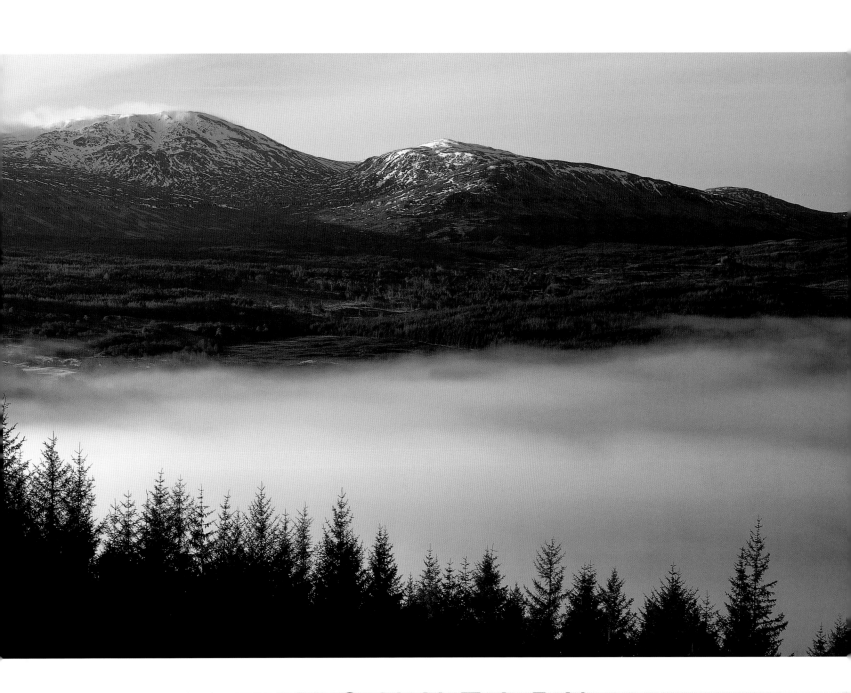

MOUNTAIN LANDSCAPES

Much of landscape photography is about capturing the natural beauty of a scene for others to enjoy. While the same fact obviously applies to images of mountains, it is also the case that great images of this type of scenery reveal the isolation, scale and ruggedness of the environment, producing quite a different reaction from the viewer to a view of a peaceful pastoral scene, for instance.

Take your pick

In every mountainous area, there's a unique characteristic that makes it worth visiting. For instance in the USA and Canada, the Rockies in the west are renowned for their spactacular views. In contrast to this expanse of grandeur that stretches for hundreds of miles, the UK is

GRAZING HORSES AND ROCKY MOUNTAINS, REDSTONE, COLORADO, USA

I waited until the horses dispersed around the field with just two facing into the frame. When I clicked the shutter the owner whistled and the horses shot off to the paddock. Camera: Wista Field 4x5; lens: 150mm Schneider; filter: polarizing filter; film: Fuji Velvia 50; exposure: 1/4 sec @ f/22.

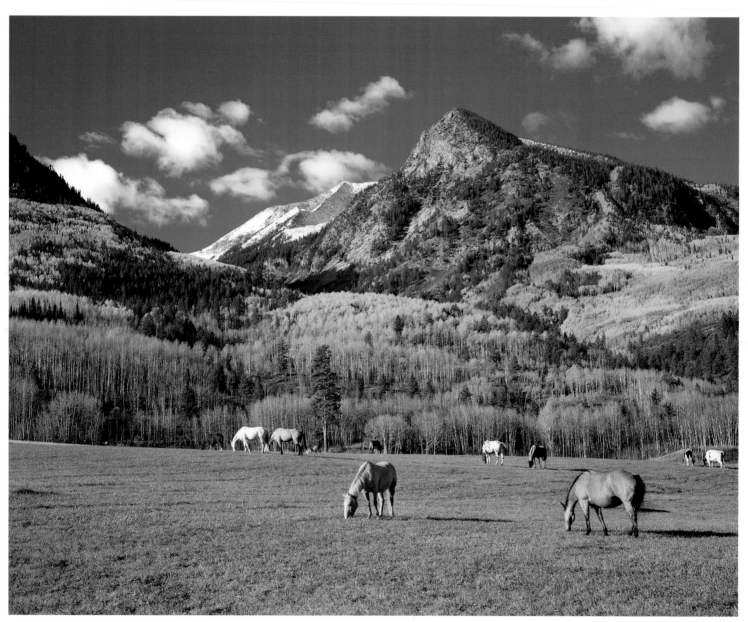

relatively small in size, but still is blessed with some amazing mountain scenery, with Scotland and the Lake District in particular offering some of the finest views you could ever hope to see.

I love Scotland because it has so many spectacular places to visit. There are the classic views, such as Buachaille Etive Mor, which has so many tripod holes around it, it's more like a golf course – but it should still be on everyone's shortlist of places to visit. The mountains of the highlands are beautiful and wild, with the Five Sisters of Kintail and Slioch being among my favourites that are well worth revisiting in different seasons and conditions.

While the mountains of Scotland are relatively spread out, the same cannot be said of the Lake District in the north of England, which offers a compact range of mountains in a relatively small area. The peaks here are comparatively easy to climb, which means it's easy to find good vantage points: the view from Cat's Bells, for instance, is incredibly popular, because it's not difficult to get to and offers two incredible views – in one direction you can shoot Derwent Water, while in the other you have a fabulous view over the Newlands Valley.

In western Europe, you have the Alps and the Pyrenees, while the Dolomites in northern Italy are stunning because they're so rugged and appear almost unreal – you often get a sense that you're looking at a painting rather than a real view. The peaks of the mountains are so imposing, while further down you can make out houses, chalets and churches, which serve to really emphasize the scale.

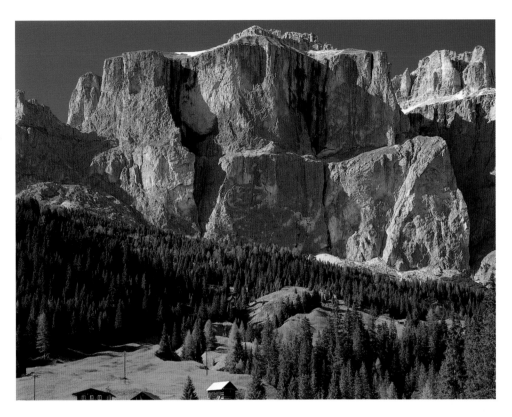

Emphazizing scale

In the Alps, particularly in the Dolomites, think about using the sheep huts or other smaller structures in the foreground to emphasize the scale of the scene. While you may realize how large and imposing a sight the mountain is, because it's there in front of you, unless you include elements in the scene for scale, its impact is in danger of becoming lost; it's therefore a good idea to add a cottage, house or some other structure to ensure that the size of the mountain is obvious.

The power of lighting

Reaching a good vantage point is one thing, getting a great shot is another; and as with other types of location, the time of day, weather and in particular the lighting conditions, all ultimately determine whether your efforts will be rewarded with a stunning image. I don't know how many times I've gone up the side of

MOUNTAIN VIEW, NEAR ARABBA, THE DOLOMITES, ITALY
In order to bring out the texture and form of mountains, sidelighting works best. I was really impressed by the sheer scale of these mountains. Then I looked at the map to discover that the road out of the valley went straight over this mountain range. Camera: Wista Field 4x5; lens: 150mm Schneider; filter: polarizing filter; film: Fuji Velvia 50; exposure: 1/2 sec @ f/22.

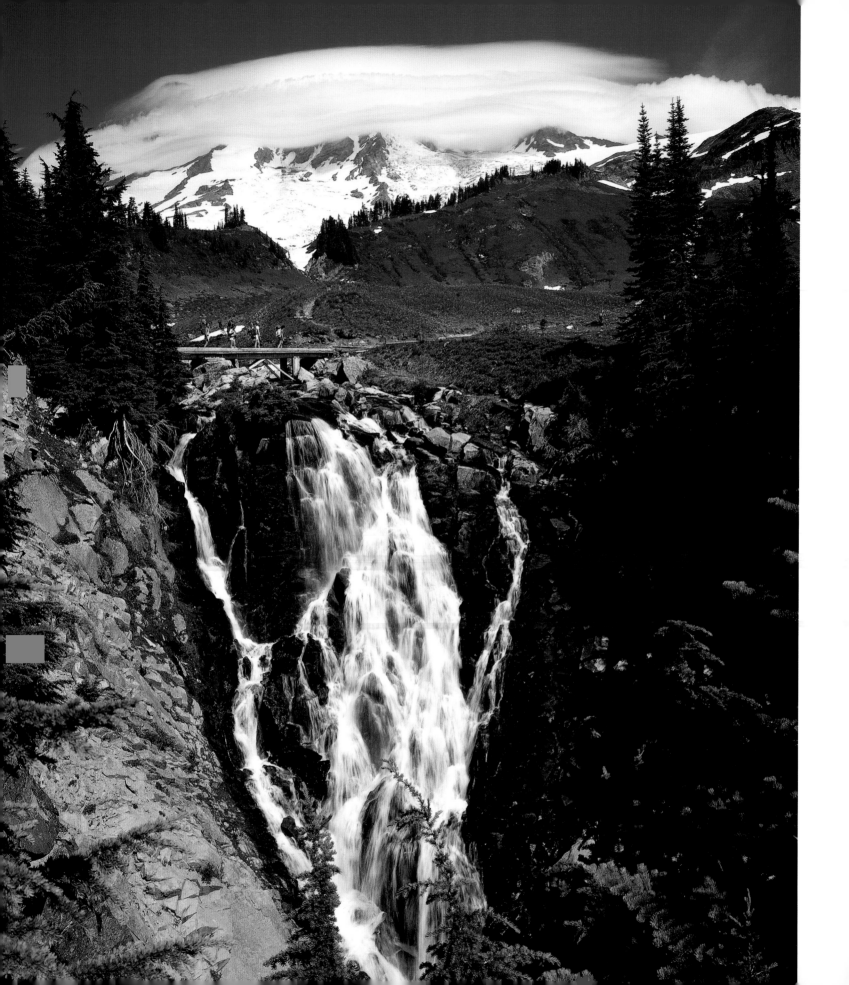

EDITH CREEK WITH HIKERS, MOUNT RAINIER NATIONAL PARK, WASHINGTON, USA

Lenticular clouds often form around high mountains, caused by waves of air from strong winds forced over the mountains. The waterfall of Edith Creek provided good foreground interest, but the inclusion of the hikers gave a better sense of scale. Camera: Wista Field 4x5; lens: 150mm Schneider; filter: polarizing filter; film: Fuji Velvia 50; exposure: 1/2 sec @ f/32.

a mountain before sunrise to get the perfect shot and find that changes in the weather ruin the conditions. While this problem is possible with any landscape, as you'd expect, it always hits you hardest when it happens after a long trek up a mountain!

It's important with any landscape to emphasize the contours of the scene but especially so with mountains. As always, the most effective way to do this is by using sidelighting, which really brings out the rugged texture and details. Sometimes it can really work to backlight the mountain, as this brings out the scale and form, but in general, sidelighting is the best option.

Most photographers shooting mountains try to capture the classic viewpoint with a lake or river in the foreground and the mountain in the backdrop. That's understandable, as this provides scale and dimension to the scene. One factor, however, that many people do

not consider is using variances in light to really make the scene stand out. The perfect time to try this technique is when early morning or late afternoon light illuminates mountains but the rest of the scene is in shade. The result is a relatively dark foreground with a brighter backdrop and, more importantly, a bright reflection of the mountain in the river, which really helps it to stand out.

Working with filters

One major consideration you need to make, especially if you're shooting at altitude, is your choice of filters. It's standard practice to use a polarizer to maximize colour saturation in the scene, but when shooting at altitude, say over 11,000ft (3,353m), you have to take care how you use one. This is because at these altitudes, the air is far clearer and the atmosphere is far thinner, resulting in the risk of a polarized sky appearing black rather than deep

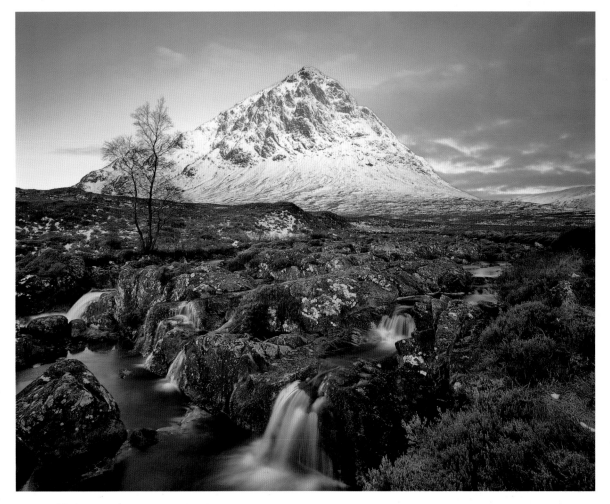

BUACHAILLE ETIVE MOR IN WINTER, GLEN COE, HIGHLANDS, SCOTLAND

To wake up and be presented with a scene like this is incredible. I knew of this spot from previous visits and set up to catch the first light on the mountain. Camera: Wista Field 4x5; lens: 90mm Schneider; filter: Lee soft 0.9 ND grad; film: Fuji Velvia 50; exposure: 4 sec @ f/22½.

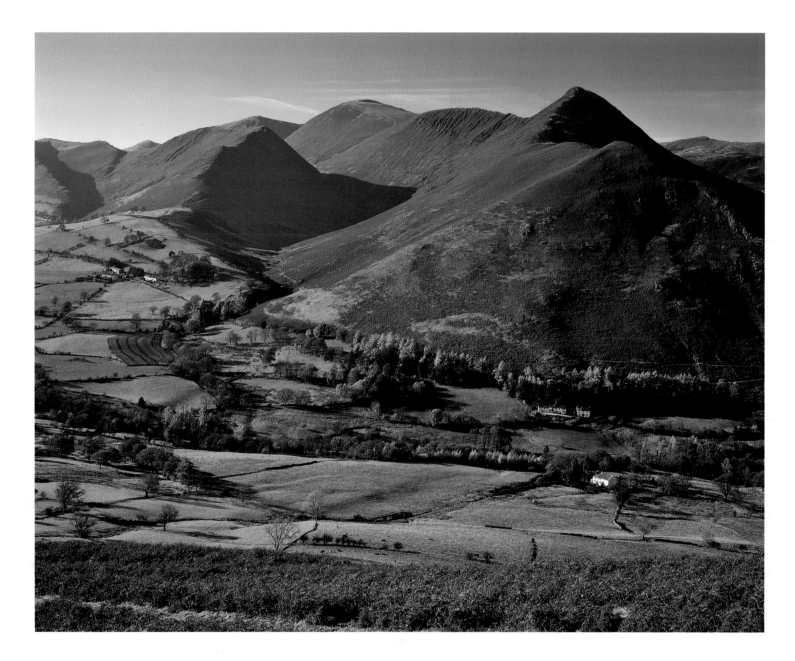

blue. In fact, the air may be so clean and free of pollutants and particles that it can record as a deep blue colour without any need for you to use filtration.

Because high elevations give very clear air, which adds a strong blue cast to the air, this not only adds a cool blue cast to the sky but can also have an impact on the mountain terrain, in particular snow. You can easily counteract this by using an 81A or 81B warm-up filter, although be careful not to overdo it, as you may add an orange cast to the snow. Start with an 81A and move to the stronger 81B if the effect of the first filter is too weak.

In the morning and evening, when the light is warm, you should consider using a yellow/ blue polarizer to accentuate colours even further. Bear in mind that over-polarization in bright conditions applies as much to this filter as with a standard polarizer. I remember

CAUSEY PIKE AND NEWLANDS VALLEY, LAKE DISTRICT NATIONAL PARK, CUMBRIA, ENGLAND
Photographing mountains from another mountain gives a completely different perspective. Whereas it may not show its grandeur from below, it will show how it relates to the rest of the landscape. The white cottages in the lower right section of the frame gives a sense of scale. Camera: Wista Field 4x5; lens: 150mm Schneider; filter: polarizing filter; film: Fuji Velvia 50; exposure: 1/2 sec @ f/22½.

LAKE CAREZZA, THE DOLOMITES, ITALY

Reflections of mountains in lakes present exposure problems especially when the foreground is in shadow. The only way to combat this is to use a ND grad over the sky to bring the exposure down to where the foreground exposure is. Camera: Fuji GSW 6x9; lens: 65mm; filter: Lee hard 0.9 ND grad; film: Fuji Velvia; exposure: 4 sec @ f/22.

LANDSCAPE SECRETS

At high altitudes the air may be so clean and free of pollutants and particles that it can record as a deep blue colour without any need for you to use filtration.

using a yellow/blue polarizer in the White Mountains of California on a particularly bright day. Because the contrast levels were so high, I bracketed my exposures and refrained from using full polarization to make sure the film could handle the extreme range. The reason I used the yellow/blue polarizer was because I wanted to increase the warmth of the pine trees in the foreground, otherwise I'd have captured the scene unfiltered.

While neutral density (ND) graduates are among the most useful of filters, take care when using them with mountains. Usually the horizon is level, so you can place the filter so that the dark area runs in line with where the sky and land meet. Obviously this is impossible with mountains, so the easiest way around this is to use a soft-edged graduate, which has a smoother gradation than a hard-edged grad.

At lower altitudes, you may encounter haze, which can prove a problem as it lowers visibility and image contrast. A polarizer is useful in this situation, although you should also look at how you can use the characteristics of the haze itself to produce a moody atmosphere.

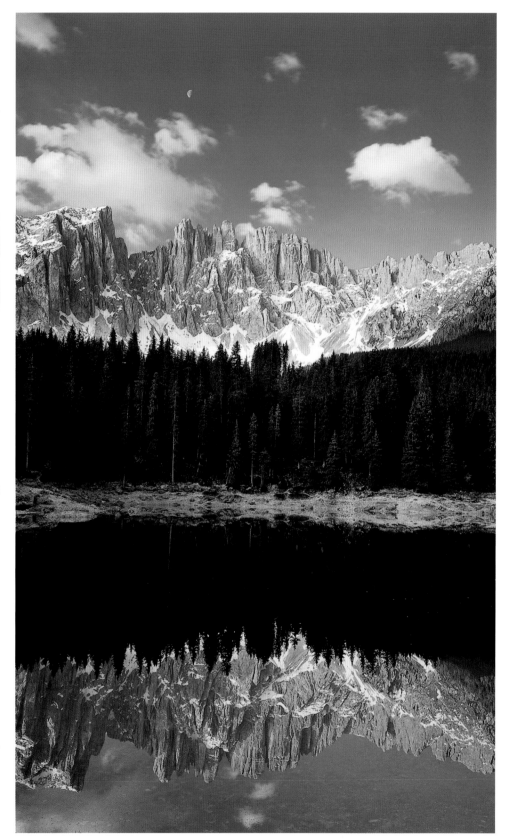

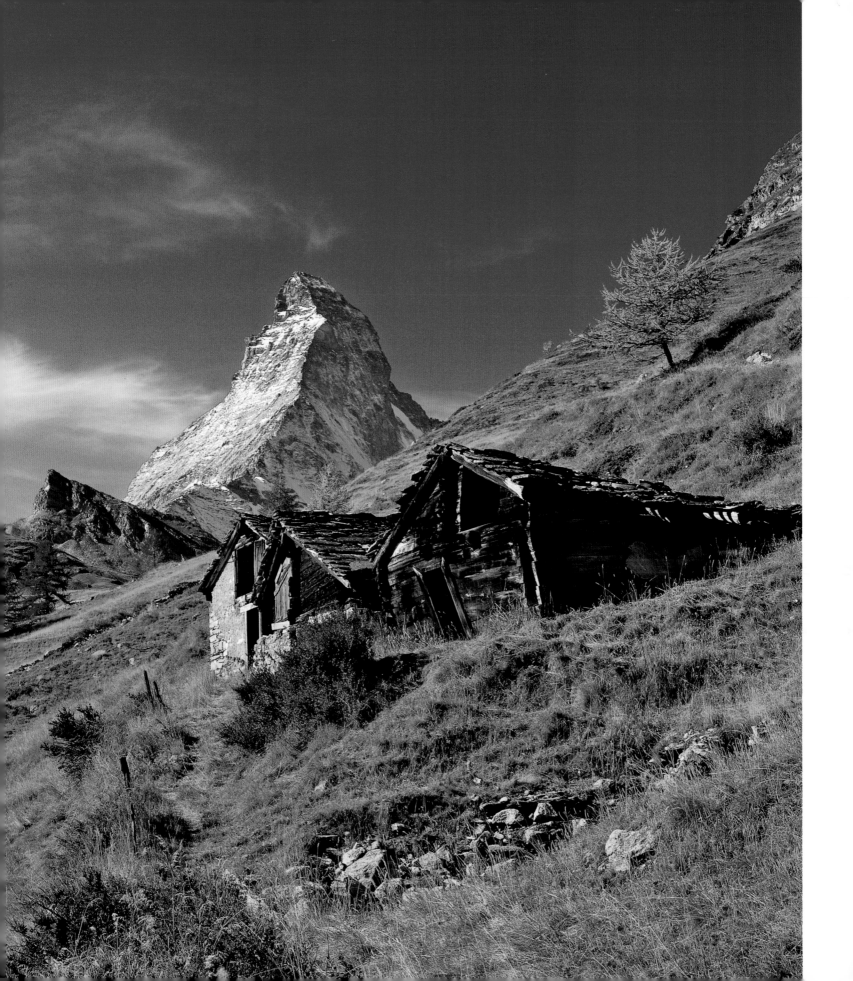

THE MATTERHORN, ZERMATT, SWITZERLAND

I hiked up out of the village to these barns to use them as a contrast to the Matterhorn. Sidelighting brought out the texture and form in the mountain and barns. I polarized the scene and left sufficient space at the top of the frame for titles in travel brochures or magazines. Camera: Wista Field 4x5; lens: 90mm Schneider; filter: polarizing filter; film: Fuji Velvia 50; exposure: 1/4 sec @ f/22.

Keeping foreground interest

While mountains are an impressive sight anyway, you need to find a way to balance them in your images; one of the best methods of doing this to include some equally impressive foreground interest. Among my favourite subjects here are waterfalls, rivers and lakes – with the latter I try to include the mountain in the reflection, as this adds to the scale.

To give just one example, the Canadian Rockies, from Banff to Mount Jasper, are among the most impressive mountains in North America. What makes these areas particularly special are the accompanying glacial lakes with their amazingly clear turquoise water – it's hard to imagine a more beautiful foreground for a scene.

When you're walking through the landscape, keep an eye out for caves or, better still, consult a local person as to the caves' location before you head out. Caves not only provide shelter for photographers if the weather turns bad, but can also be used as a natural frame for scenics. By entering a cave and using a wide-angle lens, you can shoot outwards and use the cave entrance to create a natural and attractive frame for a scenic view. In addition, in winter you have the added bonus that icicles will have formed to add an extra element to the frame. However, exercise extreme caution if you are entering a cave during bears' hibernation season, as this could put you into an incredibly dangerous situation.

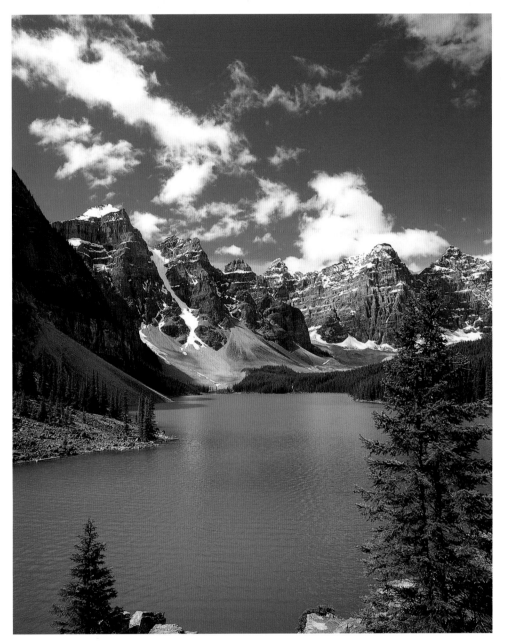

VALLEY OF THE TEN PEAKS AND MORAINE LAKE, BANFF NATIONAL PARK, ALBERTA, CANADA

The glacial waters of the lake flow freely in June, providing a great foreground to the Canadian Rockies. I balanced the foreground with the two pine trees. Camera: Pentax 6x7; lens: 45mm; filter: polarizing filter; film: Fuji Velvia 50; exposure: 1/2 sec @ f/22.

LANDSCAPE SECRETS

At lower altitudes, you may encounter haze, which can prove a problem as it lowers visibility and image contrast. A polarizer is useful in this situation.

Travel light, travel right

A serious problem that you need to avoid is setting off on a long, arduous trek carrying too much kit and not being dressed appropriately for the conditions. It's important to take only the minimum amount of equipment – carefully consider your choice of lenses and only take what you're sure you'll use. Ensure you have a good wide-angle lens, as this is the best choice for including foregrounds, and a telephoto to compress the perspective of mountain ranges.

Make sure you take waterproof clothing and, rather than wearing one thick sweater, wear two or three thinner layers, allowing you to remove one or more layers if you get too hot. Most important is your footwear – a pair of good quality walking/hiking boots is essential; most trainers aren't up to the job.

Great mountains aren't necessarily difficult to find. Just be sure to pack carefully, inform someone where you're heading, and take care.

Seasonal changes

Alpine and other wild flowers are very seasonal, so research your locations before setting off – certain months have an abundance of colour that may not have been evident only a couple of weeks earlier. For instance, there are places in North America, such as Mount Rainier, that I visit in July and August because I know I can find wild flowers such as lupins.

In the UK, the rusty red of bracken in autumn is particularly attractive. There's a short period of time when the bracken is at its peak and is so bright and crimson that it looks like it's on fire before it becomes a dull brown almost overnight. Once again, doing as much research as you can before photographing in earnest is invaluable.

Choosing exposure

Photographing mountains can present a major problem with exposure because the lighting falling on your subject is often very different to where you're standing with your camera.

If the mountain is bathed in bright sunlight while you are in deep shade or vice versa, your camera's meter is quite likely to set the wrong exposure. While many photographers believe using a handheld incident meter is infallible, it is exactly this sort of situation in which an incident meter will give the wrong exposure.

LA MER DE GLACE AND GRANDES JORASSES, CHAMONIX, FRANCE

Panoramics are ideal for mountain landscapes, especially when photographing distant peaks. Use a telephoto lens to exclude the foreground and concentrate on making the most of the peaks. This is particularly effective when the low ground is barren and unattractive, while the distant peaks are bathed in gorgeous light. Camera: Fuji GX617 panoramic; lens: 180mm; filter: polarizing filter; film: Fuji Velvia 50; exposure: 1/2 sec @ f/22½.

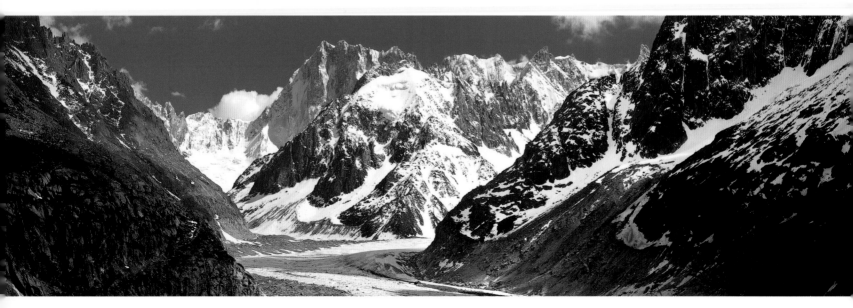

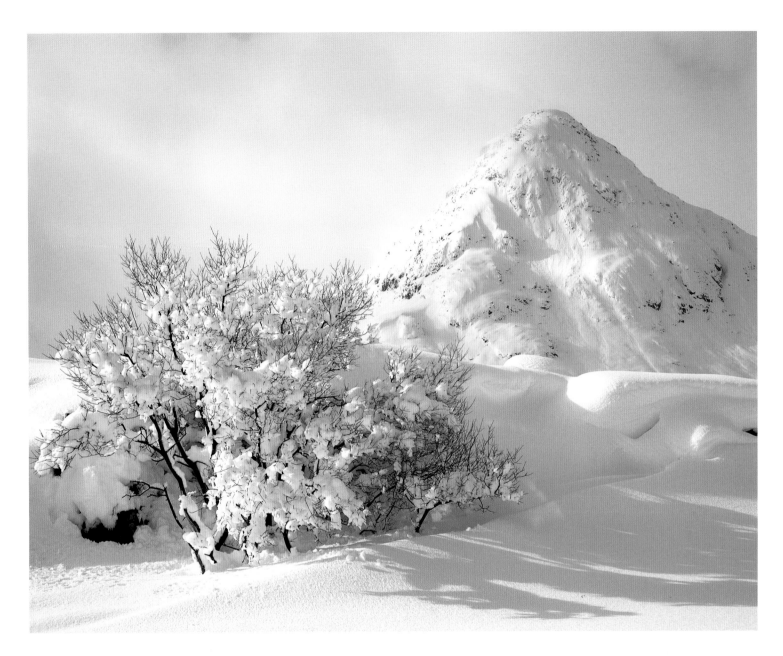

In this case, ensure that you set the correct exposure by using a spot meter and taking a reading from a mid-tone.

In snow-filled landscapes, where there are no mid-tones, you are more likely to achieve a perfect result by taking a spot reading of the snow and overexposing this reading by 1–1½ stops. Also carry a grey card cut down to the size of a credit card, as this is another way of ensuring a perfect exposure when in doubt.

Capturing the weather

Mountains are one of the most difficult landscapes to photograph as the weather is just so unpredictable – you can often spend entire days in fog or rain with no clear sight of the mountains and without any signs of the conditions improving. For every great image of a mountain range, I can remember days spent waiting for the weather to clear. Patience is a definite requirement for this subject.

BUACHAILLE ETIVE MOR IN WINTER, GLEN COE, HIGHLANDS, SCOTLAND

When I first saw this view it was overcast, so I waited until the clouds parted, giving the scene the necessary sidelighting that it needed. I could have metered from the snow and opened the aperture by 1½ stops, but I double-checked the exposure by taking a reading from a grey card. Camera: Wista Field 4x5; lens: 150mm Schneider; film: Fuji Velvia 50; exposure: 1/4 sec @ f/22½.

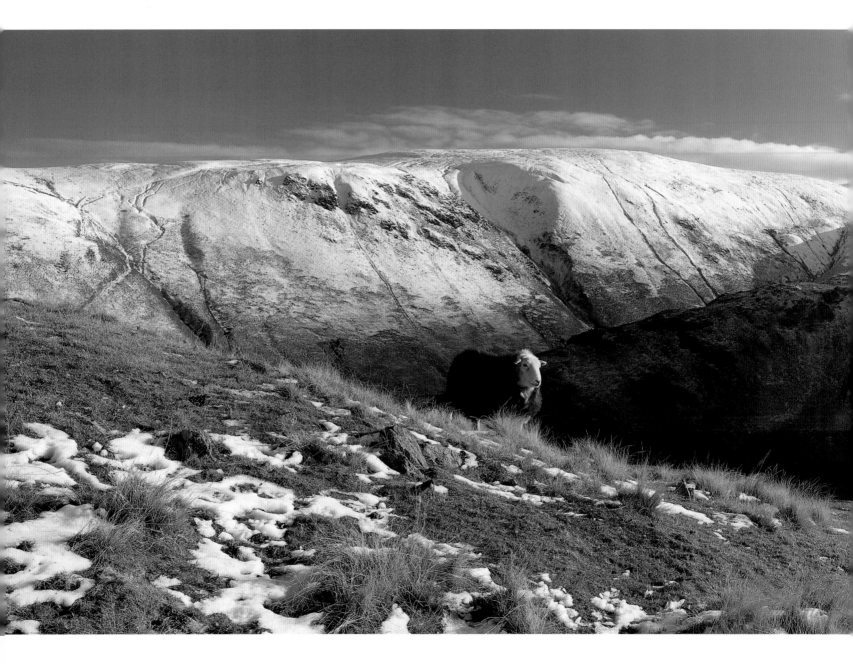

SHEEP ON HALLIN FELL IN WINTER, LAKE DISTRICT NATIONAL PARK, CUMBRIA, ENGLAND

I climbed up Hallin Fell to get a view over Martindale Common. Instead of composing just the range of mountains in the frame, I set up the panoramic with the foreground cutting diagonally up to the mountains. This lighter tone works much better against the dark tone at the base of the mountain. Utilizing a foreground in this way serves to add depth to the composition. Just before I pressed the shutter, this lone sheep came over the ridge in just the right spot long enough to fire off two shots. Camera: Fuji GX617 panoramic; lens: 90mm; filter: polarizing filter; film: Fuji Velvia 50; exposure: 1/2 sec @ f/22½.

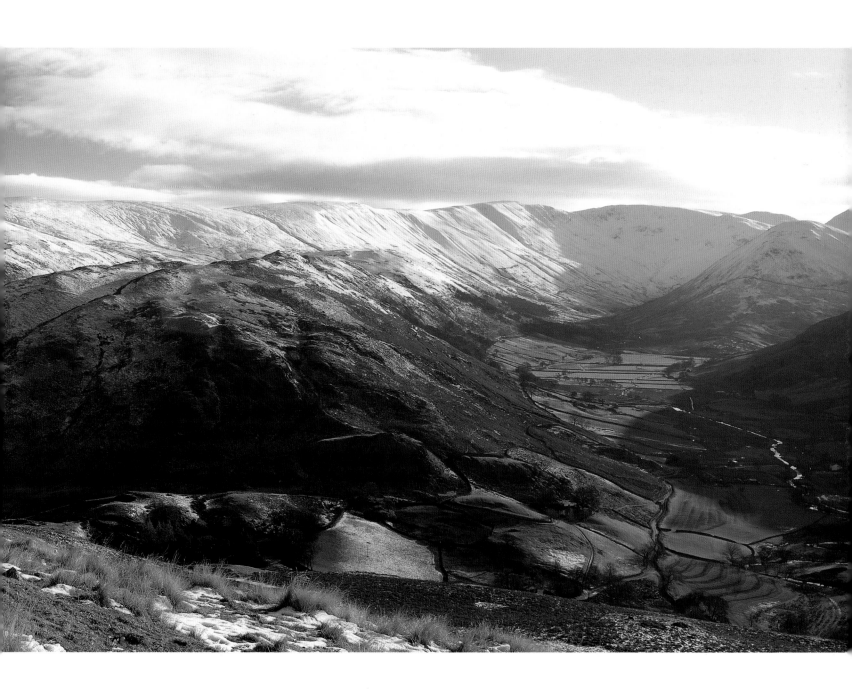

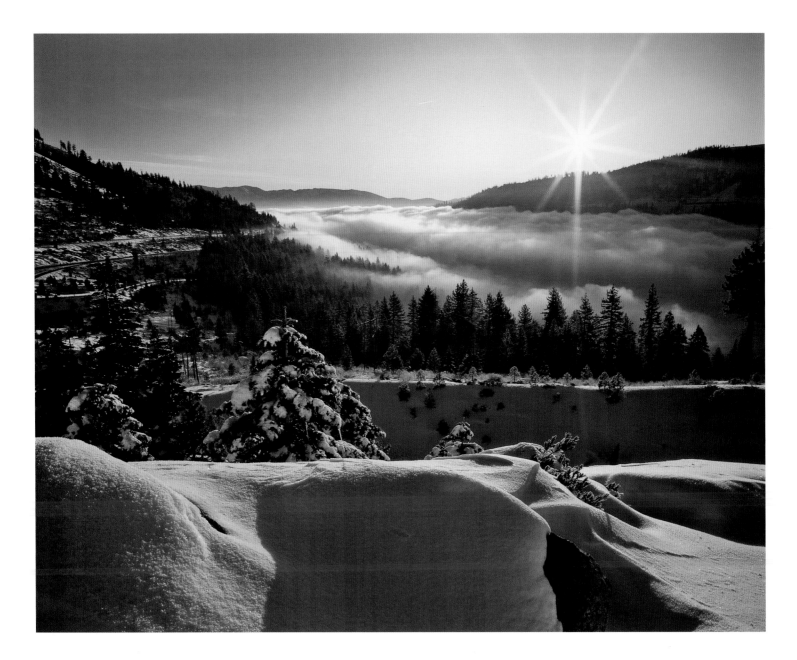

FOG OVER DONNER LAKE IN WINTER, DONNER PASS, CALIFORNIA, USA

Driving up Donner Pass, I looked back over the valley and saw this scene in brilliant sunshine. I immediately stopped the car, opened the door and stepped out in snow up to my thighs. The starburst effect was achieved by using a wide-angle lens with a small aperture. Camera: Wista Field 4x5; lens: 90mm Schneider; film: Fuji Velvia 50; exposure: 1/4 sec @ f/32.

If you're photographing mountains near a coastline, such as in the Highlands of Scotland or on the West Coast of the USA and Canada, you'll get weather patterns coming in off the ocean that affect conditions in the mountains. Sometimes the mountain holds off the weather, so you encounter heavy clouds on one side of the mountain and clear sky on the other.

Mountains often exhibit peculiar weather conditions, in particular inversions, where you can have warm air being trapped by a cold front so that there is fog in a valley with a clear blue sky above it. This can look spectacular, and you can take full advantage by shooting from a high viewpoint.

One of the best times of year to photograph mountains is in early winter when the high ground is covered in snow. The secret here is to ensure you capture the scene while the snow is fresh and brilliant white.

There are a number of weather conditions that are unique to mountainous regions. Of these, lenticular clouds, vertical clouds and alpine glow are among my personal favourites. Lenticular clouds form when moist air passes over mountains, creating a series of waves of clouds. Vertical clouds are created by upward drafts of air running up the side of a mountain. Because these phenomena are unpredictable and short-lived, you should always keep your eye out for them and take full advantage.

Alpine glow is a beautiful phenomenon that demands dedication from the photographer as it only occurs first thing in the morning and last thing at night, when the sun's rays do not reach the landscape, but some are reflected by the atmosphere on to the scene. This is especially photogenic, as not only is it colourful but it also lowers the contrast range of the scenery and helps you retain the detail throughout the scene from foreground to sky.

Finding the scenery

It's fair to say that capturing great images of mountains requires hard work, as you generally have to do some trekking to get to great locations. The following are some of my favourite locations, more easily accessed, that are well worth seeking out for yourself.

Just off the Last Dollar road in Colorado, USA, are the San Juan Mountains. This is a beautiful range, but expect to see other photographers here. In Wales, there is another equally accessible location, the Llanberis Pass, which provides an absolutely spectacular view across the valley and is well worth visiting. But you'll be very lucky to find it bathed in glorious sunshine the first time you visit – I have been there on numerous occasions and, typically for Wales, the weather has rarely been good.

In Scotland, head for Loch Maree, which has some incredible views dominated by Caledonian pines. Looking over Loch Garry just outside Invergarry is a lay-by that offers one of the best Highland views in Scotland.

Glaciers are interesting to photograph due to their scale. It's even possible to go inside hollowed-out glaciers and make use of the turquoise-blue of the pure ice. To balance the darker interior and lighter exterior, shoot two exposures and then merge them together in Photoshop later on.

LONE COTTAGE IN WINTER, GLEN COE, HIGHLANDS, SCOTLAND

This cottage is ideally placed in the middle of this glacial valley, and the format of the panoramic conveyed its remoteness beautifully. The dark, meandering stream helps to break up the largely white landscape. I had to use a ND grad over the irregular skyline so that the clouds didn't burn out. Camera: Fuji GX617 panoramic; lens: 90mm; filter: Lee soft 0.9 ND grad; film: Fuji Velvia 50; exposure: 1/4 sec @ f/22½.

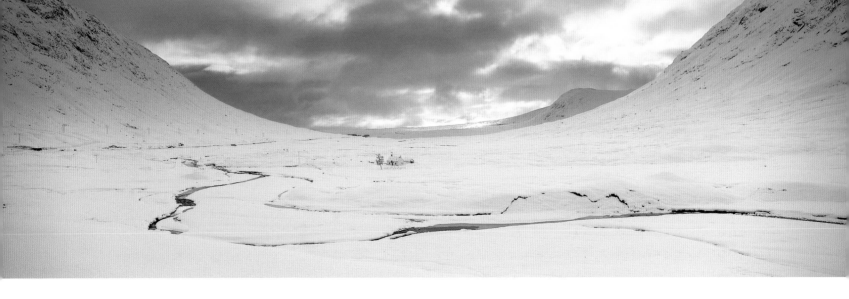

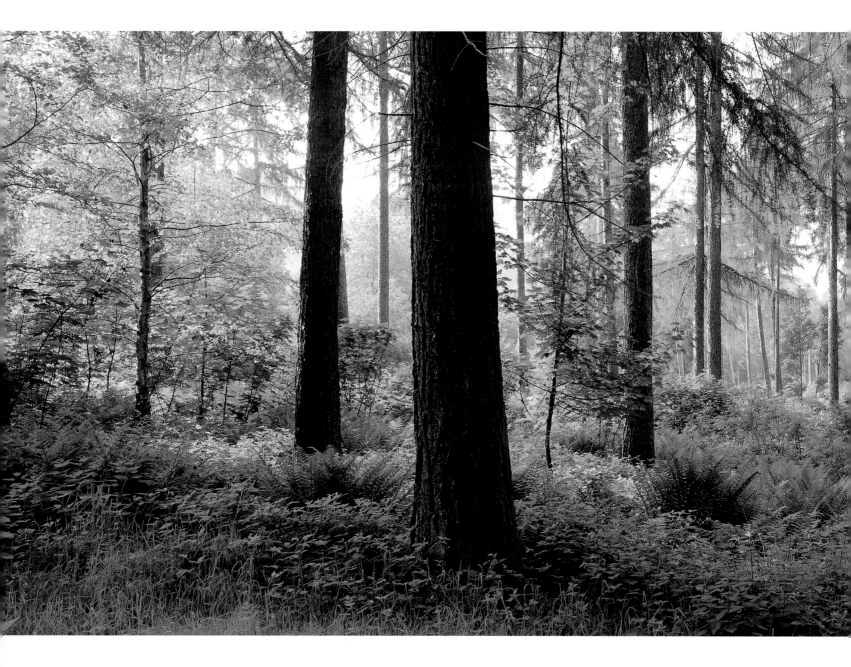

PINE FOREST, HASCOMBE, SURREY, ENGLAND

When photographing random trees in a forest, the photographer should compose a certain degree
of conformity within the frame. I balanced the frame by placing two dominate dark trunks in the
left of the composition and one dark trunk on the right. Camera: Fuji GX617 panoramic; lens:
180mm lens; filter: polarizing filter; film: Fuji Velvia 50; exposure: 1 sec @ f/32.

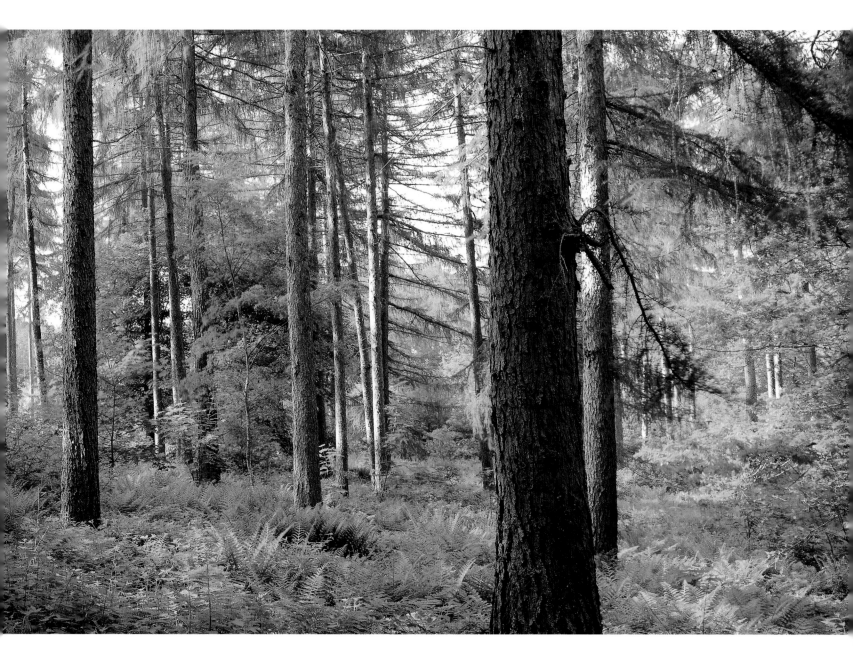

FOREST LANDSCAPES

There is something magical about woodlands and forests. It seems as though when you step beneath the canopy of trees, you leave one world and enter another. Here, you can stand alone in a place where what goes on elsewhere is left behind and where your senses are filled with the sounds and smells of an ecosystem that thrives of its own accord.

The forest entices the photographer with its mysterious appeal – a promise of ever-changing scenery and endless photographic possibilities. No matter the season or the weather conditions, if you have a keen eye and the right gear, you'll emerge from its embrace with pictures you'll treasure.

Seasonal cycles

Life in the forest follows a cycle based around the weather, so it is no surprise that your images of woodlands, meadows and forests will be determined by the seasons. Spring is the most colourful time of year, with the undergrowth boasting as much vibrancy and colour as the trees themselves. It's a season of freshness and new life, with a carpet of flowers bursting from their winter shelter beneath the earth to adorn the forest floor with colours – bluebells, wild garlic and snowdrops are popular choices to photograph. Catching the trees when the leaves are freshly emerging from their branches so that they have a lush green colour evokes the concept of birth and new life.

In contrast to what you might expect, summer isn't a particularly good season to photograph woodlands because the mass of green foliage dominates the scenery. At this time of year, you'll need to work hard to find interesting subjects or concepts that depict the vibrancy of life or the majesty of trees. While wide vistas may not work so well in this season, you do have the opportunity to get in close and capture natural patterns or unusual shapes.

As autumn approaches, be ready to do some research on the locations of nearby deciduous woods, such as aspen, silver birch, oak or maple, and prepare to exploit one of nature's most colourful sights. There is absolutely no doubt that autumn offers the most promise for stunning

PATH THROUGH BLUEBELL WOOD, BLICKLING ESTATE, NORFOLK, ENGLAND

This path is not overcongested with trees and scrub, allowing clean expanses of bluebells. It's obvious that the main subject here is the flowers, so I cropped tightly into the trees, which would otherwise distract from the final image. The snaking path is better than a straight one and makes a good lead-in line. Camera: Fuji GX617 panoramic; lens: 90mm lens; filter: polarizing filter; film: Fuji Velvia 50; exposure: 1 sec @ f/22½.

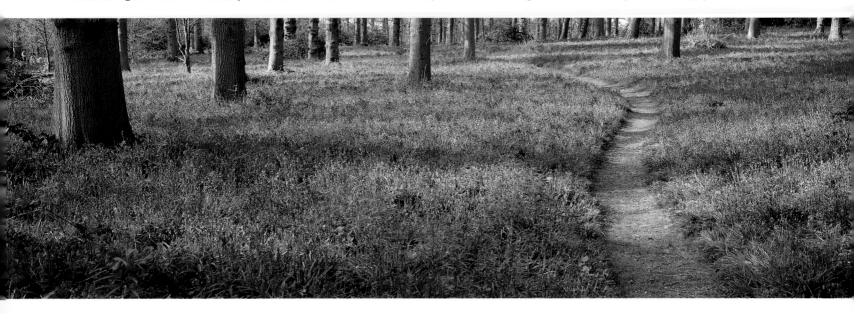

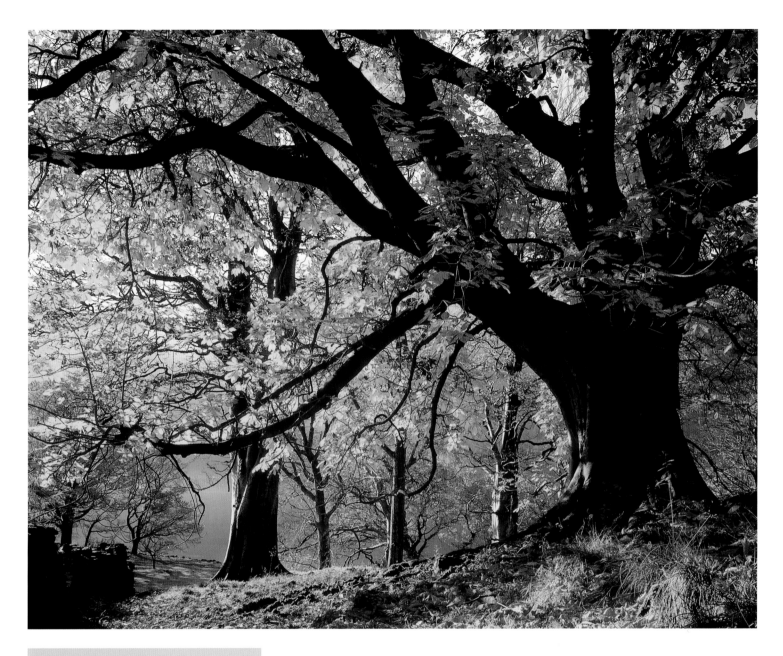

forest images – as green turns to glorious gold, the potential to capture poignant and atmospheric landscapes is better than at any other time of the year.

The strong reds and golds of autumn are extremely easy on the eye and often do not require the use of warm-up filters to accentuate the colours. However, it's worth shooting the same scene with and without filters and determining which works best afterwards.

SUNLIGHT THROUGH AUTUMN TREES, LAKE DISTRICT, CUMBRIA, ENGLAND

I saw the dominant silhouette of this chestnut tree, especially the low, sweeping branch, and knew it would make a good image. I enhanced the autumn colours of the backlit leaves with a filter. Years later I returned to the same tree, only to find that the low branch had been cut off. Camera: Wista Field 4x5; lens: 150mm Schneider; filter: 85B filter; film: Fuji Velvia 50; exposure: 1/8 sec @ f/22.

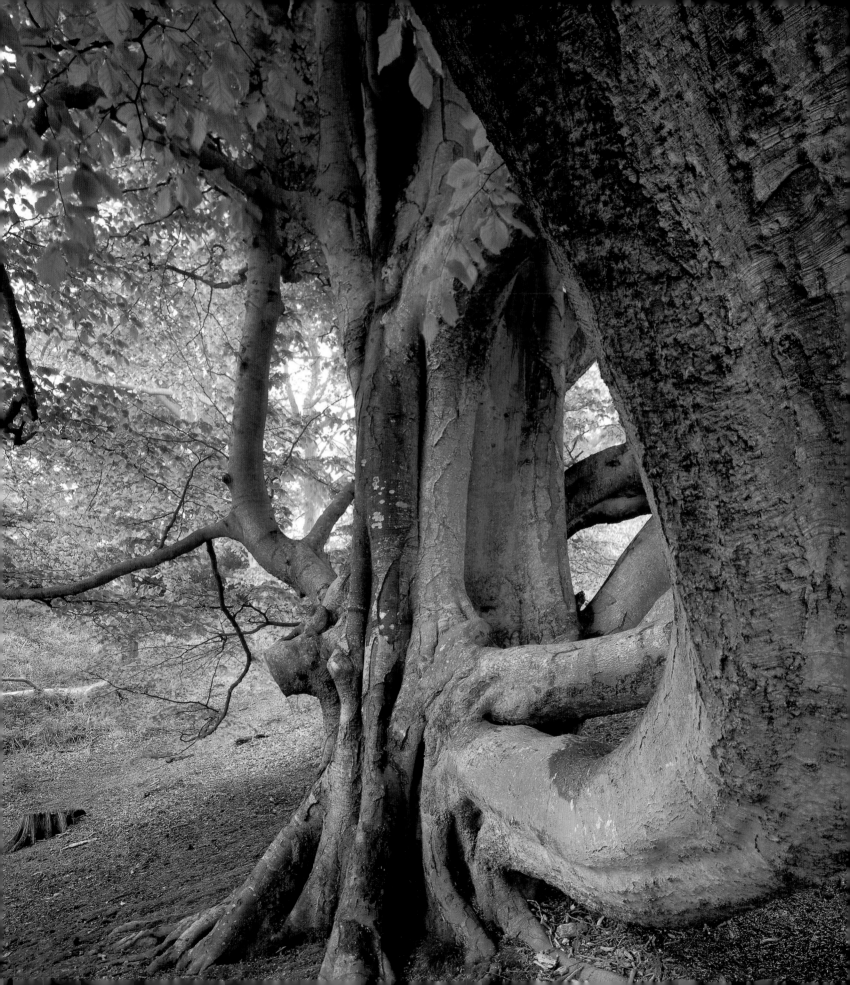

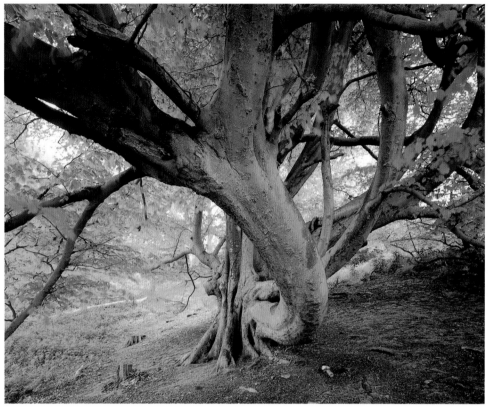

BEECH TREE, SHERINGHAM PARK, NORFOLK, ENGLAND

Getting in close and using a wide-angle lens exaggerated the unusual shape of this prominent beech tree limb. It's important to look for details as well as shooting the typical wide-angle vista. Camera: Wista Field 4x5; lens: 75mm Schneider; filter: polarizing filter; film: Fuji Velvia 50; exposure: 1 sec @ f/32.

A polarizer is another good choice of filter, as it helps saturate the autumn colours. Over the years however, I've discovered that one particular filter above others really adds to the natural richness of the season – the coral filter. As I discovered its versatility, I asked Lee Filters to develop a coral variant for me, which boasts a little extra red to it and adds extra warmth to the scene without being overpowering.

That said, don't get caught up by the splendour of the autumn colours to the extent that you ignore details and interesting shapes and patterns in the forest – look for

natural still lifes, such as pine cones on the forest floor, or a blanket of fallen autumn leaves.

Winter sees trees devoid of leaves and vegetation, but while the bare limbs lack the obvious beauty of the earlier seasons, this season does make for strong, graphic images, in particular when shot in black and white. Look out for interesting patterns formed by trunks, branches and even roots, and experiment with the results you can get using different types of lenses, from wide-angle to telephoto.

Snowfall adds another dimension to forests in winter, but it is essential to head out early and capture the snow while it is still fresh. If you do leave shooting until the snow has settled for several hours, you will find that it has already started to look a little discoloured and lacking the sparkle of newly fallen snowflakes; in addition, snow on the ground is likely to have footprints running through it.

> ### LANDSCAPE SECRETS
> Look out for interesting patterns formed by trunks, branches and even roots, and experiment with the results you can get using different types of lenses, from wide-angle to telephoto.

TRUCKEE RIVER IN WINTER, TRUCKEE, CALIFORNIA, USA
A heavy snowfall the night before left these pine trees completely covered the next morning. Within an hour, most of the snow had either fallen or melted off the branches. I used a wide-angle lens to take in enough foreground to lead along the river bank into the scene. Camera: Wista Field 4x5; lens: 90mm Schneider; filter: polarizing filter; film: Fuji Velvia 50; exposure: 1/2 sec @ f/32.

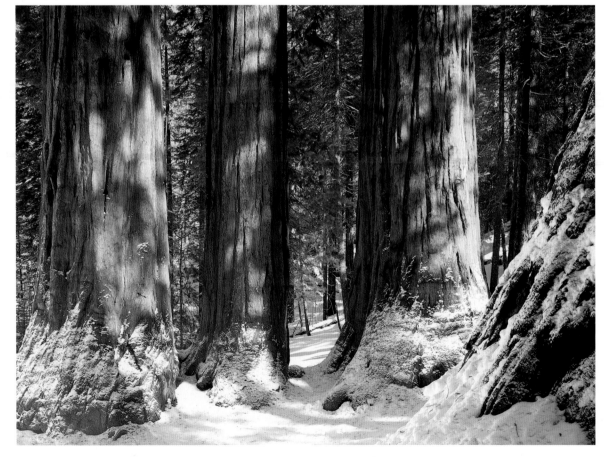

GIANT SEQUOIAS IN WINTER, YOSEMITE NATIONAL PARK, CALIFORNIA, USA
During heavy snowfalls the road to this sequoia grove is closed, so I hiked the two miles. I would have preferred to have overcast conditions, which would have given the scene more of an even exposure range, but often you have to work with the conditions that are present. Camera: Wista Field 4x5; lens: 150mm Schneider; filter: warm polarizing filter; film: Fuji Velvia 50; exposure: 1/2 sec @ f/32.

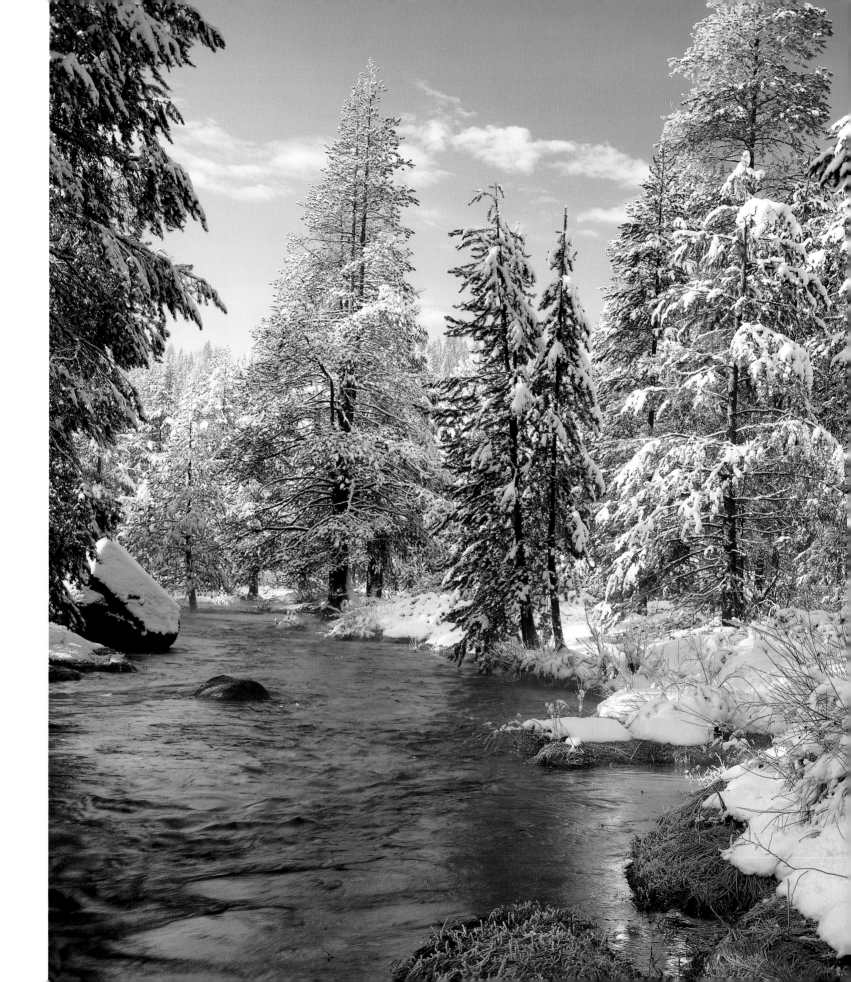

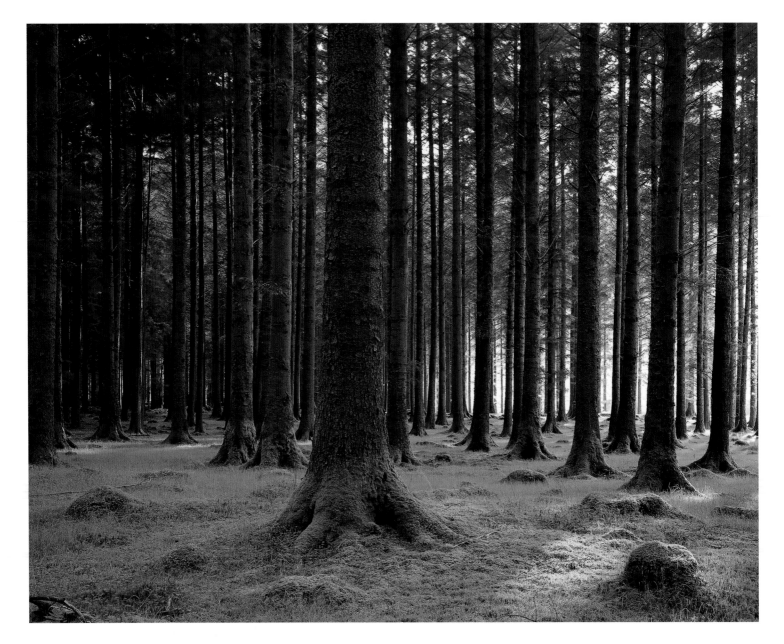

PINE FOREST, GOUGANE BARRA FOREST PARK, CO. CORK, IRELAND

I went to Gougane Barra to photograph the moss-covered mountainside reflecting in the lake, but the lighting conditions were overcast. Instead, I headed for the lush, green forest, which was more appropriate in these conditions. Being flexible and adaptable is the key. Camera: Wista Field 4x5; lens: 150mm Schneider; filter: polarizing filter; film: Fuji Velvia 50; exposure: 4 sec @ f/22.

Putting impact into forest landscapes

The obvious viewpoint and the best place to start is to capture a scene as you'd see it; in other words, photograph the trees at eye level. While this might not sound particularly exciting, it can produce very graphic and powerful images. This is especially true when captured as a panorama, with a line of broad trunks intersecting the frame.

Because forests and woodlands are packed with trees, it is easy to find yourself struggling to capture strong compositions, as the scene is so busy. However, by looking for subjects that naturally lead your eye into the scene, such as a path, a fence, a river or a fallen tree, you should be able to find suitable resting points for the viewers' eye to settle on.

That said, there's nothing wrong with filling a scene with several upright trunks, as these can

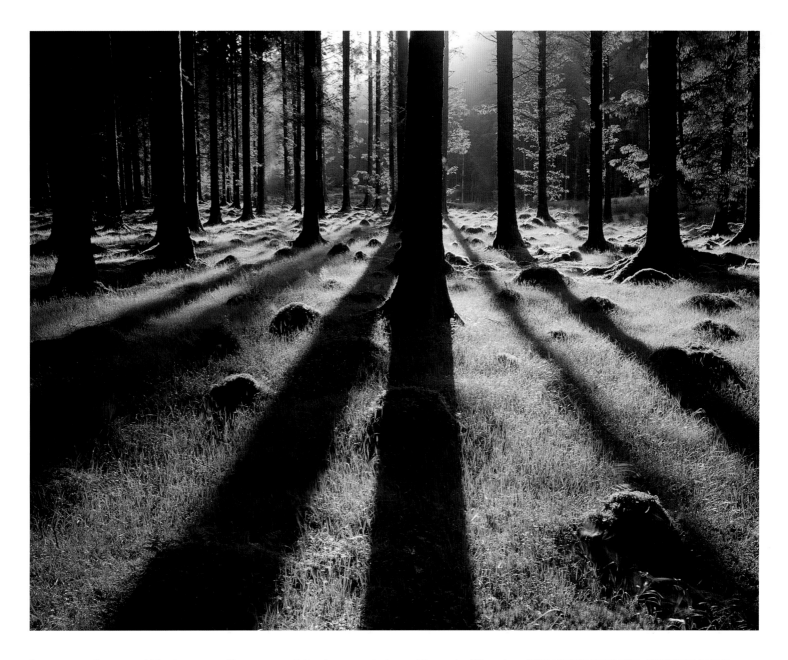

form strong elements within the composition. As well as shooting from within the forest, don't forget to head out from the canopies and shoot the trees from outside. You can often find higher ground or open spaces, such as a nearby hill or a mountain pass that offer the best vantage points.

Within the woods, there are a variety of viewpoints and shooting angles that you can try – attempt them all, as they will help test and develop your photographic eye in different ways. Start by looking for potential subjects on the forest floor, then move on to capturing interesting detail shots of the bark, and from that work your way up to shooting the canopy.

Once you've spent some time within the forest, head out to capture interesting patterns of trees. Managed woodlands, such as pine, poplar and aspen are particularly good for finding vertical patterns.

PINE FOREST SHADOWS, GOUGANE BARRA FOREST PARK, CO. CORK, IRELAND
No sooner had I set up the previous image when the light started to change. The contrast in the forest quickly became extreme. I ran to the edge of the forest where the trees and shadows were more evenly spaced. I placed the sun behind a central tree and used a wide-angle lens to play upon the shadows. Camera: Pentax 6x7; lens: 45mm; film: Fuji Velvia 50; exposure: 1 sec @ f/22.

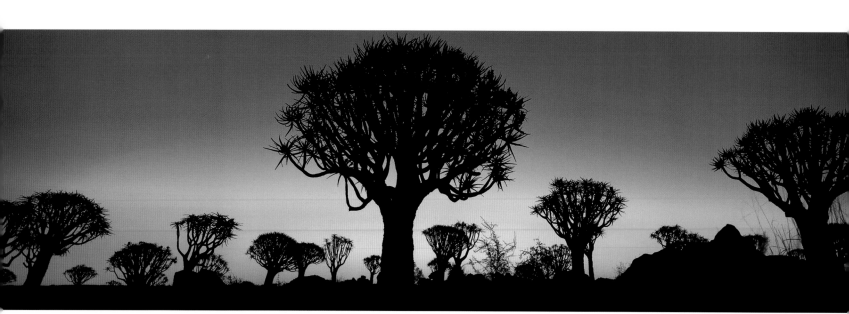

QUIVER TREES AT DUSK, KEETMANSHOOP, NAMIBIA, AFRICA

Quiver trees are actually giant aloes. The graphic shapes of the branches show up best when photographed at dusk or dawn. I found a prominent, round-shaped tree to feature in the centre of the frame, making it the main point of interest. I based my exposure from spot meter readings from the sky at the top of the frame to retain good separation between the tree and the sky. Using a Lee 6 coral grad reversed into the bottom of the frame enhanced the warm afterglow. Camera: Fuji GX617 panoramic; lens: 90mm lens; filter: Lee 6 coral grad; film: Fuji Velvia 50; exposure: 10 sec @ f/22.

Because most of the pictures you shoot of woodlands will be from within, you will find that a wide-angle lens proves to be the best choice. This gives a sense of place, and you can create depth by having subjects such as flowers in the foreground. A standard lens and a macro for close-ups are also worth having in your kit.

Lighting the forest

Lighting is crucial when you're in the forest. The best conditions are when it is bright and overcast so that the light has a diffused nature that casts soft beams and shadows over the scenery. If the sun is too bright, the contrast range will be too high to record detail in the shadows and highlights. Dappled sunlight can give lovely results when small shafts of light filter through the leaves and create patterns of light through the scene – the contrast between highlighted and shadowed parts forms a pattern that is very pleasing to the eye.

Strong light works best when you are backlighting the subject, as you can create pictures with drama and impact. You must, however, take extreme care to avoid lens flare – the easiest way is to ensure the sun is placed

behind a tree or thick branch: positioning a single tree at the centre of the image, with others interspersed in the frame, works best. With a clear sky and a sunset behind the main tree, you can produce strong silhouettes by exposing for the top section of the frame.

If you're aiming to get dramatic lighting, you want to be shooting early in the morning or late in the afternoon, as you want to capture the shafts of light while they are at a low angle. This is especially effective in fog or misty conditions. Backlighting is the best method of capturing shafts of light streaming through the trees.

Bringing out the best

Different trees have unique characteristics and so each can be photographed to bring out the best aspects. For instance, aspens are very delicate-looking, slender trees that have an attractive white bark and look particularly

appealing set against a deep blue polarized sky. Pine trees are great for pattern shots, whether you shoot them from within the forest or from a high viewpoint with a telephoto to isolate their triangular peaks. Many oak woods have trees dating back hundreds of years, which benefit from compositions that show off their grandeur.

When you are photographing very tall trees, it's important to try and include something in the scene that brings a sense of scale to the image. The easiest way to do this is to include a person walking through the frame – if you're on your own, set-up the camera on a tripod and use the self-timer or a remote release to fire the shutter, giving you enough time to enter the scene and position yourself appropriately. You have to be very careful when photographing groups of trees that there is a decent space between them, otherwise they may merge in the frame and lose their definition.

SILHOUETTED SCOTS PINES, BUTTERMERE, CUMBRIA, ENGLAND

The distinctive trees backed by mountains were heightened by the use of backlighting. In-camera meters can be fooled in lighting conditions such as this, resulting in underexposure; bracket by using a wider aperture or use a spot meter. Camera: Wista Field 4x5; lens: 150mm Schneider; filters: Lee soft 0.9 ND grad, 81EF warming filter; film: Fuji Velvia 50; exposure: 1 sec @ f/22.

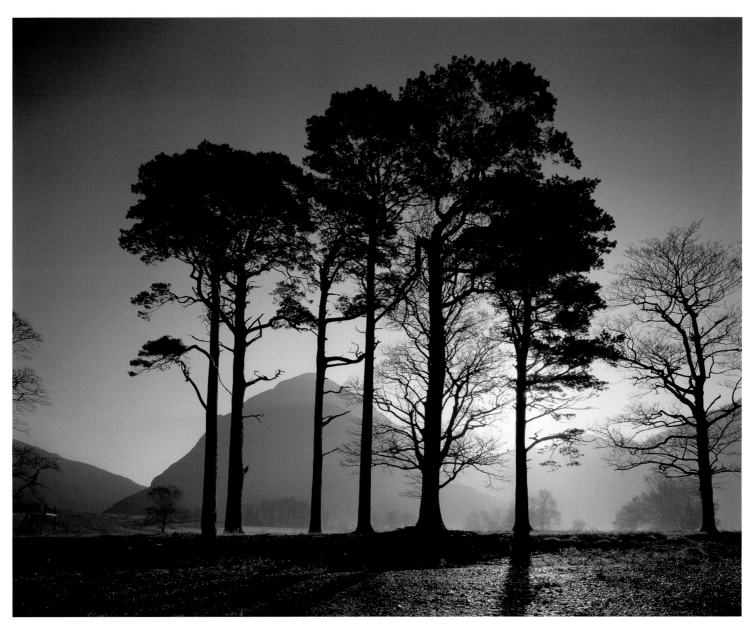

ASPENS, DIXIE NATIONAL FOREST, UTAH, USA
I liked the contrasting shapes of the stark aspens against the blue sky. This was accomplished by using a polarizing filter. Camera: Fuji GSW 6x9; lens: 65mm; filter: polarizing filter; film: Fuji Velvia; exposure: 1 sec @ f/22½.

When shooting details, don't be afraid to arrange a composition if you cannot find the perfect still life. With leaves, choose fresh specimens that have the least imperfections.

Be creative

The graphic nature of trees makes them highly suitable for trying out some interesting creative techniques. A soft-focus filter is ideal to diffuse lighting conditions and add an extra element of romanticism to the image – alternatively, apply Vaseline in streaks to a UV filter to create impressionistic pictures; if you like, you can do this post-production in Photoshop.

If you have a wood in close proximity to a river and you're shooting when seasons are in transition, mist often develops because of the difference between the air and water temperature – April and September are particularly good months for mist and fog. Another natural feature to keep your eye out for are spider's webs covered by dew: these look best when backlit, but do take care with flare. By placing the sun slightly off the lens axis you can avoid the light flaring into the lens. A helpful gadget called the Flarebuster allows you to clamp a card on its lightweight adjustable arm and position it in front of the sun. It's also great for using small reflectors for detail shots.

As you can see, there's no shortage of possibilities for capturing stunning images of woodland and forest – regardless of the season and the location.

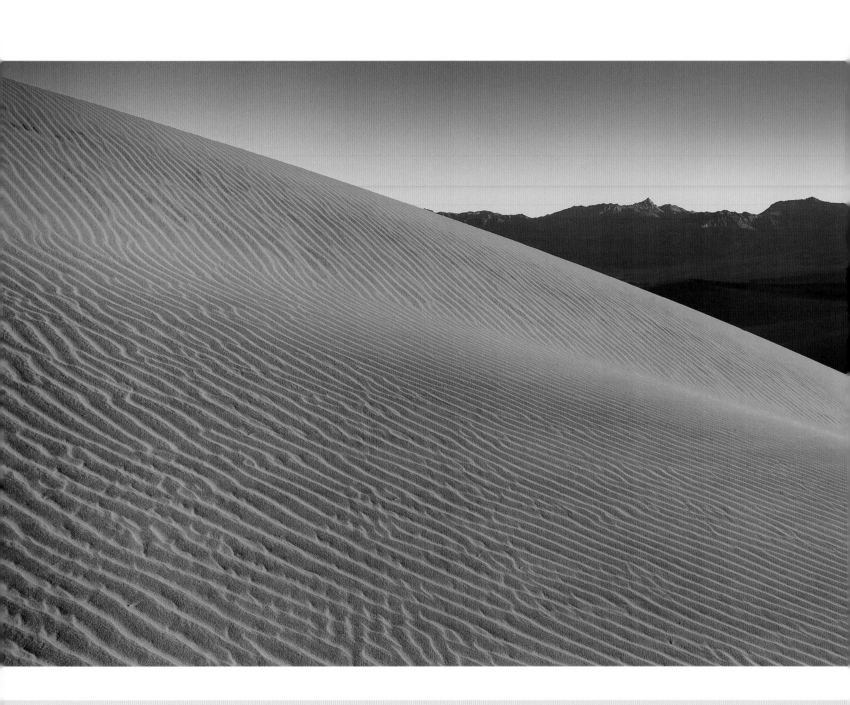

MESQUITE DUNES, DEATH VALLEY NATIONAL PARK, CALIFORNIA, USA

I hiked deep into the dune field to find this sensuous, sweeping dune. The sun broke the horizon, and within minutes the landscape was bathed in a warm light that brought the dunes alive. Perhaps another photographer had the same idea and it is his silhouette that can be seen on top of the final dune? Camera: Fuji GX617 panoramic; lens: 90mm; filters: Lee hard 0.6 ND filter, polarizing filter; film: Fuji Velvia 50; exposure: 2 sec @ f/32½.

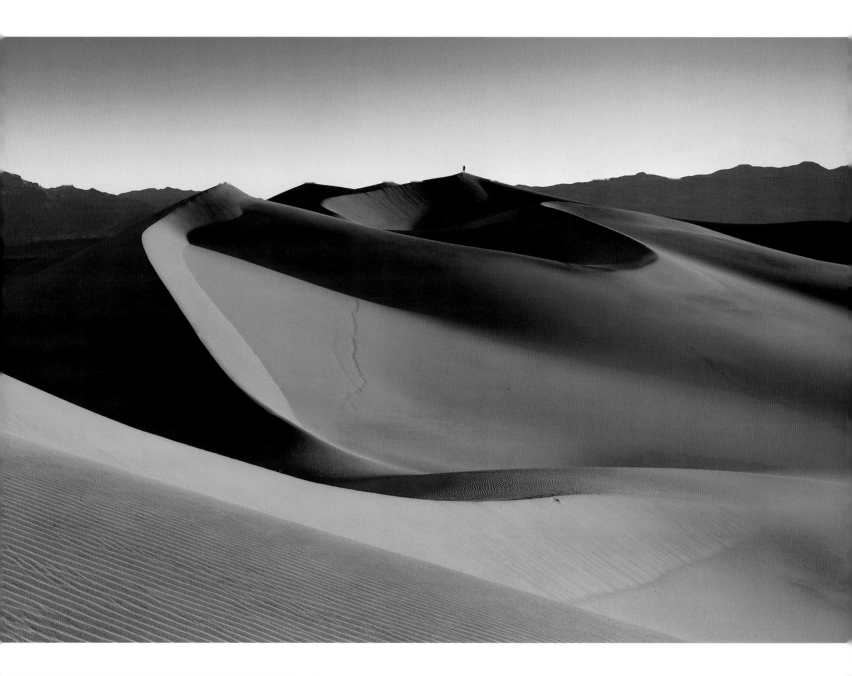

DESERT LANDSCAPES

When asked to imagine what a desert is like it's easy to think of a dry, barren wilderness. However, while it's fair to say there isn't an abundance of life on show in most deserts, closer examination reveals an ecosystem that offers more than is obvious at first. Every desert has its own unique characteristics – even within a very small area you'll discover a diversity of geology that makes one location very different from another. The following selection of deserts reflects my own experiences of photographing these locations over the years.

Photographing the dunes

The Namibian desert is unique in that the sand dunes are the main attraction. These are very different to dunes you'll find elsewhere in terms of their scale – they are much larger, some are

SAND DUNE AND TREE, NAMIB RAND, NAMIBIA

Landscape photography doesn't always have to come with sacrifices of mod cons. I stayed in a first-class dune camp on this private reserve. There is nothing like waking up before sunrise and being presented with exquisite scenery like this. I composed the image with diagonal sand patterns with the tree in the upper third intersect as in the Rule of Thirds. Camera: Pentax 6x7; lens: 45mm; filter: Cokin yellow/blue polarizer; film: Fuji Velvia 50; exposure: 1 sec @ f/22.

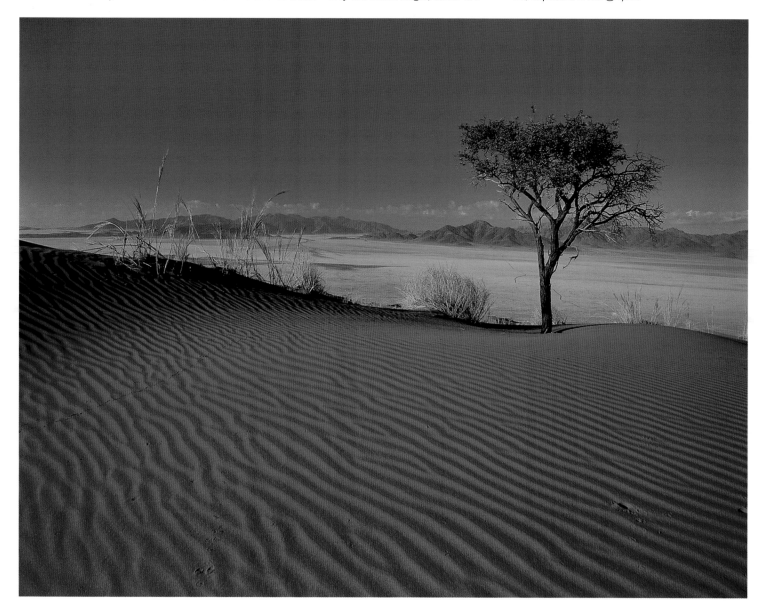

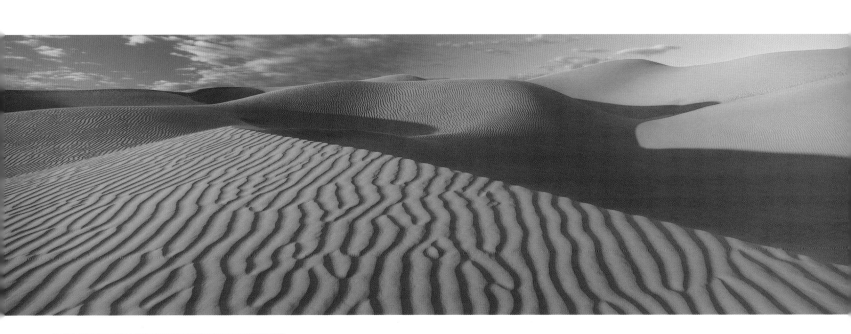

LANDSCAPE SECRETS

The most important factor when shooting the dunes is the lighting. There is only a small window of opportunity in the morning and evening when the lighting hits the dunes at the appropriate angle.

over 1,000ft (300m) high. In addition to the dunes themselves, there is Deadvlei, a salt pan containing skeletal remains of Camel Thorn trees. This is located at the end of a 40 mile (65km) road followed by a short hike over sand dunes. My favourite location in Namibia is a private reserve south of Sossusvlei, which has an incredible view, with an expanse of dunes set against a backdrop of a spectacular mountain range.

The most important factor when shooting the dunes is the lighting. There is only a small window of opportunity in the morning and evening when the lighting hits the dunes at the appropriate angle. The best advice is to check out the area and locate the scenes you want to capture at sunrise. The next day, be set up with time to spare and ready to make full use of the day's first light. Sidelighting is without doubt the best light to shoot dunes, because this enables you to record all the ripples and patterns in the sand and reveal its texture.

With large dunes, unless you're aiming for semi-abstract patterning, it's important to include objects in the frame that reveal their scale, such as brush, trees or other desert plants, or animals if you are lucky enough to see them.

The wonderful thing about sand dunes is that they are a fluid, never static environment; with each day the winds change the shapes and patterns of the sand, so there is always something new to photograph. High winds at night followed by a calm morning are the best conditions to encounter, as this practically guarantees you'll wake up to a fresh, clean landscape in the morning.

A diverse landscape

North America might not at first seem like a country packed with deserts, but it actually offers several desert landscapes, each of which has its own appeal.

Death Valley in California has just such a diverse landscape, boasting mountains, salt

ALGONDONES DUNES WILDERNESS, CALIFORNIA, USA

The most important aspect in photographing sand dunes is timing – there is such a small window of prime light that it is vital to find a suitable composition, set up and wait until the light is at its best. I tend to find a primary composition that I will devote time to, then a secondary composition within a close distance so that I can maximize the prime light. Camera: Fuji GX617 panoramic; lens: 90mm; filter: polarizing filter; film: Fuji Velvia 50; exposure: 1 sec @ f/22½.

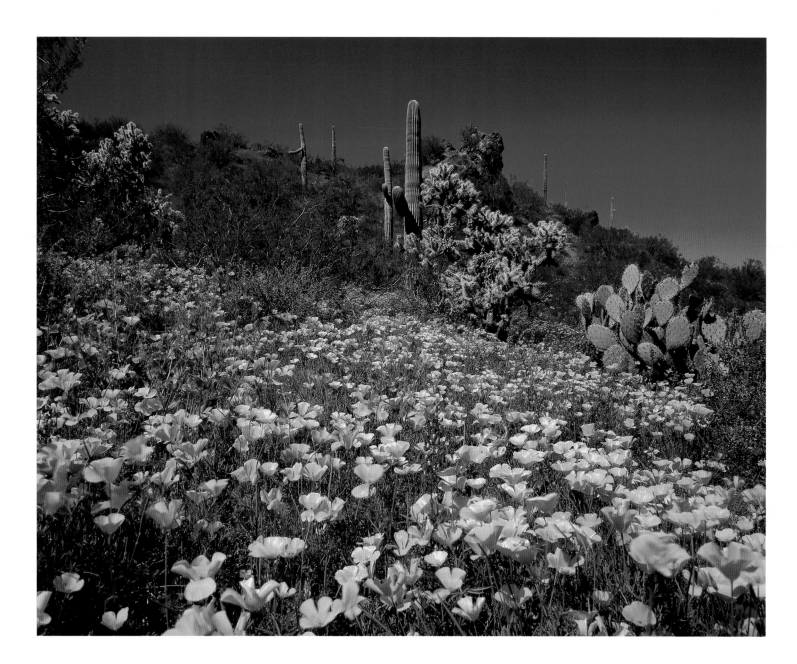

POPPIES AND LUPINS, PICACHO PEAK STATE PARK, ARIZONA, USA

Every March, this small state park is a popular location for people wanting to see and photograph wildflowers, probably because it is easy to get to. The blooms in this spot vary from year to year, depending on the amount of rainfall in the winter months. Camera: Pentax 6x7; lens: 45mm; filter: polarizing filter; film: Fuji Velvia 50; exposure: 1/4 sec @ f/22.

polygons and sand dunes. It's relatively easy to get to but is fairly popular, so you need to plan your visits carefully – I went once in February, expecting it to be uninhabited, and found that all the 'snowbirds' from the Midwest and east had escaped from the cold in their motorhomes and were camped out there. Avoid weekends and steer clear of holiday seasons. Spring is a good time to make a visit, as the wildflowers are in bloom – but I do advise you to check

with the rangers beforehand about the level of rainfall, as this will have an effect on the amount of bloom. Avoid the summer, as temperatures can soar to 120°F (49°C).

One of the best locations in Death Valley is a remote area called the Racetrack. It's difficult to get to, which means that less people make the journey to visit it, and it is thus more appealing to enthusiast photographers. It's around 27 miles (46km) off the main road from

Ubehebe Crater and is best reached using a 4x4, as the road is so bumpy and rough. The Racetrack lies between two mountain ranges running north to south with a dry mud playa in between. During torrential storms, the mud gets very slippery and the wind blows small rocks across the playa, creating trails several hundred yards long. You're advised not to walk on the mud when it's wet, as the footprints will last for decades! Unfortunately, some of the rocks have been stolen from the site, so you have to travel a fair way to find them.

Finding the viewpoint

Many great photographers, most notably Ansel Adams, have photographed Manly Beacon from Zabriskie Point in California. This is best shot at sunrise when the warm rays of light bathe the scene in a saturated golden glow, but because the sun is mostly at your back, the light soon flattens and the scene lacks form.

When I photographed Manly Beacon (see overleaf) I walked around an adjacent hillside ridge and shot it from a different angle so that it was side-lit. I was at a high viewpoint looking down and had a stunning view with the valley in the backdrop and the Panamint Range in the distance. A yellow/blue polarizer was ideal because it enhanced the natural golden colour of the earth and the vivid blue sky.

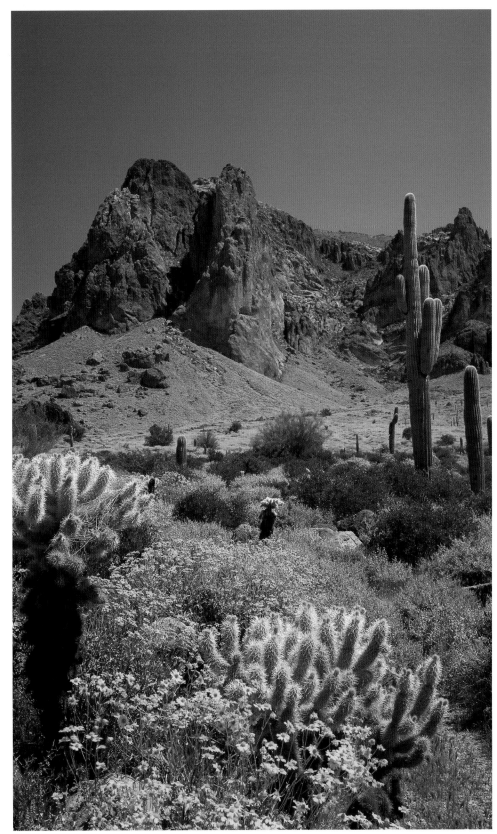

MANLY BEACON AT FIRST LIGHT, DEATH VALLEY NATIONAL PARK, CALIFORNIA, USA

I had to take a short hike to find this high viewpoint overlooking Manly Beacon, but it was worth it as it put me in a perfect position to obtain sidelighting. The lighting brought out the texture and form of this dramatic landscape. Camera: Wista Field 4x5; lens: 150mm Schneider; filter: Cokin yellow/blue polarizer; film: Fuji Velvia 50; exposure: 1/2 sec @ f/22.

Erosion

Bryce Canyon in Utah has a number of viewpoints along its 18 mile (30km) road looking east over the canyon. What's so striking about it is its incredible eroded rock formations, called 'hoodoos', and its range of colours.

Unlike the way most of us commonly think of deserts – located at a low elevation, desolate and arid – Bryce Canyon sits high on the Colorado Plateau between 6,000 and 9,100ft (1,830 and 2,775m), and averages about 19in (48.5cm) of rainfall a year. It becomes very cold in the winter, averaging about 9½ft (3m) of snow per year, and is a wonderful time to photograph the contrast between the snow and desert colours. It's a suitable location for those who want a spectacular view that they can reach by car with minimal effort, but offers far more for those willing to trek down into the canyon and seek different perspectives.

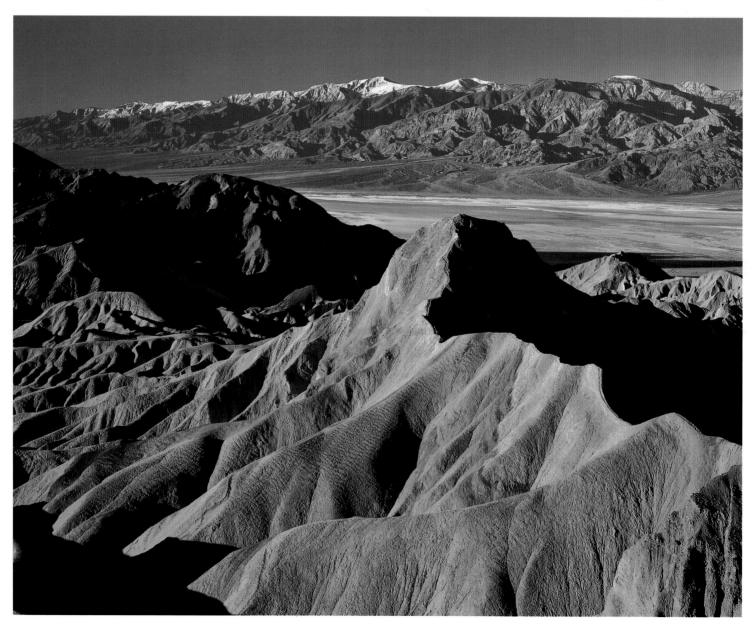

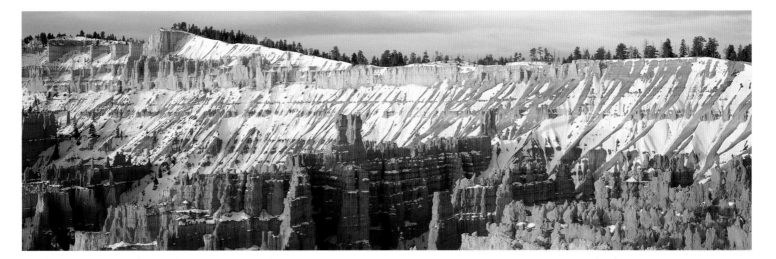

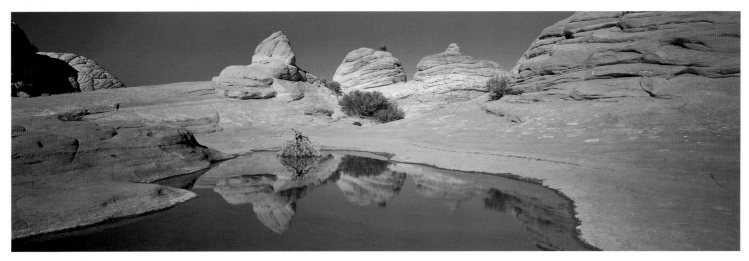

A popular viewpoint is from Sunset Point at sunrise, although it's advisable to arrive early to set your tripod up because you will find many other photographers turning up. This location offers a variety of great compositions within a short distance – as well as capturing the sun rising over the canyon, you can literally pivot the camera on the tripod to photograph the Queen's Garden in one direction and a few steps in the other, the Silent City.

Gypsum sand

White Sands in New Mexico offers a startling landscape made up of gypsum sand with a white surface that resembles snow. What's

particularly beautiful about it is that the white sand reflects the colour of the sky, so at sunset or sunrise the entire scene can take on a beautiful warm glow. What struck me about this location was that the surface is relatively hard, making walking across it easy – an important consideration when carrying equipment.

Vegetation and mittens

In Monument Valley, Arizona, yucca plants are scattered across the landscape and are a very photogenic element to include in the foreground. Monument Valley has its fair share of sand dunes, but is better known for its buttes and natural arches. It's probably

(TOP) SILENT CITY, BRYCE CANYON NATIONAL PARK, UTAH, USA

In the winter, snow creates distinctive patterns against the eroded orange rock formations, best captured at sunrise. Camera: Fuji GX617 panoramic; lens: 90mm; filter: polarizing filter; film: Fuji Velvia 50; exposure: 1 sec @ f/22½.

(BOTTOM) HOODOO REFLECTIONS, COLORADO PLATEAU, ARIZONA, USA

I mounted the camera on the tripod near to ground level to see these hoodoos reflecting in the pool of water. Camera: Fuji GX617 panoramic; lens: 90mm; filter: polarizing filter; film: Fuji Velvia 50; exposure: 1/2 sec @ f/22½.

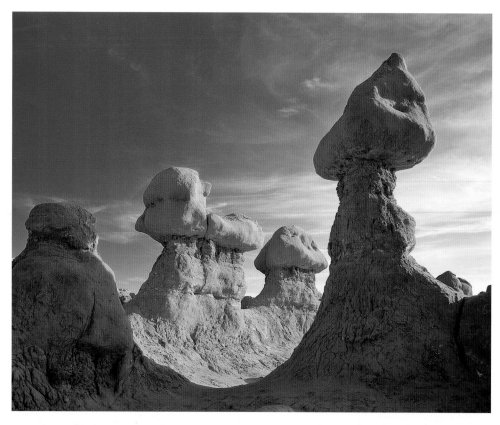

ROCK FORMATIONS, GOBLIN VALLEY STATE PARK, UTAH, USA

This lesser known park offers some incredible eroded rock formations. I spent hours just walking around looking for possible compositions, and found that the possibilities are endless as the light changes revealing new images. I used the U-shape shadow of the formation in the foreground to frame the hoodoos in the background. Camera: Pentax 6x7; lens: 75mm shift; filter: polarizing filter; film: Fuji Velvia 50; exposure: 1/4 sec @ f/22.

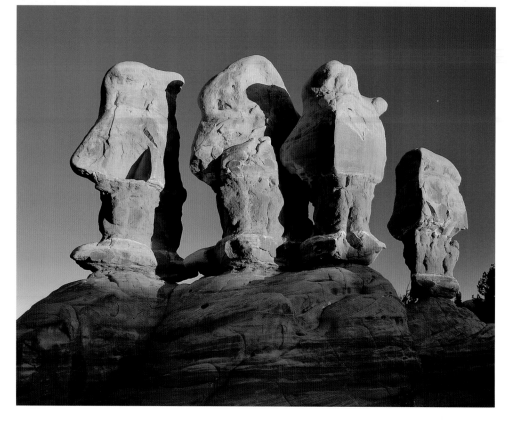

DEVIL'S GARDEN, GRAND STAIRCASE-ESCALANTE NATIONAL MONUMENT, UTAH, USA

I reconnoitred the area the night before to determine what I would choose for my dawn shot. Using my Flight Logistics sun compass (see page 138), I determined that first light would provide good side lighting on the rock faces. A polarizing filter deepened the sky, giving a good colour contrast between warm tones in the rocks and the blue sky. Camera: Pentax 6x7; lens: 75mm shift; filter: polarizing filter; film: Fuji Velvia 50; exposure: 1 sec @ f/16.

LANDSCAPE SECRETS

Photography tours led by professional photographers who know the area are becoming increasingly more common as they meet the needs of the enthusiast photographer properly.

best known for the extraordinary lithic Mittens, which can be shot from the tourist centre.

I'd advise anyone heading to Monument Valley to think seriously about getting a good guide, otherwise you could miss out on some fantastic scenery. There are some poor guides at this location, so head for a reputable company and inform them of what you want so that you make the most of the landscape. Bear in mind that they are not photographers and so won't know what you're looking for (best light etc.) unless you explain this to them properly.

Photography tours led by professional photographers who know the area are becoming increasingly more common as they meet the needs of the enthusiast photographer properly – in fact, I will be running tours aimed at taking photographers to the very best places at the best time of day.

While you're there, head to one of my favourite destinations – Hunt's Masa. It's fairly unknown, as it's difficult to get to, but provides a great view of Monument Valley. The best time to visit is in winter.

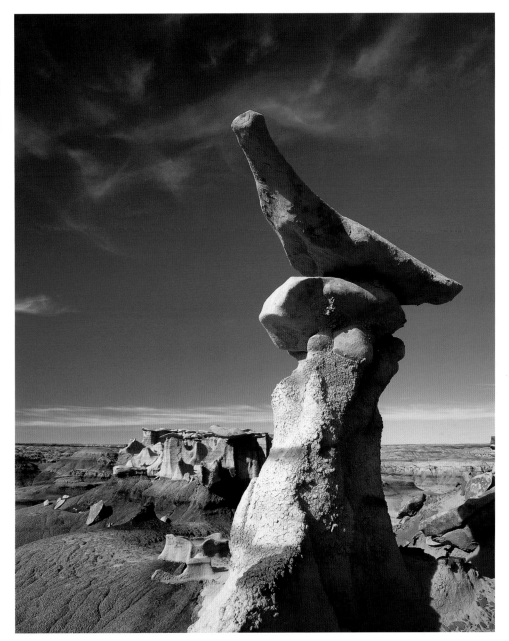

Photographing rock formations

The rock formations are the most appealing factor about the American deserts and offer stunning images thanks to their shape, scale and colours. There are many locations that aren't particularly well known that offer some stunning formations. In particular, the Bisty Wilderness Area in New Mexico features eroded channels and petrified trees and offers very unusual formations.

Another relatively unknown location is Goblins Valley State Park in Utah, which offers some of the best rock formations you are ever likely to find. It's a small valley carved out in the desert, where wind and water have continually eroded the rock to leave hoodoos that look like small goblins, hence their name. You do need

BALANCED ROCK, BISTI WILDERNESS AREA, NEW MEXICO, USA

After about a 2 mile (3¼km) hike in the dark to reach the formations for first light, I spent the day exploring numerous geological features. Finishing up at sunset, I walked out once again in the dark not seeing a soul the entire day. Camera: Pentax 6x7; lens: 45mm; filter: polarizing filter; film: Fuji Velvia 50; exposure: 1/4 sec @ f/16½.

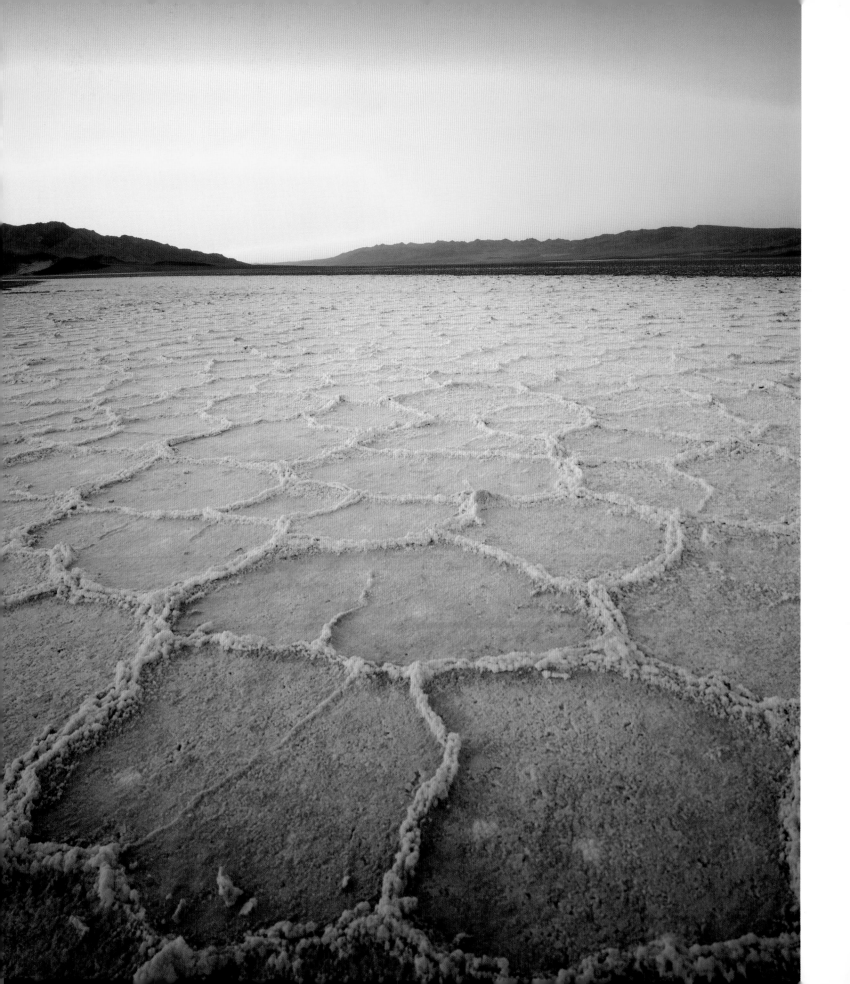

SALT POLYGONS, DEATH VALLEY NATIONAL PARK, CALIFORNIA, USA

I photographed these polygon patterns a few hours earlier with harsh sidelighting, but I prefer the soft, dusk light shown here. A wide-angle lens, pointed down at a 45-degree angle to the desert floor, accentuated the shapes. The coral stripe filter enhanced the afterglow. Camera: Wista Field 4x5; lens: 75mm Nikkor; filter: Lee coral stripe filter; film: Fuji Velvia 50; exposure: 4 sec @ f/22½.

to spend some time here, as the best photo opportunities are at first and last light.

One other place that's very interesting is near Escalante in Utah, on the National Park route between Capital Reef and Bryce Canyon. There's a road called the Hole in the Rock Road that seems to be leading you to nowhere but eventually takes you to Devil's Garden. As well as other unusual formations, there are four stone faces that are reminiscent of the mysterious monoliths found on Easter Island.

Keeping foreground interest

While a desert can often be seen as a barren landscape, there are certain subjects that can act as strong foreground interest. Cacti, wildflowers and other vegetation are particular examples, while the natural patterns created in the rock or sand are also worth including.

When photographing these subjects, try to point the camera slightly downwards to make full use of the foreground, and aim to include some midground and background elements as well, to give a three-dimensional look.

Because a desert scene can cover such a large area, it's important to include elements that give some sense of scale or depth. A person is the ideal subject, but you can include anything that has an easily recognizable size.

Because desert rock and sand are so reflective, you need to be extremely careful with your exposures. If you rely on the camera's integral meter, you will find that the majority of your pictures are almost certain to be underexposed. Multi-zone metering patterns are sophisticated and reliable, but these testing conditions are prone to being influenced by the high reflectivity of the scene. In the end, it's best to always use a handheld meter and a grey card to ensure you end up with the perfect exposure.

Desert abstracts and by night

The desert is a great place to try out some conceptual images. The isolation and remoteness of the environment means it's worth shooting concepts such as footprints in the sand, or placing a dry skull prominently in the foreground.

Look for images that depict themes such as survival – a single flower jutting from the ground, or long shadows from rocks that look like something else are just two examples.

If you head out to remote locations where the nearest town is a long way away – and deserts are prime examples of this – you'll have the wonderful opportunity to shoot star trails at night. Because there is no artificial light, the night sky is clear and devoid of light pollution,

TOTEM POLE AND SAND SPRINGS, MONUMENT VALLEY, ARIZONA, USA

The panoramic format in a vertical orientation is ideal for showing details in front of the camera up to the sky. I focused using hyperfocal distance with a small aperture to ensure sharp focus throughout. Camera: Fuji GX617 panoramic; lens: 90mm; filter: polarizing filter; film: Fuji Velvia 50; exposure: 1 sec @ f/32.

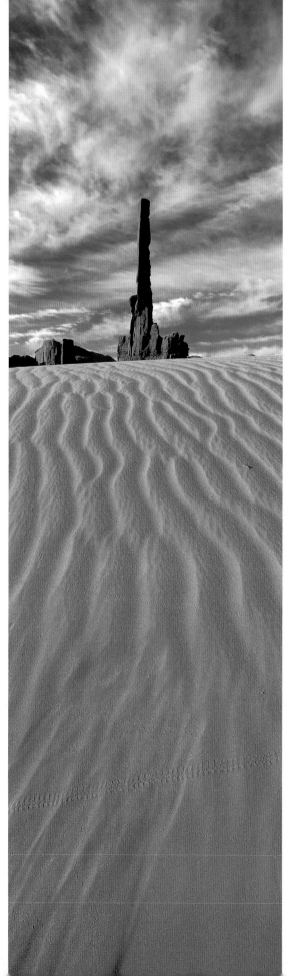

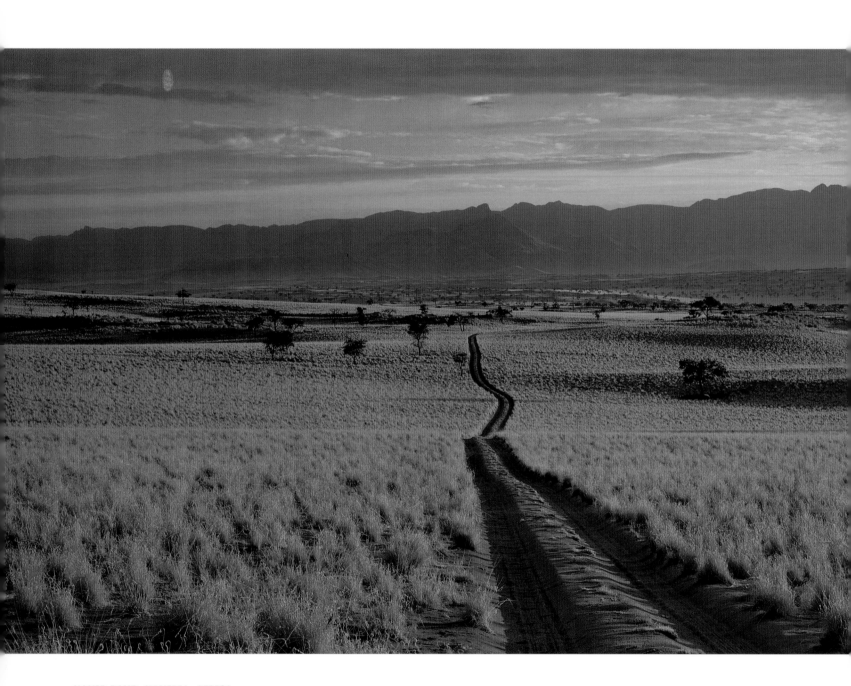

NAMIB RAND, NAMIBIA, AFRICA

Roads, paths or trails are useful compositional tools. I used the road as a lead-in line and a strategically placed tree on the right side of the frame to balance the composition. The evening light was enhanced with a sunset filter. Camera: Fuji GX617 panoramic; lens: 90mm; filter: sunset filter; film: Fuji Velvia 50; exposure: 1 sec @ f/22½.

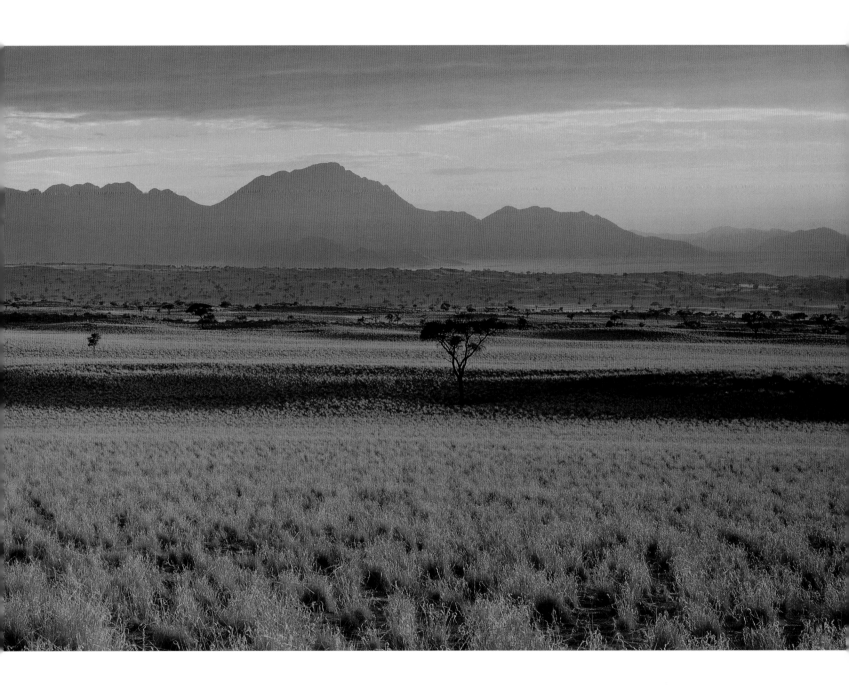

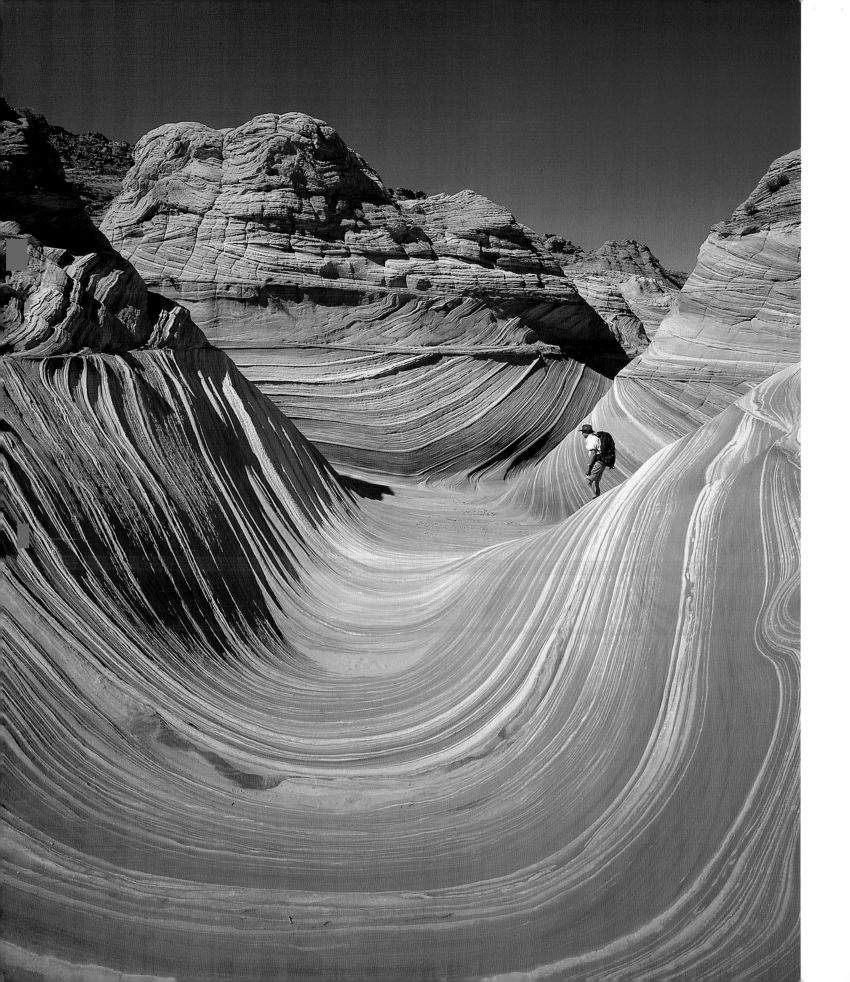

HIKER ON THE SANDSTONE WAVE, COLORADO PLATEAU, ARIZONA, USA

It is hard to imagine the scale of these unusual rock formations unless a person is included in the frame. The striations in the foreground help to guide the viewer to the hiker and provide a strong base. I averaged my exposure between the sky and the foreground. Camera: Wista Field 4x5; lens: 90mm Schneider; filter: polarizing filter; film: Fuji Velvia 50; exposure: 1/4 sec @ f/22½.

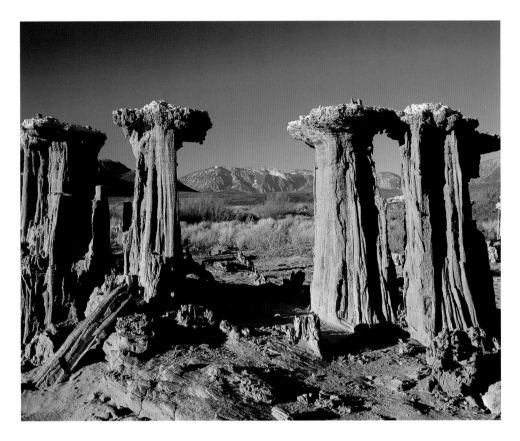

allowing you to shoot long exposures of the night sky and capture the movement of the stars as bright streaks of light set against a black sky.

Set the camera on a tripod with the camera pointing towards the North Star and shoot exposures ranging from one to two hours. The results can prove to be incredible.

Desert gear and precautions

Although you'll usually head to a location by car, you will still need to do a fair bit of walking in very hot, dry conditions, so it's essential that you only carry what you will need, as if you have too much you will tire quickly and won't reach the more inaccessible locations.

My photographic outfit is large, as I need to cover every option – I normally carry a panoramic camera system and a 5x4in camera or 6x7cm medium-format outfit – along with plenty of water, food and camping equipment. Amateurs, however, don't need to carry this amount of camera gear – one or two bodies and a choice of lenses, in particular those covering the wide-angle end, as well as small selection of filters (polarizer and warm-ups), should cover most eventualities.

It's essential that you protect your equipment properly, as sand carried by the wind can play havoc if it gets inside the seals. This is especially true with digital SLRs – a dirty sensor could effectively ruin all your images. Using safeguards such as storing equipment away when not in use should do the trick. You can also place your backpack inside a plastic bag, especially when working in sand dunes, as this ensures no sand makes its way inside.

The desert is home to some dangerous wildlife such as snakes and scorpions, so it's always advisable to take precautions. For instance, when scrambling up rock faces,

LANDSCAPE SECRETS

It's essential that you protect your equipment properly, as sand carried by the wind can play havoc if it gets inside the seals. This is especially true with digital SLRs – a dirty sensor could effectively ruin all your images.

NAVY BEACH, MONO LAKE, CALIFORNIA, USA

These tufa formations are actually only about 3ft (1m) feet high. To exaggerate their height by setting the camera on the ground, I nestled the camera on my coat and positioned the camera with the Eastern Sierras between the tufa. Camera: Pentax 6x7; lens: 45mm; filter: polarizing filter; film: Fuji Velvia 50; exposure: 1/4 sec @ f/22.

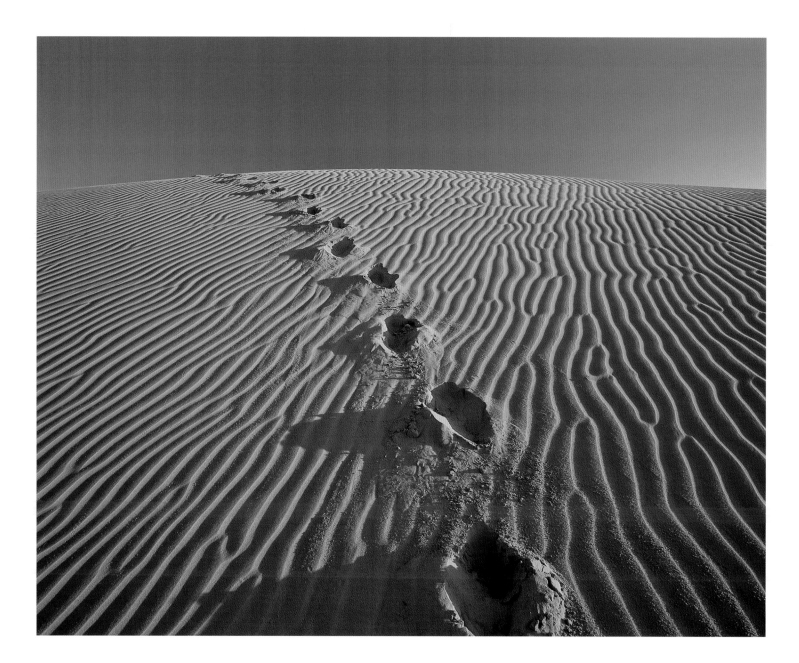

FOOTPRINTS IN SAND DUNES, ALGONDONES DUNES WILDERNESS, CALIFORNIA, USA

Sand dunes present all sorts of conceptual images to the imaginative photographer. I walked up and over the dune to get a photograph of my own footprints. This image was used to advertise a major airline with the slogan 'Make your money go further'. Camera: Pentax 6x7; lens: 45mm; filter: polarizing filter; film: Fuji Velvia 50; exposure: 1/4 sec @ f/16½.

never place your hands in crevasses without checking first. Be very careful, as medical aid is likely to be hours away at best.

The desert has one of the harshest environments on the planet, so you do need to take great care. In particular, ensure you have ample protection from the sun. Wear a hat at all times and ensure you apply plenty of sunscreen. The intensity of the sun is such that if you do not carry out these two very simple

precautions, you are likely to get acute sunburn at best or severe sunstroke at worst. If you are travelling alone, the latter can prove to be a potentially life-threatening problem.

Good walking/hiking boots are an absolute essential (definitely no flip-flops!), and you should also think seriously about wearing gaiters, as these will protect you from any needles and thorns that could lodge in your legs if you brush against desert cacti.

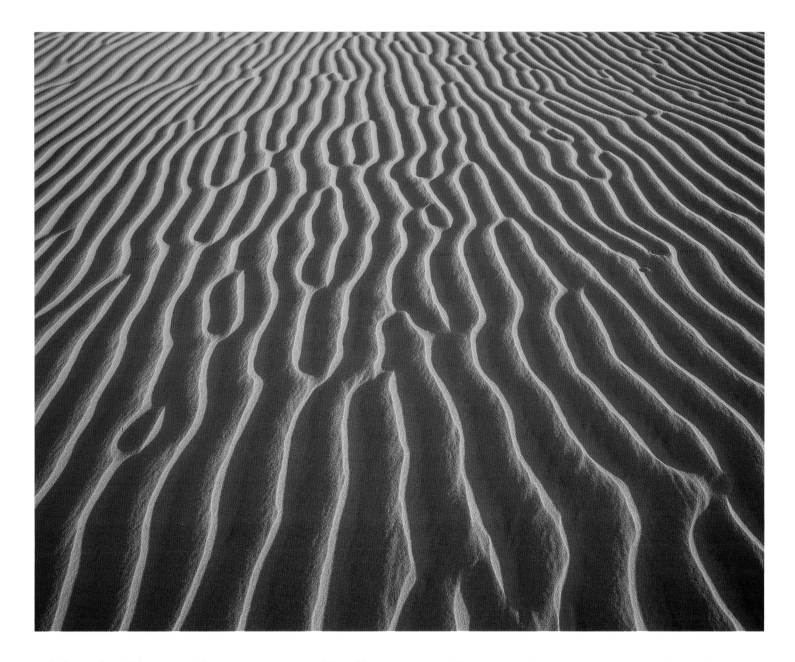

Before setting off, be sure to inform someone of your planned journey and plan a deadline date to contact them by. Should this date pass without any word from you, this person can then contact the authorities and give them an idea of how long you've been away and where you might be.

Because deserts cover such a large area and are sparsely populated, it's vital that you pay particular attention to your bearings. Be responsible and keep a compass with you at all times so that you can track your journey.

I once photographed the Algondones Dunes in Southern California at dawn and headed deep into the desert to capture dunes that weren't spoiled by footprints. When I had finished I realized that I couldn't see the telegraph poles by the roadside that provided my bearings. I was lost and spent hours walking until I found my way back.

SAND DUNE PATTERNS, ALGONDONES DUNES WILDERNESS, CALIFORNIA, USA

A tight crop of patterns can be used as backgrounds. I used a wide-angle lens to exaggerate the lines converging into the frame. Sidelighting brings out the best texture in the sand. This image was taken at the same time as the image shown on the previous page. Camera: Pentax 6x7; lens: 45mm; filter: 85B filter; film: Fuji Velvia 50; exposure: 1/4 sec @ f/16½.

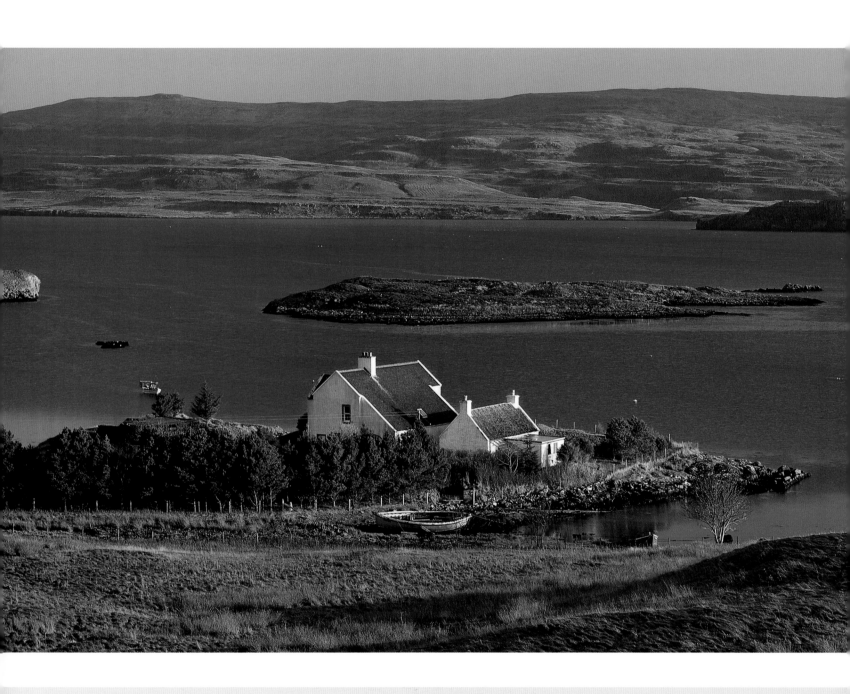

LOCH DUNVEGAN, ISLE OF SKYE, HIGHLANDS, SCOTLAND

There are occasions when compositions just present themselves without any intervention. The cottage on its own would have been fine, but the sailing boat is a good addition that balances the frame. Camera: Fuji GX617 panoramic; lens: 180mm lens; filter: polarizing filter; film: Fuji Velvia 50; exposure: 1/2 sec @ f/22.

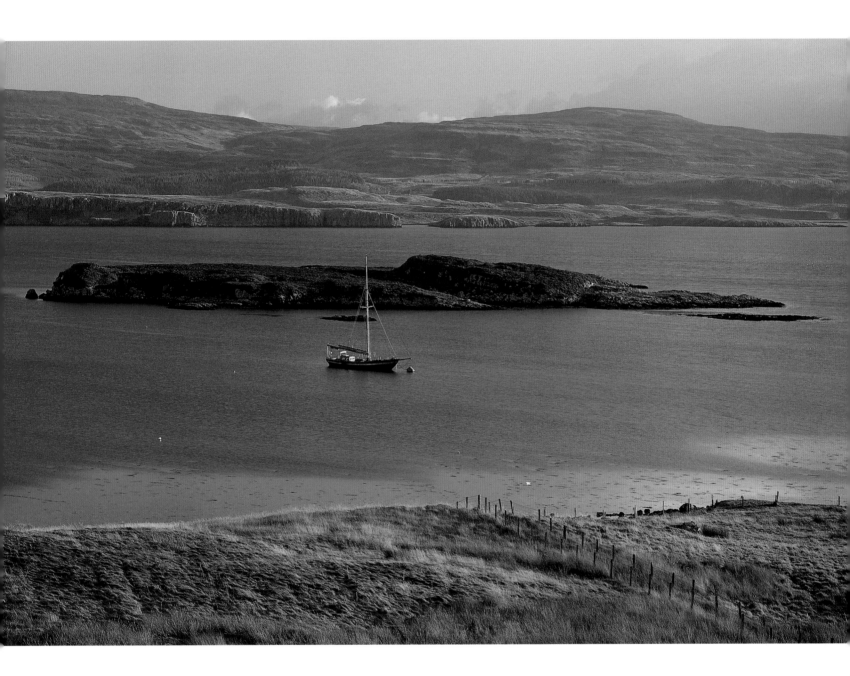

WATER IN THE LANDSCAPE

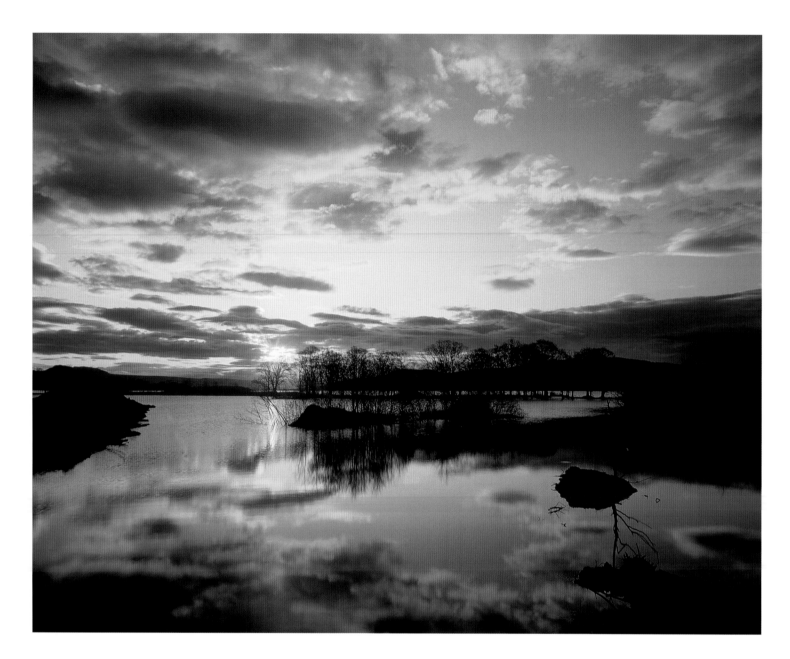

Water is the single most important element of our world. Two-thirds of our planet is covered in H$_2$O, while most of our body is formed from water. And, unless you live in the most arid areas of the world, you will find water in your landscape in various forms, including rivers, lakes, ponds, waterfalls and streams. The element of water as a concept in a landscape can evoke various moods such as tranquillity, purity or power. It's worth seeking out some of these subjects, as they can add to your landscape compositions. Water is a compelling subject that can add an extra dimension to your images. In particular, strong reflections entice the eye, especially where a perfect reflection is on view or where there is a little bit of ripple across the surface. They are mysterious, because the mind often sees more than there really is.

SUNRISE OVER LOCH LOMOND, STRATHCLYDE REGION, SCOTLAND

I travelled through the night to reach Loch Lomond for sunrise. This is my very first image of a place that has become my second home. Because the sky had some interesting clouds I wanted to find a clear body of water in the foreground to reflect the sky. Camera: Wista Field 4x5; lens: 90mm Schneider; filter: sunset filter; film: Fuji 50D; exposure: 1 sec @ f/22.

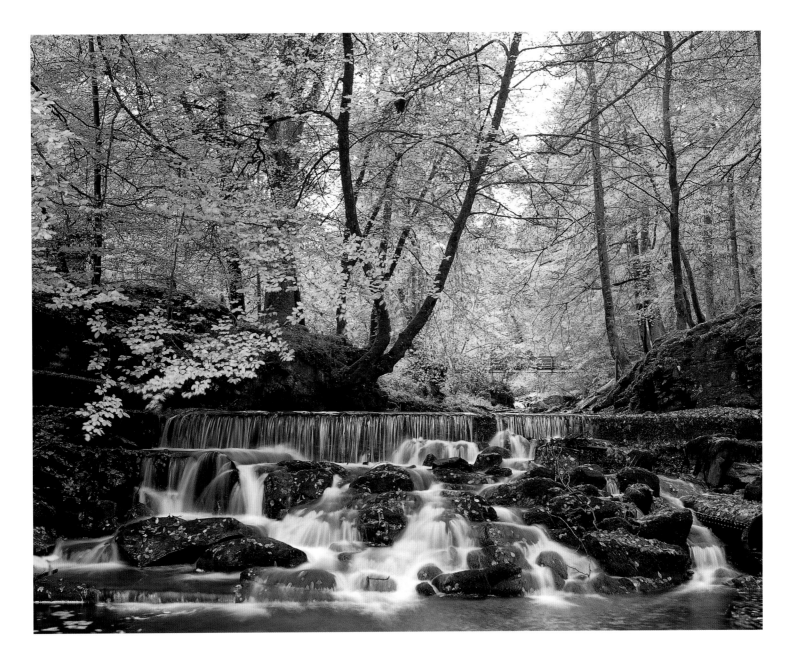

Exposure

Water is one of those subjects where the appearance of the main feature can be manipulated and controlled by the photographer. Simple techniques, such as selecting either a fast shutter speed (to freeze the movement of water) or a slow shutter speed (to record its motion as a blur), have a major impact on how the subject is recorded.

Blurring water by setting a long exposure is a relatively easy technique to try, but only practice really teaches you how to estimate which shutter speed is best. It all depends on the amount of water that is coming down the waterfall or stream – the greater the flow, the faster the shutter speed needs to be. Start at about 1/15 sec and go to longer shutter speeds from there. In bright conditions even setting the smallest aperture may not give you the long exposure you require, but

THE BIRKS IN AUTUMN, ABERFELDY, TAYSIDE, SCOTLAND

Overcast conditions provided ideal conditions to bring out the colour and details of the autumn foliage. I waded into the middle of the river to shoot the falls straight on, and used a warming filter to neutralize the cool colour cast that occurs in shaded conditions. Camera: Pentax 6x7; lens: 135mm; filter: Lee custom warming filter; film: Fuji Velvia 50; exposure: 1 sec @ f/22.

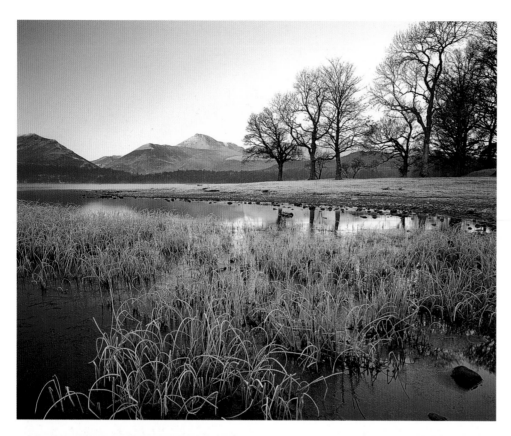

FROST ON DERWENTWATER, KESWICK, CUMBRIA, ENGLAND

Lakes in winter offer some unique photo possibilities, but you have to get out early to get the best images. I caught the first light on the distant mountains with the frost-covered grass in the foreground while tourists and dog walkers where still having breakfast. When I came back later, there were people along the shoreline and dogs running through the water and grass. Camera: Wista Field 4x5; lens: 90mm Schneider; filter: polarizing filter; film: Fuji Velvia 50; exposure: 2 sec @ f/32.

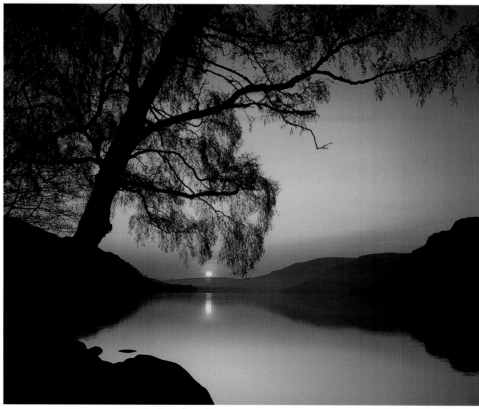

SUNRISE OVER ULLSWATER, LAKE DISTRICT, CUMBRIA, ENGLAND

When looking for a suitable composition to capture the sun rising at the end of the lake, I wanted a strong shape to silhouette. I framed the scene with a birch tree, being careful with the camera height so the branch didn't break the line of the horizon. Camera: Wista Field 4x5; lens: 150mm Schneider; filter: sunset filter; film: Fuji Velvia 50; exposure: 8 sec @ f/22½.

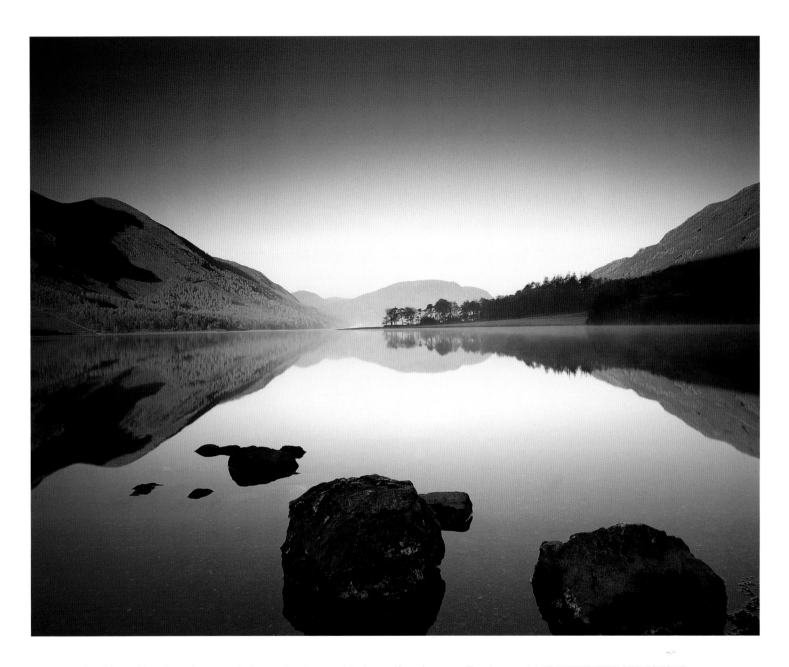

you can solve this problem by using a neutral density (ND) filter. These filters do not affect the colours in the scene – the only effect they have is to reduce the amount of light entering the lens, therefore allowing you to set longer or shorter shutter speeds as required.

In most situations, you need to use a faster speed only if there is an exceptionally high rate of water. Again, look for objects such as rocks that break up the flow and give it more

structure and texture, otherwise you will only record an undefined mass of white water.

Although there are some photographers who don't like freezing water's movement, as to them it looks static, unnatural and lacking in movement, should you wish to, in instances such as strong waves crashing against the shoreline, a fast shutter speed of at least 1/250 sec should be enough to freeze the water in time.

LAKE BUTTERMERE REFLECTIONS, LAKE DISTRICT, CUMBRIA, ENGLAND

Photographing reflections is one circumstance when placing the horizon in the middle of the frame can work very well. The large boulders in the foreground give the image a strong base. I chose an angle that made sure one boulder didn't merge into the other. Camera: Wista Field 4x5; lens: 90mm Schneider; filter: soft 0.6 ND grad; film: Fuji Velvia 50; exposure: 7 sec @ f/32.

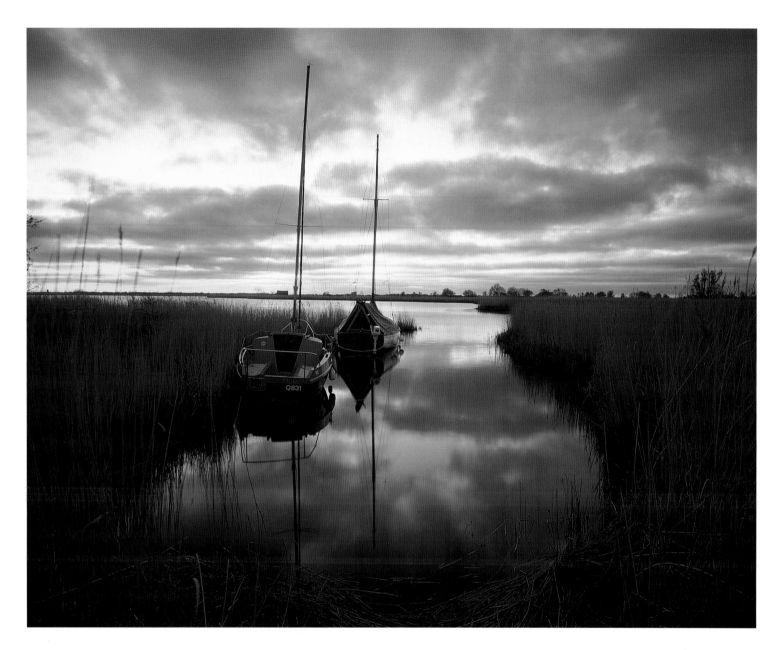

CLOUDS REFLECTING IN HORSEY MERE, NORFOLK BROADS, ENGLAND

There wasn't much hope of good images on this cold, windy winter afternoon, but I found a sheltered inlet. To show the U-shape of the reed bed, I used a wide-angle lens. The vertical lines of the masts help to break up the composition. Camera: Wista Field 4x5; lens: 75mm Nikkor; filters: Lee soft 0.9 ND grad, sunset filter; film: Fuji Velvia 50; exposure: 1 sec @ f/22.

Shutter speed

Shutter speed can really have a major say on the manner in which an image is perceived. A long exposure, where water has a silky or misty effect, produces a very inviting image, while a fast shutter speed that freezes water is effective if you want to illustrate its sheer power.

Having a concept of what you want to portray in the image is vital, and you should practise working on this while at the location.

Say, for instance, you visit Niagara Falls. You will want to show its energy and power, so a fast shutter speed is perfect, freezing the water as it is breaking over the edge of the falls.

On the other hand, if you visit a beautiful, tranquil winter landscape with a waterfall surrounded by icicles and snow, the ideal mood is attained by using an exposure of 1 sec or more to capture the misty effect that makes it more of a dreamy image.

Compositional considerations

It's important that in addition to concentrating on water features, you also consider how to incorporate them as a prominent element in a more general scene.

Rivers, for example, are a perfect natural lead-in line, and you can look for elements along the bank that will reflect well and give you strong shapes, such as trees and clouds. However, while this can provide an interesting and appealing element of the frame, you still need to find a main point of focus for the composition to work.

Rivers

A good pair of waders are worth investing in if you do plan to shoot rivers or lakes. Often the best viewpoint is found not on the shoreline, but by wandering a few steps into the drink and looking around you to find new opportunities. Doing this offers new angles to familiar scenes and can help to lift your work above that of photographers who restrict their picture-taking to the banks. From this position, you can compose the frame so that the edge of the river leads the eye through the scene.

Don't be afraid of getting into the river if you have spotted a potentially strong foreground subject, such as lily flowers – using a wide-angle lens at near-water level to the flower can produce an unusual perspective. Once in the water, be patient before you start taking pictures. Your movements will have created reflection-ruining ripples, so stay still and wait a minute or more until the surface has settled before you start shooting. Take care to keep a firm footing, and ensure that you don't take risks if the water is flowing quickly.

It's worth carrying a small torch with you, as this can be used to add light to areas of the frame. For instance, if there are attractive leaves around the bank and the light is low, shine the torch over the leaves during a long exposure to help them stand out. The torch can also be used to highlight specific subjects or small areas of the subject when shooting details.

Leading the eye

When it comes to composing a meandering 'S-shaped' river, think about having the beginning of the river going into the scene from the left-hand corner of the frame and meandering to

SUNSET AT TURF FEN MILL, HOW HILL, NORFOLK, ENGLAND

I wanted to give the feeling of space, and to achieve this I used a wide-angle lens on the panoramic camera. I positioned the windmill on the right side of the frame so the sails faced into the composition. Camera: Fuji GX617 panoramic; lens: 90mm lens; filter: sunset filter; film: Fuji Velvia 50; exposure: 4 sec @ f/22.

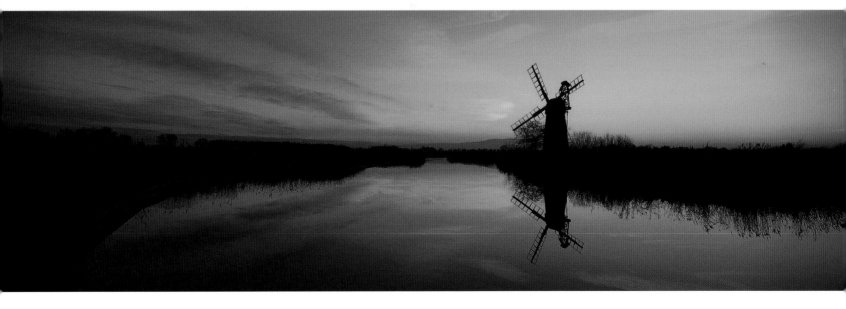

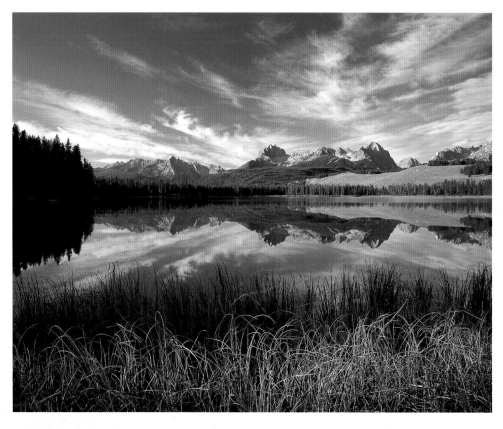

SAWTOOTH MOUNTAINS, LITTLE REDFISH LAKE, IDAHO, USA

I arrived before sunrise to photograph the still waters of Little Redfish Lake. As the morning progressed, cirrus clouds began to form in the sky. Their reflections angled towards the mountain to add a natural lead-in line to the composition. Camera: Wista Field 4x5; lens: 75mm Nikkor; filter: polarizing filter; film: Fuji Velvia 50; exposure: 1/2 sec @ f/22½.

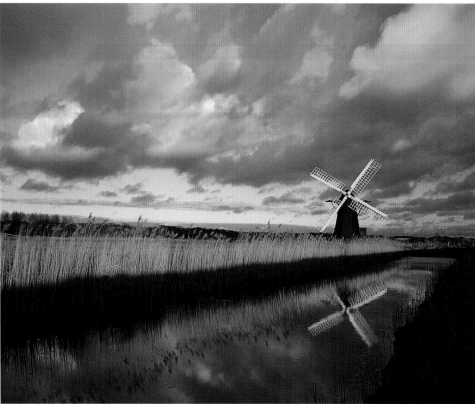

HERRINGFLEET WIND PUMP, SUFFOLK, ENGLAND

First experiences are often the best. This was my first visit to this wind pump, and after countless other visits, resulting images have never surpassed or even equalled my first. It's an experience that every landscape photographer has, when everything just naturally falls into place. This has sold more times than any other image in my library; the natural lines of the reed bed, dyke and graphic shadow lead the eye into the wind pump. Camera: Wista Field 4x5; lens: 90mm Schneider; filter: polarizing filter; film: Fuji Velvia 50; exposure: 1/2 sec @ f/22½.

the diagonal corner, as opposed to beginning in the right side of the frame. We are taught to read from left to right and when viewing images this will feel naturally balanced to the eye.

Filling the frame

Due to the sheer scale of large lakes and lochs, you need to take great care not to fill the frame with water and little else, or you'll end up with a very empty and unfulfilling image. The secret is to give it a real three-dimensional effect by introducing foreground, mid-ground and background – this way, your eye has something to settle on in every area of the frame, from the reeds and rocks of the foreground to the distant hills or mountains in the backdrop.

Because the foreground subjects are so prominent in this situation, it's important to take care where you place them in the frame, to avoid common mistakes, such as having them break the edge of the frame or have two large rocks merge together.

Keep your eye on how the foreground subjects work together and how they balance with the rest of the scene. Get it right and they will provide a strong anchor for the viewer's eye to settle on. And if you want to get reflections at their best, arrive early in the morning when the wind is low and the colours in the sky are strong and warm.

Filters

If you're shooting with digital cameras that have a limited minimum ISO setting (such as ISO 100 or 200), you may find it impossible to set a

long enough exposure to capture moving water as a blur. The best way around this is to set the minimum ISO rating and attach a polarizer (which reduces the light by 2 stops) and a neutral density filter, which should allow you to make an exposure of several seconds.

To give a completely different mood to your images, try shooting with an 80B filter, which will have the effect of creating a strong blue cast – this instantly changes the way people view the image. Depending on the scene, using a blue filter can add a relaxed tranquil feel or a cold, solitary mood.

Controlling reflections

Photographing reflections is not as straightforward as it might seem. The main thing is the exposure control, because there is a difference between your exposure latitude from the reflection in the water and the sky – this could be as much as 2–3 stops, depending on the light – so you need to control these by using a split ND graduate filter. Take a reading from the sky and its reflection, and use the difference in exposure to help select which strength filter you intend to use.

Bear in mind that when using a polarizer in a scene containing water, as well as deepening blue skies, the polarizer also has the effect of

WATERFALL IN AUTUMN, LAKE DISTRICT, CUMBRIA, ENGLAND

I wanted to include some the surrounding foliage, making the waterfall almost secondary in the final result. Taking into account the +2 stops for the filter and the dark woodland conditions, this resulted in a long exposure, giving the water a silky appearance. Camera: Fuji GX617 panoramic; lens: 90mm lens; filter: polarizing filter; film: Fuji Velvia 50; exposure: 8 sec @ f/45.

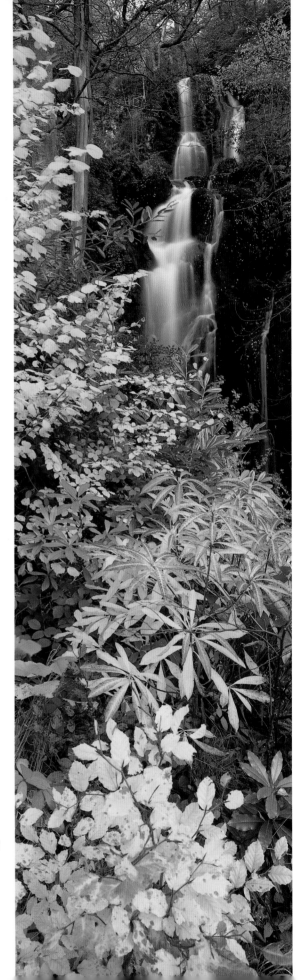

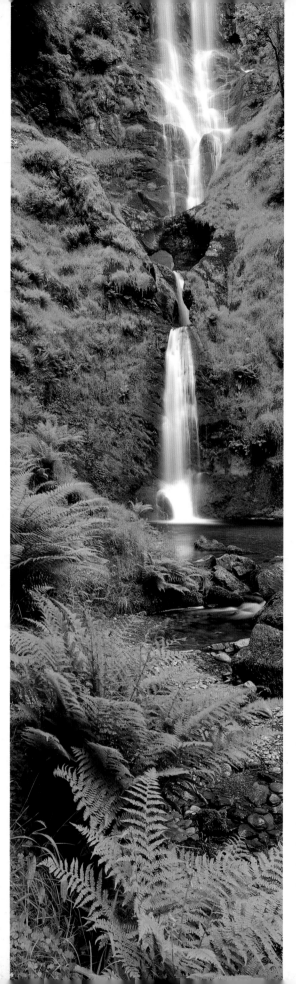

PISTYLL RHAEDR WATERFALL, NEAR LLANRHAEADR YM MOCHNANT, DENBIGHSHIRE, WALES

By using a vertical panoramic I was able to include these ferns in the foreground. There had only been a small amount of rainfall during the week, so the amount of water falling down the cliff was just enough for texture to be seen in the cascades. Too much water would have resulted in one long ribbon of white. Camera: Fuji GX617 panoramic; lens: 90mm lens; filter: polarizing filter; film: Fuji Velvia 50; exposure: 8 sec @ f/45.

reducing reflections in the water. If you want the reflections to remain, turn the polarizer ring back half a rotation until the reflection reappears yet the sky remains a deep blue.

Sunrise and sunsets are obvious times of the day to capture reflections, as they make the most out of the sky's colours. However, it's still possible to get good shots throughout the day, depending on the time of the year and the angle of the light.

Shooting the rapids

When the weather takes a turn for the worse, there's no better water feature to head for than a waterfall. Instead of ruining the image, rain can often improve your waterfall shots because all the foliage around them is wet, so you have a lovely sparkle and glisten to the general scene. In these conditions, use a polarizer to take the reflection off the foliage and deliver a strong, saturated result.

While most people concentrate on getting in close to waterfalls and filling the frame with them, you may prefer to incorporate the surrounding area and almost make the waterfall secondary amongst the foliage, ferns and flowers in the scene. If you have a panoramic camera or fancy the idea of

stitching images together digitally, try shooting some vertical panoramics, as waterfalls obviously lend themselves well to this format. If stitching digitally, make sure that your shots overlap each other by around 40 per cent. I usually find myself shooting a waterfall in several formats as it can be captured in so many different ways.

When including foreground interest, look for strong lead-in lines, but also try and find subjects that can reveal the scale of the waterfalls, even if this means setting the self timer and running into the picture yourself!

A common error that people make when shooting a waterfall is to capture it as one straight body of water, so that it appears as a single blurred ribbon. This composition can be greatly improved by something as simple as including rocks that break up the water, so that you have little spills that cascade, providing the viewer with a bit more detail and more definition to the water.

When you're photographing waterfalls, it's often the case that the scene is enclosed in

MARYMERE FALLS, OLYMPIC NATIONAL PARK, WASHINGTON STATE, USA

To get an idea of the size of this waterfall I framed it alongside these pine trees, but the inclusion of a person in the obligatory red shirt was possibly more conclusive and left no doubt as to the actual scale. Camera: Wista Field 4x5; lens: 90mm Schneider; filter: polarizing filter; film: Fuji Velvia 50; exposure: 1 sec @ f/16½.

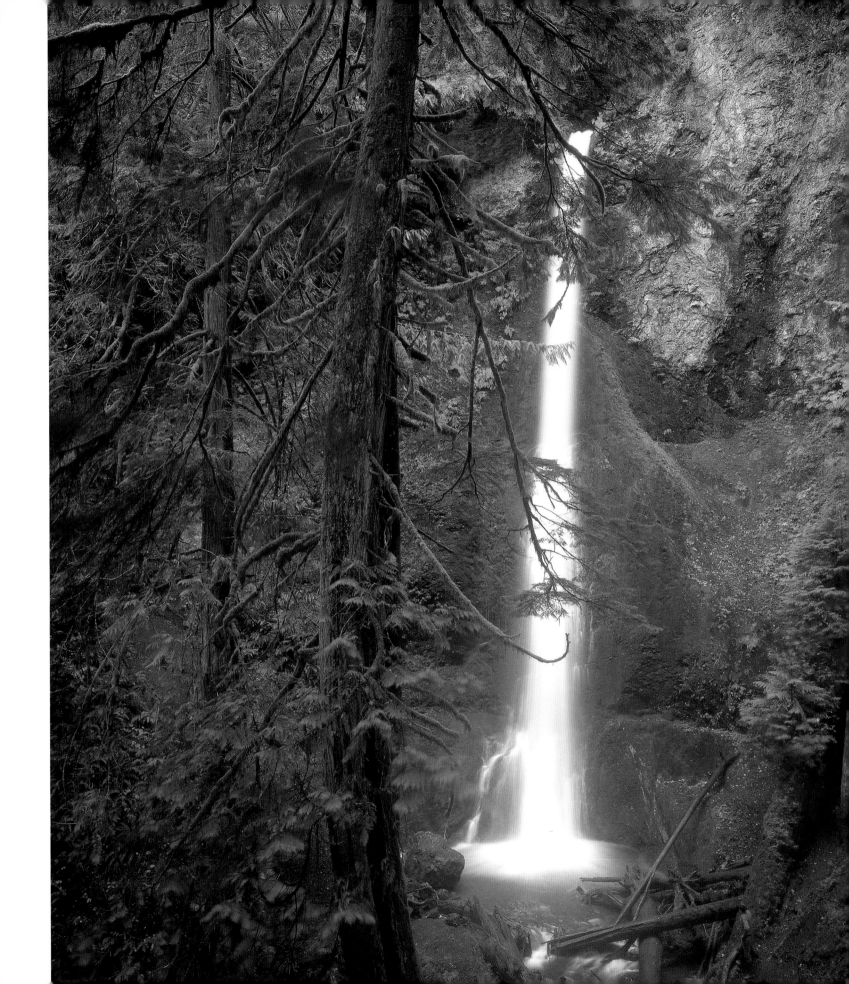

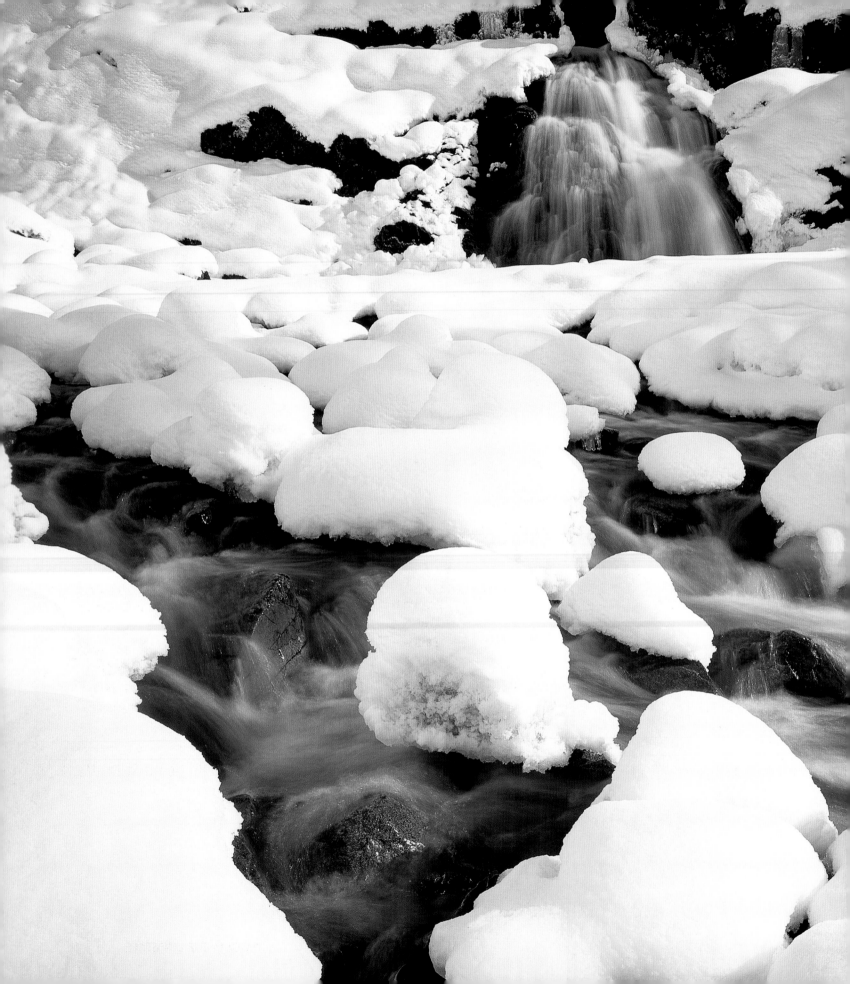

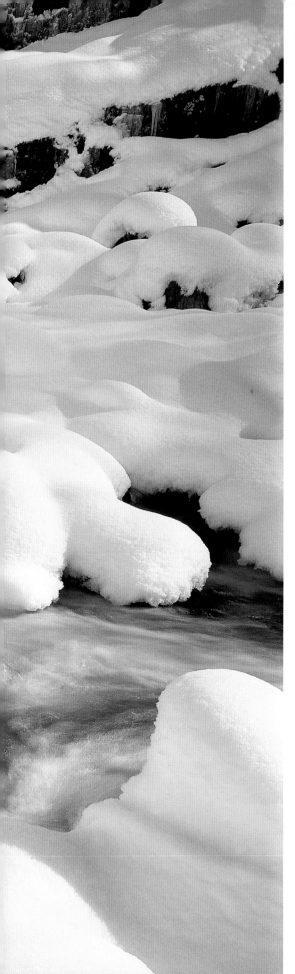

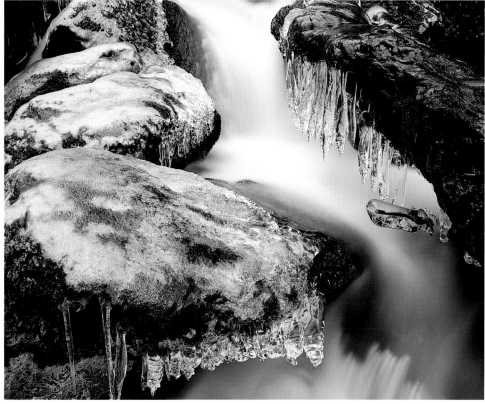

(ABOVE) ICICLES IN STREAM, LADORE FALLS, CUMBRIA, ENGLAND

The skies were dull and overcast, so I went in search of icicle-adorned waterfalls. I spent most of an afternoon standing in the middle of an icy stream, persevering in the frequent light showers at creating various compositions. The shape of these two ice-covered rocks made a natural curve that balances the frame. An 81B warming filter removed the blue cast under the shaded conditions. Camera: Wista Field 4x5; lens: 150mm Schneider; filter: Lee 81B warming filter; film: Fuji Velvia 50; exposure: 1 sec @ f/16½.

(LEFT) WATERFALL IN GLEN COE, HIGHLANDS, SCOTLAND

After a fresh snowfall, waterfalls, streams and rivers take on a magical appearance. It was quite easy to make gorgeous images wherever the camera was pointed, but determining an exposure proved to be more difficult with the lack of a mid-tone. I metered from the snow and opened up the aperture by 1½ stops, which I also bracketed around. Again, an 81B filter removed the blue colour cast that results from the blue sky reflecting in the snow. Camera: Wista Field 4x5; lens: 90mm Schneider; filter: 81B warming filter; film: Fuji Velvia 50; exposure: 1/2 sec @ f/32.

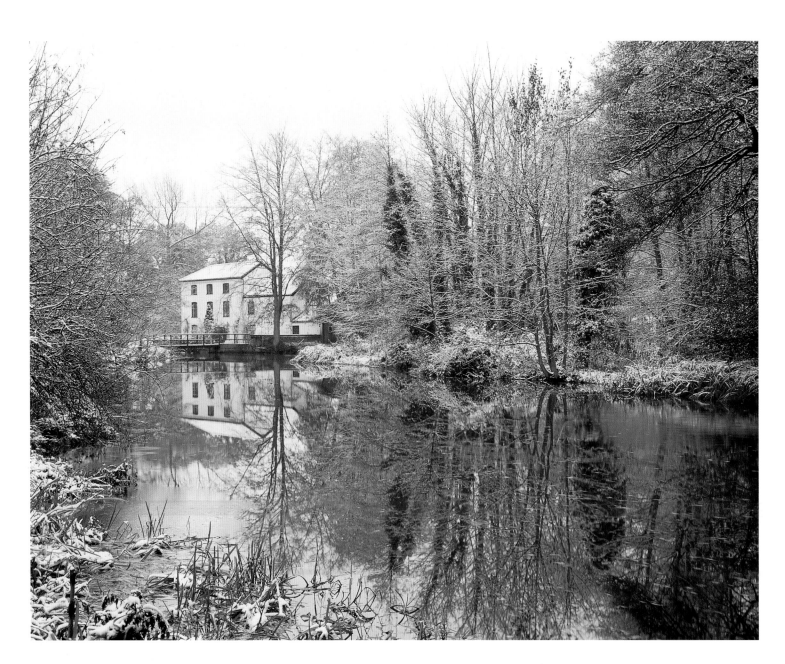

CRINGLEFORD MILL IN WINTER, CRINGLEFORD, NORFOLK, ENGLAND

Mirror images of reality create an almost surreal representation. Utilizing the compositional rule of thirds, I placed the mill in the left third of the frame, with the somewhat eerie reflection of the snow-covered trees encompassing the rest of the frame. Camera: Wista Field 4x5; lens: 90mm Schneider; film: Fuji Velvia 50; exposure: 1 sec @ f/22½.

foliage and relatively dark; this can be a good way to set the scene effectively. However, it does mean that when you expose for the general scene, the water appears overexposed. A useful trick in this situation is to use a soft-edged neutral density grad to even out the exposure. By shooting the waterfall from the side at an angle, the grad can be positioned to darken the water and yet leave the rest of the scene unaffected.

Winter waterscapes

In winter, water takes on a totally different quality. A detail you should make sure to include is icicles, because you can come up with some fantastic shapes and compositions. Head to waterfalls and streams to find crystal-like shapes created by the falling water. Close-up images of ice-encapsulated grass or overhanging tree branches can make wonderful abstract images.

FRIAR'S CRAG REFLECTIONS IN WINTER, LAKE DISTRICT, CUMBRIA, ENGLAND

When there is equal interest in the composition it is easy to divide the frame in half. In this case, with no clouds to make an interesting sky it would be pointless to give it equal status. The main attraction is in the foreground with the ice shapes leading up to the graphic silhouettes of the Scots pines. I used partial polarization so I could see the stones under the surface of the water, and this served to add contrast between the water and the icy shoreline. Camera: Wista Field 4x5; lens: 75mm Nikkor; filters: Lee soft 0.6 ND grad, polarizing filter; film: Fuji Velvia 50; exposure: 2 sec @ f/22½.

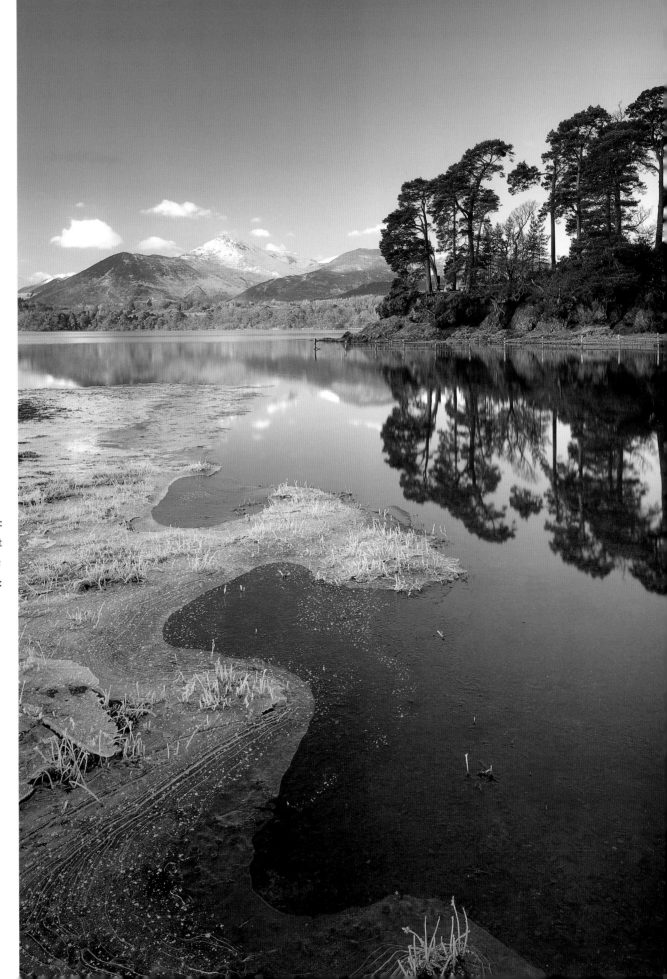

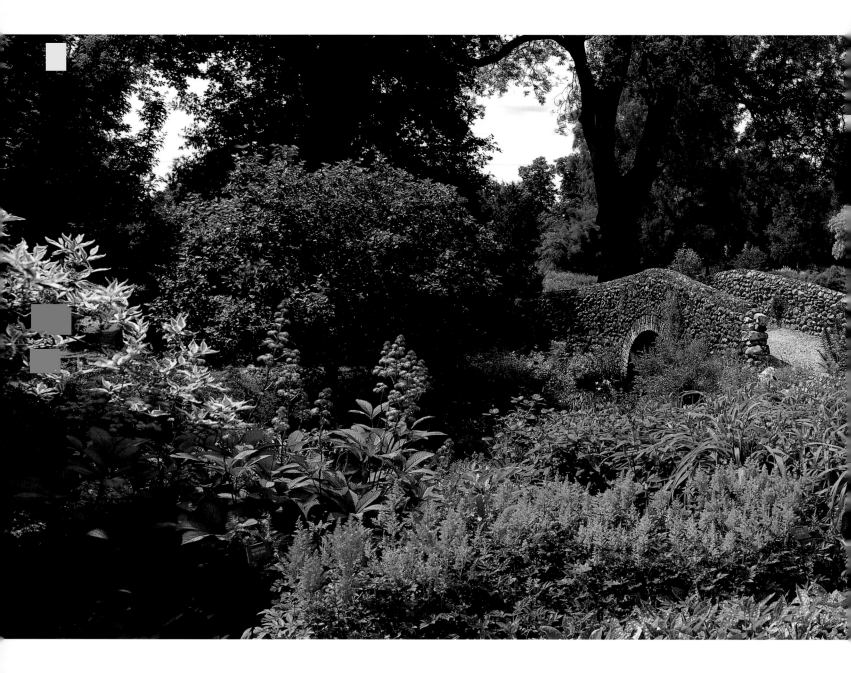

BRESSINGHAM GARDENS, BRESSINGHAM, NORFOLK, ENGLAND

Gardens are merely a formally designed landscape; elements of a scene are laid out for the photographer to capitalize upon. The stone bridge is the main focal point of the frame, and the other elements, such as the grass area and the flower borders, serve to support the composition. Camera: Fuji GX617 panoramic; lens: 90mm lens; film: Fuji Velvia 50; exposure: 1/2 sec @ f/22½.

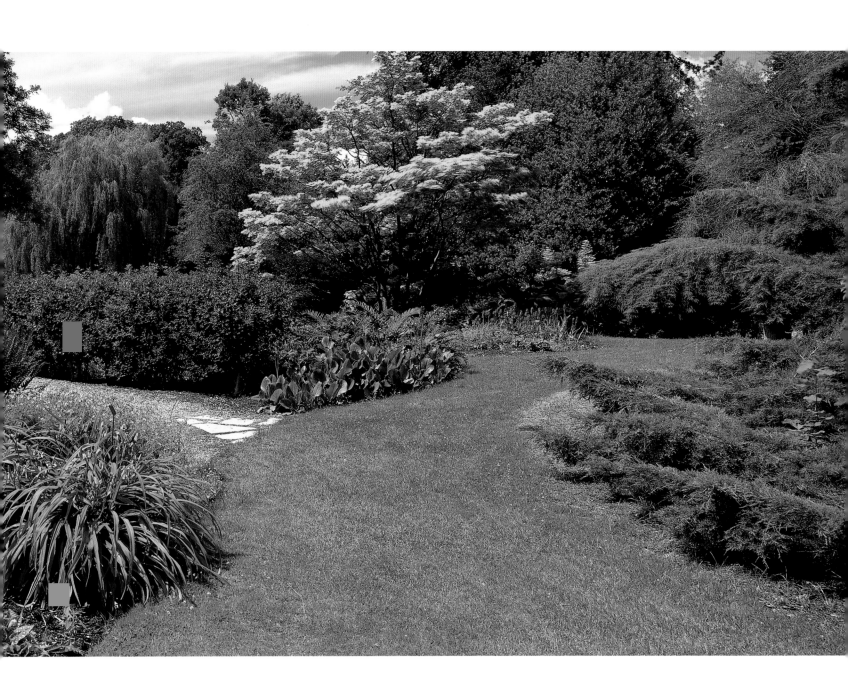

GARDEN LANDSCAPES

While Mother Nature is responsible for the natural beauty of most landscapes, there is one type that is tended by man simply to look beautiful – the garden. While for most people, the thought of a garden is a small plot of land by the home, for the photographer, gardens represent the chance to visit a stately house, castle or other magnificent home to capture stunning images.

Whatever the weather

While most visitors head to gardens when the weather is bright and sunny, I normally aim to shoot them when conditions aren't perfect for general landscapes. When you're out travelling the countryside and conditions deteriorate, you can photograph gardens because they are the type

KEUKENHOF GARDENS, LISSE, HOLLAND
Bright, overcast lighting was just right to bring out the saturated colours of the flowers. I particularly like the way the garden designer used the dark purple grape hyacinths to lead into the beds. Camera: Wista Field 4x5; lens: 90mm Schneider; film: Fuji Velvia 50; exposure: 1 sec @ f/22½.

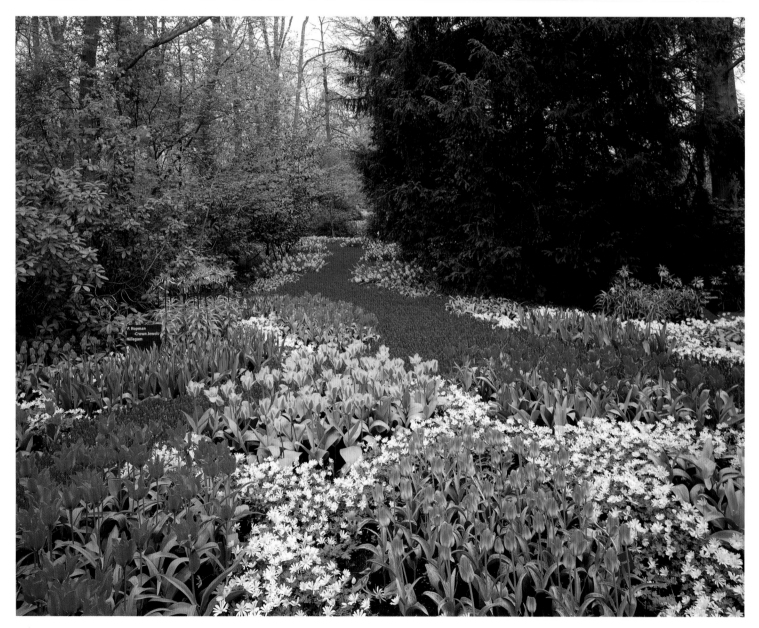

of location that often doesn't depend on sunny days and that can look beautiful in bright, overcast conditions.

Photographing a garden is much like shooting a portrait of a person – the aim is to find the subject's most flattering aspects and use a quality of light that brings out the best details. So, if the garden boasts attractive features such as topiary, then you want to use strong lighting to bring out its shape and form; or if the garden has a lot of foreground colour and intricate shades of green, you want diffuse light (overcast conditions) to reveal this.

Planning and inspection

When approaching a garden for the first time, always make sure to speak to the owner or gardener first to discover the various features the garden has to offer, especially if you've not been able to research the garden in a book or

ARCHWAY AND TOPIARY, HIDCOTE MANOR GARDENS, GLOUCESTERSHIRE, ENGLAND
Archways and paths are good elements to include in compositions. This image would not have worked as well on a bright, sunny day as the contrast would have been too great to see details. Because the sky was overcast, I chose a tripod height that allowed the archway to hide it. Camera: Pentax 6x7; lens: 75mm shift; filter: Lee 81B warming filter; film: Fuji Velvia 50; exposure: 1 sec @ f/22½.

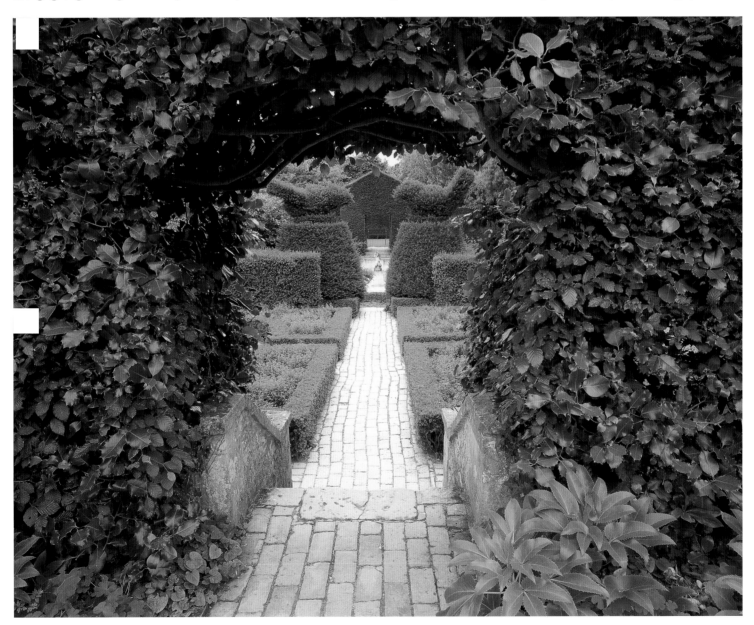

magazine beforehand. The owner will also be able to tell you the optimum time of year when particular plants or shrubs are at their best.

Depending on the size of the garden, the next stage is to make a quick assessment of which shots to do first, according to lighting. This should enable you to see straight away what are going to be the most compelling elements that will work well in compositions, such as fountains, bridges and pathways.

Size and detail

The size or scale of even a small garden means that you can try a number of viewpoints, ranging from general views to individual flower studies. If you want to show the flowers within the landscape, use a wide-angle lens and get fairly close to a clump of flowers. Alternatively, try a more abstract view and use a macro lens to fill the frame with a close-up of an individual

LANDSCAPE SECRETS

Often the basic elements used in creating a garden's design are similar to those used by photographers, so rules of composition such as the Rule of Thirds and strong foreground interest, aren't too difficult to achieve.

flower. And because some gardens are built to a large scale, it's worth trying to find a very high viewpoint, such as an upper floor of a building or the top of a church tower, and fill the frame with a bird's-eye view of the garden.

The inherent design

Most gardens have been designed and planned to look as good as possible. This, along with the fact that they are regularly maintained, should make life somewhat easier for the photographer. Unlike a wild landscape, which has its form shaped by nature, a garden has been specifically designed either formally or informally to appear at its best.

Often the basic elements used in creating a garden's design are similar to those used by photographers, so rules of composition such as the Rule of Thirds and strong foreground interest, aren't too difficult to achieve. When you are photographing gardens you are primarily trying to exploit colour combinations, patterns and shapes. Well-designed larger gardens feature a wealth of lead-in lines, S-shaped pathways and features such as fountains, pots, plants and benches, which can all be used in constructing your composition.

INULA HOOKERI AND MALVA, PITMEDDEN GARDEN, GRAMPIAN REGION, SCOTLAND
When photographing floral portraits or close-ups of flowerbeds, what you crop out of the image can be as important as what you retain in the composition: this can be distracting backgrounds, bright spots of sky or anything that pulls the viewer's eye away from the main subject. The main subject here is the yellow flowers, and I closed in on one particular bloom that stood out from the rest, positioning it close to the lens to make it more prominent. Camera: Wista Field 4x5; lens: 75mm Nikkor; filter: Lee 81B warming filter; film: Fuji Velvia 50; exposure: 1 sec @ f/22½.

VILLA RUFOLO GARDEN, RAVELLO, AMALFI COAST, ITALY
The symmetrical design of this Italian garden could only be appreciated from a high angle. There was a high village wall from which I could shoot down into the garden. Camera: Fuji GX617 panoramic; lens: 90mm lens; film: Fuji Velvia 50; exposure: 1/2 sec @ f/22½.

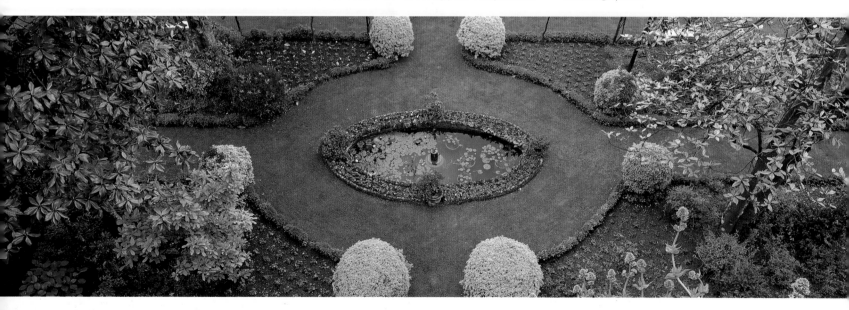

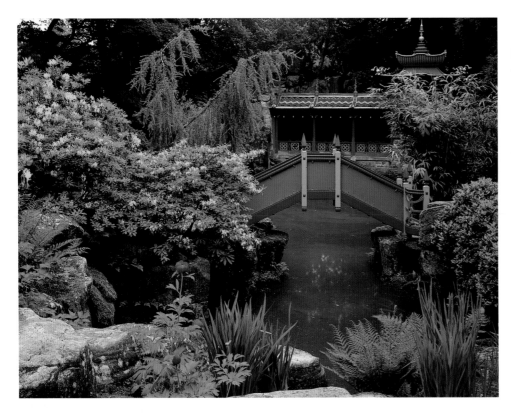

(LEFT) CHINESE GARDEN, BIDDULPH GRANGE, STAFFORDSHIRE, ENGLAND

The colours of garden features, such as this ornate Chinese temple and bridge, help to break up the greenery. I positioned the temple and bridge in the upper third, with the yellow azaleas breaking up the colour on the left side of the frame. A polarizer removed the reflections from the foliage, saturating the colours. Camera: Wista Field 4x5; lens: 150mm Schneider; filter: polarizing filter; film: Fuji Velvia 50; exposure: 4 sec @ f/22½.

(BELOW) PACKWOOD HOUSE GARDEN, LAPWORTH, WARWICKSHIRE, ENGLAND

The enormous unusual hedges in this garden are difficult to photograph under bright conditions, because their close proximity to one another causes distracting shadows. When I went to the end of the garden, it opened out to this unusual hedge that reminded me of a spaceship. The sidelighting helped to bring out the shape. Camera: Fuji GX617 panoramic; lens: 90mm lens; film: Fuji Velvia 50; exposure: 1/2 sec @ f/22½.

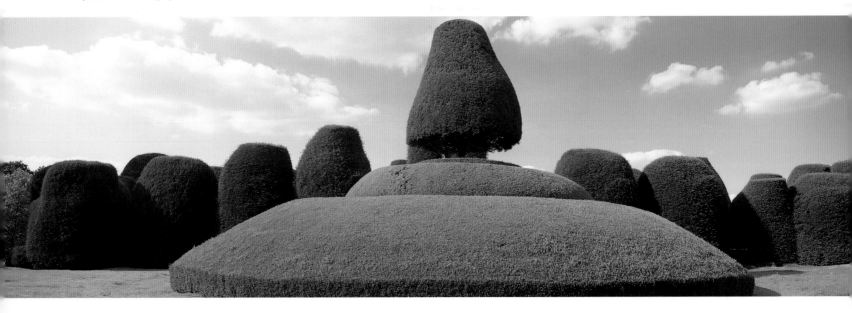

Lighting considerations

The best time of day to visit a garden will
depend on the type of scene you want to
photograph, as lighting conditions must suit
the subject matter. For instance, if you want
to set a building – whether it is a cottage or a
stately home – in the background of the image
to give a sense of place, it's best to choose a
time when the building is lit, ideally from an
aspect opposite the camera's position so that
the shadow side of the building is closest to the
camera. This type of lighting achieves better
modelling to the scene and appear less flatly lit.

Soft, overcast light is best for flower portraits,
as you do not have to worry so much about the
strong contrast caused by the strong directional
light of a sunny day. On bright days, wait for
clouds (nature's own diffusers) to pass in front
of the sun to soften the effect and reduce the
contrast range.

While some photographers use flash for
their flower portraits, the results more often
than not look too artificial. A better option is to
use reflectors to bounce sunlight back on to
the subject. The most common reflector types
are gold, silver and white, with silver having the
strongest reflectance, white the most subtle
(and best for lifting highlights) and gold adding
a tinge of warmth to the scene.

Don't even out the amount of direct light
from the sun and reflected light, as the subject
will appear false due to the light being too even
– instead, look to create shape and form by
having a lighting ratio of 1:2.

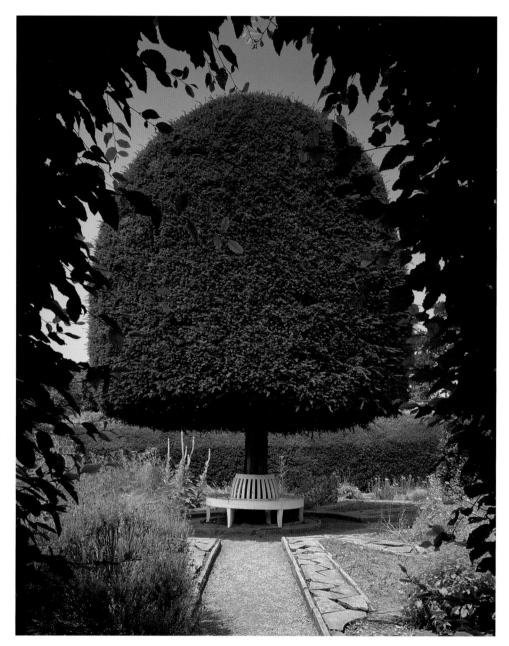

Seasonal variations

It's vital to investigate the best time of year to
visit a garden. Often the easiest way to find
out is as simple as contacting the owner or
gardener and asking what the main attributes
of the garden are. For example, if the garden
has shrubs such as rhododendrons, camellias
and azaleas, then you are going to have to visit
in late April/early May, when they are in bloom.

IRISH YEW TREE, ST FAGANS, CARDIFF, WALES

When I walked into this section of the garden,
straight away I noticed how the shape of the arch
in the hedge had the same shape as the yew tree,
so I utilized it for framing the image. The path
was a good lead-in line to the bench and the tree.
Camera: Wista Field 4x5; lens: 90mm Schneider;
filter: polarizing filter; film: Fuji Velvia 50;
exposure: 1/2 sec @ f/22½.

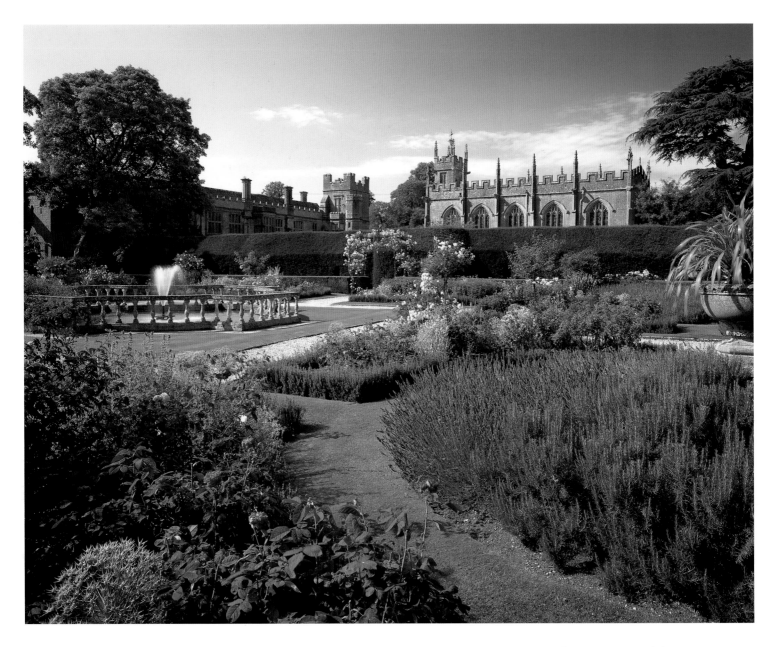

QUEEN'S GARDEN, SUDELEY CASTLE, GLOUCESTERSHIRE, ENGLAND

The gardens on these two pages are in complete contrast, but both follow basic compositional guidelines. Here I used the curve of the path to lead into the frame from the right hand corner, positioning the chapel in the upper right third intersect. Camera: Wista Field 4x5; lens: 150mm Schneider; filter: polarizing filter; film: Fuji Velvia 50; exposure: 1/2 sec @ f/22½.

Bear in mind that many trees and shrubs also take on an amazing display of colour in the autumn, for example the Japanese maple. This tree is often used by garden designers in spring planting schemes but turns a fiery red colour when the autumn arrives.

Herbaceous borders are at their best in July and August, when they are overflowing with a good show of colour. Again, doing some research before you go is invaluable.

Knowing your subject

It helps greatly if you know at least a minimum about plants and flowers, as otherwise you'll have no real basic grounding for which look best and at what time of year they are in bloom, and will end up missing the best subjects.

If you're not particularly knowledgeable, then you will initially need to put in a fair amount of research, but with time you will learn what you need to know about your subject.

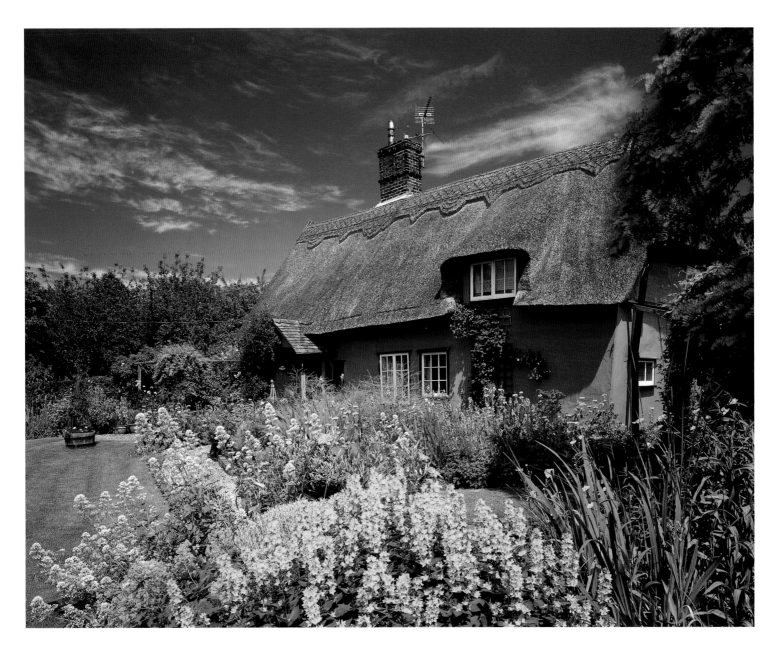

To find out the best locations for gardens, check magazines, books and the Internet, and also contact large gardening bodies – in the UK, the largest are the National Garden Scheme, the Royal Horticultural Society and the National Trust. Through the National Gardens Scheme many private gardens are opened to the public for one or two weeks of the year, and you can find really unusual gardens that aren't normally accessible.

Seeking permission

When working in a garden that is open to the public, it is best to contact the owners for permission to visit on a day that it is closed, as this will allow you to shoot all day without having to wait for visitors to leave a scene. Whether or not the owner will provide you such access depends on their flexibility and your credentials. They are often more open to the idea because they can see the potential of a

THATCHED COTTAGE GARDEN, SUFFOLK, ENGLAND

With any garden subject, foreground colour and texture are important to establish a good base to a composition. I especially look for bright, vibrant colours such as red, orange or yellow in flower groupings, as these stand out particularly well. Camera: Wista Field 4x5; lens: 90mm Schneider; filter: polarizing filter; film: Fuji Velvia 50; exposure: 1/2 sec @ f/22½.

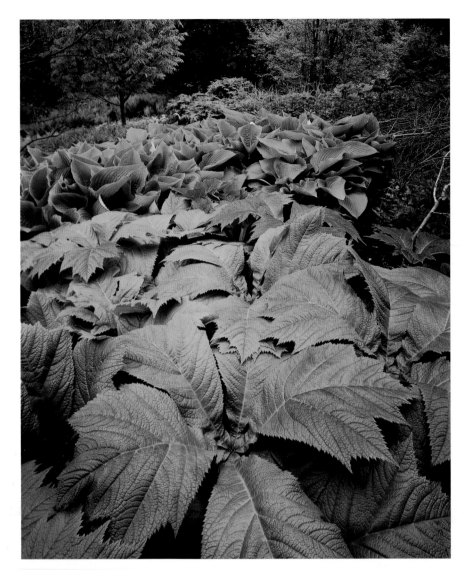

(LEFT) WAKEHURST PLACE, ARDINGLY, WEST SUSSEX, ENGLAND

I often use a polarizer to remove reflections on plants to bring out colour saturation, but on this occasion I chose not to as I wanted to show the glossy sheen on the fantastic leaves of this *Rodgersia podophylla* plant in the foreground. I placed one dominant plant that showed a good array of leaves in the central foreground. An 81A filter removed the cool colour cast in the overcast conditions. Camera: Wista Field 4x5; lens: 75mm Nikkor; filter: Lee 81A; film: Fuji Velvia 50; exposure: 1 sec @ f/32.

(BELOW) GARDEN OF LOVE, CHATEAU VILLANDRY, LOIRE VALLEY, FRANCE

This is one of the finest gardens in Europe. It has so much to offer the photographer – this is only one small section of the garden. I wanted to show off the design of the parterre, so I chose a high angle shooting down on the garden. The backlighting defined the hedges, but I had to be careful not to get flare into the lens. Camera: Fuji GX617 panoramic; lens: 90mm lens; film: Fuji Velvia 50; exposure: 1/4 sec @ f/22½.

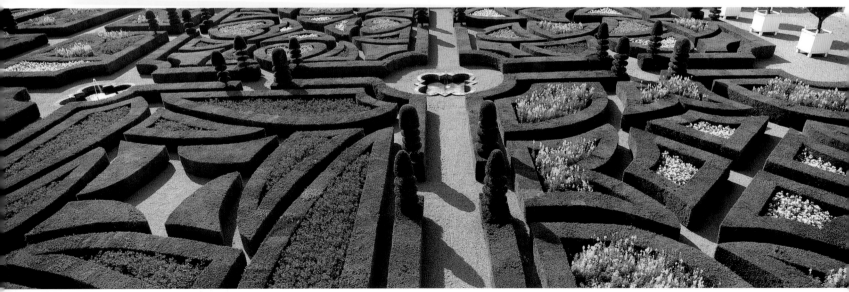

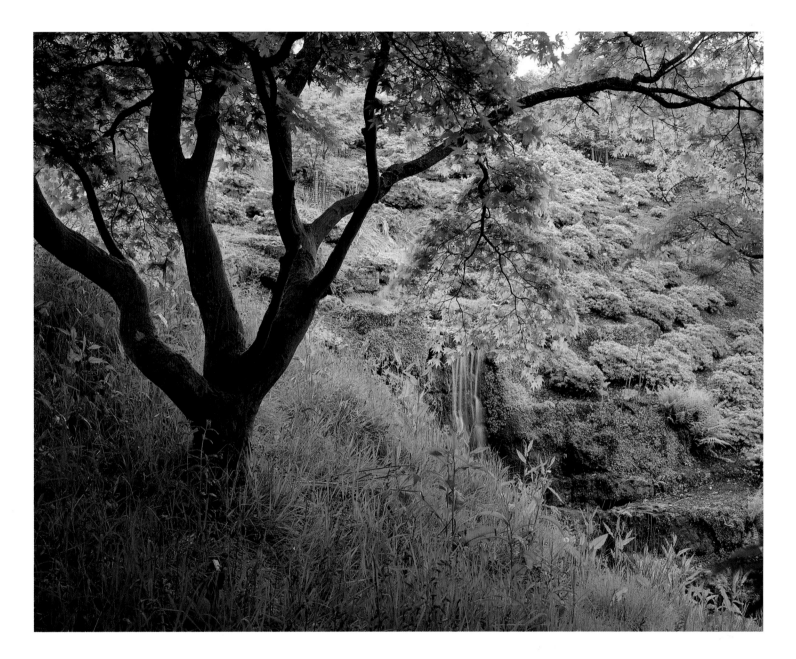

photographer coming in – if you offer to provide a 'free' set of images for their brochures, you can enjoy a full day's shoot without any trouble. If this isn't possible, arrive early and shoot the most difficult views first before the garden becomes too crowded.

Sometimes, however, it is nice to include a figure in the frame for scale and an element of human interest. However, because you'll often be using small apertures for increased depth of field, the exposure time can run into seconds, so the person must be still, for instance sitting on a bench, or else they may be recorded as an unsightly blur.

Filters for gardens

A polarizing filter is an essential accessory because it takes the sheen off the foliage to achieve a nice saturated colour. Another filter worth considering is a warm-up, such as

WAKEHURST PLACE IN SPRING, ARDINGLY, WEST SUSSEX, ENGLAND

The exposure presented a problem because the difference between the brightly lit background and the shaded foreground was too extreme for the film to handle. A cloud covered the sun, acting as a giant diffuser and evening out the exposure latitude. Camera: Wista Field 4x5; lens: 75mm Nikkor; filter: polarizing filter; film: Fuji Velvia 50; exposure: 1/2 sec @ f/32.

AZALEA STEPS, WINKWORTH ARBORETUM, SURREY, ENGLAND

I've visited this arboretum many times, but either the lighting conditions were too bright, there was a poor show of blooms or tourists decided to set up camp on the bench. On this occasion, everything fell into place. Camera: Fuji GX617 panoramic; lens: 90mm; filter: polarizing filter; film: Fuji Velvia 50; exposure: 1 sec @ f/32.

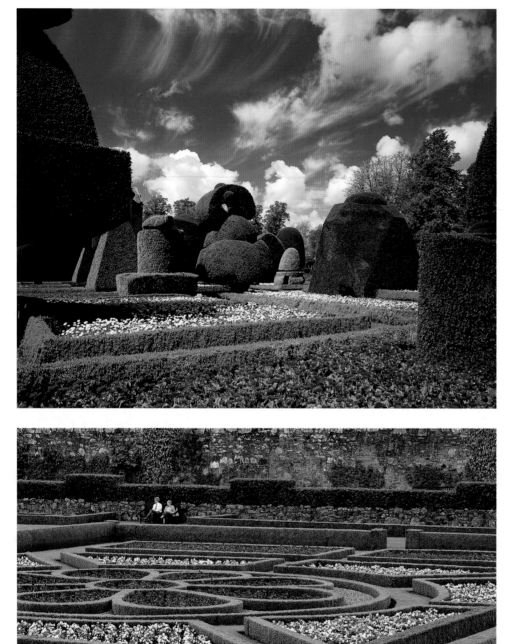

TOPIARY GARDEN, LEVENS HALL, CUMBRIA, ENGLAND

I spent the whole morning photographing the giant topiary until I was down to my last sheet of 4x5 film when this amazing cloudscape presented itself. I used a polarizing filter to accentuate the clouds against the deep blue sky. Camera: Wista Field 4x5; lens: 90mm Schneider; filter: polarizing filter; film: Fuji Velvia 50; exposure: 1/2 sec @ f/22½.

PARTERRE, PITMEDDEN GARDEN, GRAMPIAN, SCOTLAND

Sometimes people add a sense of scale or a point of interest to a scene. I try to only include one or two people with plain, discreet clothes that don't date the image. None of the images in this book have been cropped, as I try to compose exactly how I want the final image to look. But because of the constraints of the equipment I couldn't achieve the right composition with this image, so cropping the 6x7 into a panoramic format greatly improved the impact of the design. Camera: Pentax 6x7; lens: 200mm; filter: polarizing filter; film: Fuji Velvia 50; exposure: 1/2 sec @ f/22.

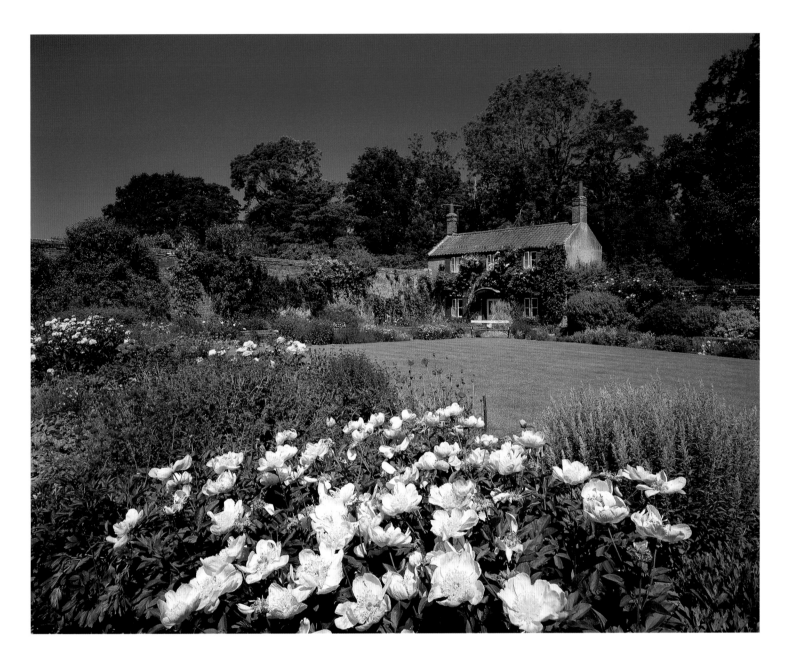

an 81A or 81B, which can neutralize a cool colour cast when shooting in shady conditions. Warming filters can improve the appearance of greens, especially when shooting flowers.

Planning your shots

Look around the garden for groups of flowers that work well in colour combinations. While you're at the mercy of the garden designer on how the plants are arranged, you should still look around for angles that you can use to mix contrasting or harmonious colours. Strong colours attract the viewer's attention, so try to keep these in the foreground if possible.

Think about taking some abstracts if the location and conditions are right. If the wind is high and you can't set a fast enough shutter speed, try some creative blur shots. Use a long shutter speed to capture the motion of flowers and leaves for a lively and fluid result.

GARDENER'S COTTAGE, HOVETON HALL GARDENS, NORFOLK, ENGLAND

A garden with good foreground interest in terms of colour and texture is essential for complementing buildings such as this cottage. The light tonal value of these peonies first direct the viewer to the flowers, and then to the cottage. Camera: Wista Field 4x5; lens: 90mm Schneider; filter: polarizing filter; film: Fuji Velvia 50; exposure: 1/2 sec @ f/32.

MY EQUIPMENT

As a professional photographer who makes a living from the images I take, it's essential for me use the best equipment available. Despite advances in technology, in particular with digital cameras, it may come as a surprise to some that my choice of gear, in particular the cameras I use, dates back several years.

Cameras

I remember when Fuji brought out Velvia and discontinued the 50D film stock of which I was an avid user. I hated Velvia, but I had to move with the times, and eventually I adjusted my shooting methods to cope with the increased contrast and I've been a fan ever since. Everything has its limitations though, and despite the rapid movements in digital technology, I feel that even the current king of digital – the Canon EOS-1DS Mark II – hasn't reached a standard that will replace the quality and capability of producing large reproductions from a 4x5 transparency. This isn't to say that I would discount using the Canon for shooting general stock images, as most photographs don't ever get reproduced any larger than A3-sized (a double-page spread in a magazine).

There is a general rule in film photography that the larger the format, the better the potential image quality, which is why I use medium- and large-format cameras. The first is the Pentax 67, an ancient workhorse by modern standards, but one capable of delivering razor-sharp 6x7cm slides thanks to the quality of the optics. The other medium-format model I use regularly is the Fuji GX617, which is employed exclusively for shooting panoramics.

For the ultimate in image quality, large-format cameras are unrivalled and deliver a result that justifies the extra weight and bulk. I currently use the Wista Field camera for most of my work; it is relatively compact and produces 4x5in transparencies that offer biting sharpness.

These three cameras are all professional models, providing the quality needed to sell images in a competitive market. The optics are good enough to allow huge enlargements to be made, opening up the potential for pictures to be used poster size and even larger. However, if you are an amateur who isn't planning to sell work or to print images larger than 12x8in, then a 35mm or digital SLR is a more affordable and portable system and delivers excellent results.

Lenses

While the versatility of zoom lenses mean they dominate the amateur market, prime lenses offer sharper results and remain the choice of professionals. I use the following list of lenses along with the corresponding cameras: on the Wista Field I use 75mm, 90mm, 150mm and 210mm; on the Pentax 45mm, 75mm shift, 135mm macro and 200mm; and on the Fuji 617 90mm and 180mm.

Film

As for most of the world's landscape photographers, Fuji Velvia 50 slide film remains my first choice. Its strong colour saturation, fine grain and sharpness are unmatched, although it is in the process of being replaced by Velvia 100, which claims to offer similar characteristics as well as a 1-stop increase in sensitivity.

CAMERAS AND LENSES

From left to right: Wista Field 4x5, Fuji GX617 panoramic, and Pentax 6x7, shown with a selection of my most frequently used lenses.

FILM

Fuji Velvia 50 120 and 4x5 sheet film – I generally load 4x5 film holders from 50-sheet boxes, but will use the convenient Fuji Quickload 4x5 film with a Quickload holder to reduce weight when doing long hikes and when travelling on aeroplanes.

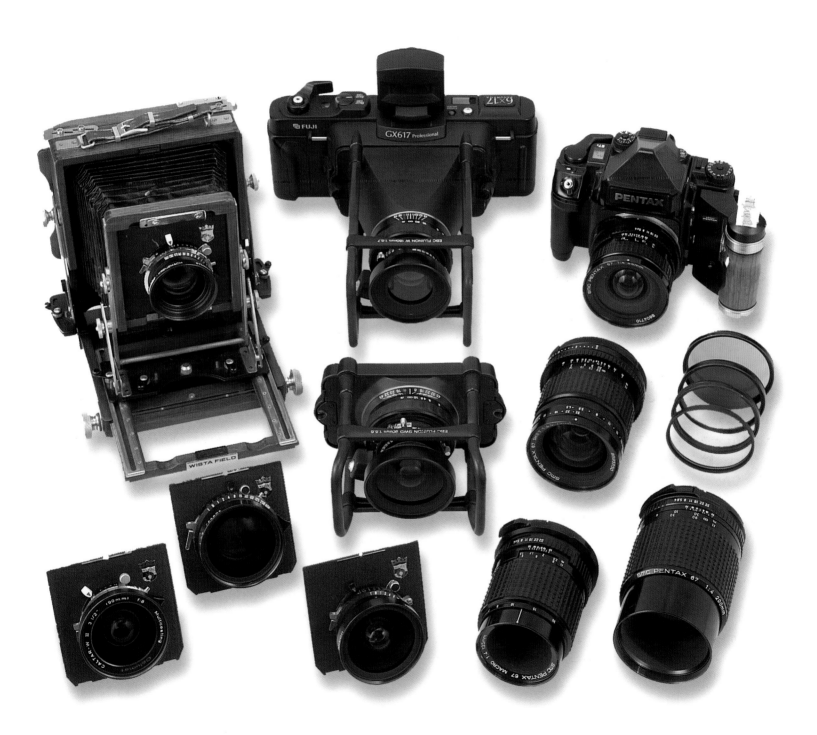

Essential accessories

There are a small number of accessories that are essential for landscape photography.

Filters

The polarizer is indispensable, helping to increase colour saturation (in particular blue skies) and reduce glare and reflections on water, glass and foliage. If you can only pack one filter, make sure it's a polarizer.

In addition, consider investing in a Cokin yellow/blue polarizer, which increases the saturation of the sky while also adding warmth to the landscape.

Warm-up filters (81 series) are useful when light is on the cool side, or when you want to enhance the colours of a sunrise or sunset.

Graduates allow you to balance the exposure of the sky with the foreground; while various colour grads are available, the neutral-density, or ND, grad is the best choice. These filters are also worth having if you think you need to increase exposure times, such as when shooting long exposures of water.

While screw-in filters are popular with amateurs, the slot-in type are far better value if your lenses have different diameters. For several years, the British brand Lee Filters has been my favourite, as the company produces a wide range offering superior quality.

Tripod

If you are going to use small apertures to maximize depth of field, you need to support your camera on a tripod. Your primary consideration should be to choose a sturdy platform – look for a good head as well as the tripod. Weight should be your next consideration – if you can afford it, opt for a carbon-fibre model, as these tripods are far more lightweight than those made from aluminium. Manfrotto's new MagFiber range has already established a good reputation.

An inexpensive, but very useful, tripod accessory is plumber's foam pipe insulation. Lengths of this tubing fit nicely around the tripod legs and can be fixed in place with tape. They are very effective in keeping your hands from sticking to the cold tripod legs in winter, and also provide comfortable padding when carrying the tripod over your shoulder.

Photo backpack

A good camera bag should offer plenty of space, protect your gear from knocks as well as the elements, and be comfortable even when fully laden. Backpacks spread the weight across both shoulders and back, and represent a better choice than the more traditional gadget bag that hangs off one shoulder. Lowepro offers a range of backpacks to suit every photographer's needs.

Light meter

While modern cameras boast very sophisticated metering systems, for accuracy and consistency there is nothing to match a hand-held light meter. I use the Pentax Spotmeter V, as this gives very accurate results.

Other accessories

Sun compass

When you're planning on shooting sunrises or sunsets, this inexpensive gadget helps you plan what time of the year the sun will rise or set in a particular position. It's great for determining when certain aspects of a building will be lit, and is also helpful when you get lost. It's available through www.flightlogistics.com

Flarebuster

While amateurs often fit lens hoods to reduce flare and increase contrast, these accessories are in fact unnecessary, as they take up too much room in your bag.

Instead, use your hand to shield the lens, or fit a Flarebuster. This is especially useful when there is a slim margin between shielding the sun from entering the lens and running a risk of having the black card in the frame. The flexible arm allows exact placement of the card and leaves a hand free for holding reflectors, shielding the camera from wind, etc. The kit also comes with silver and gold reflector cards that are great for reflecting light back into flowers in macro photography.

Plastic sacks

These are great for protecting your gear from dust, sand and salt spray, so make sure you pack a couple when you plan to shoot in deserts or by the coast. You can also use them to set your backpack upon on dewy mornings when the grass is wet.

Another useful item is resealable plastic food bags. These come in various sizes, and a large bag is ideal for enclosing cameras when shooting in the rain, near the coast to keep out salt spray, and in windy conditions where dust or sand might be blown into delicate camera components. Just cut a hole in the bag just big enough to put the lens through, and if necessary fix the bag tightly around the lens with an elastic band.

Clothing

Be sensible with what you wear. If you're in temperate climates, ensure you have a waterproof jacket and something warm. If you're in hot, sunny climates, protect yourself from the sun. Always wear good footwear that is comfortable and breathable, as blisters can put you out of action for days.

FILTERS AND ACCESSORIES

Lee coral set, Lee coral stripe, Lee 0.9 hard ND grad, Lee 0.9 soft ND grad, Lee 0.6 hard ND grad, Lee 0.6 soft ND grad, Lee blue grad. Lee filter case, Flarebuster, Pentax V spot meter, Flight Logistics sunset sunrise compass, Manfrotto 455B tripod with Manfrotto #168 ball head.

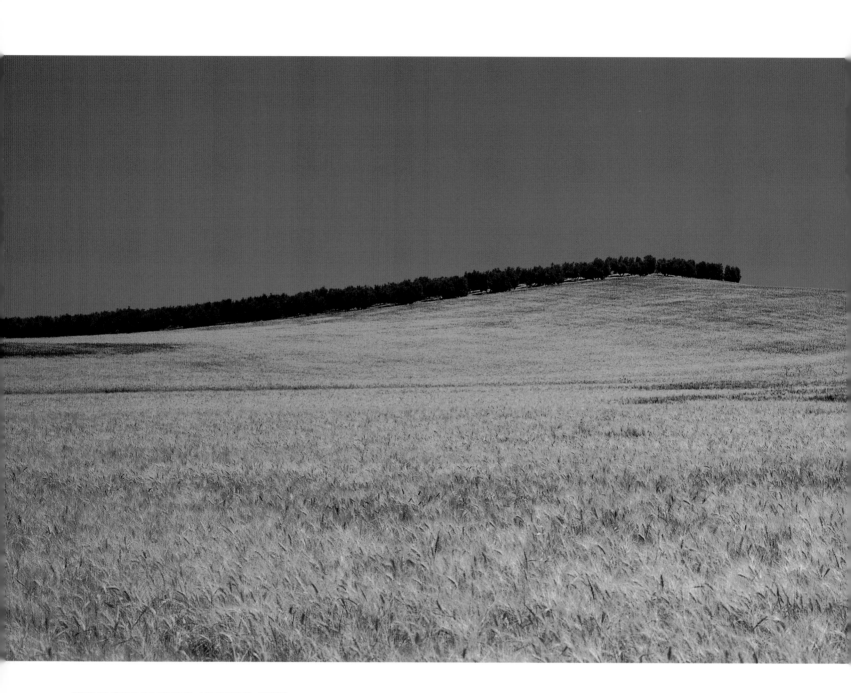

TREE IN FIELD OF BARLEY, ANDALUSIA, SPAIN

I photographed this lone tree on the Pentax 6x7, but I felt the panoramic format improved the composition by including more of the dark line of trees on the left side of the frame. This naturally placed the tree in the right third of the frame. Camera: Fuji 617 panoramic; lens: 180mm; filter: Cokin yellow/blue polarizer; film: Fuji Velvia 50; exposure: 1/2 sec @ f/22.

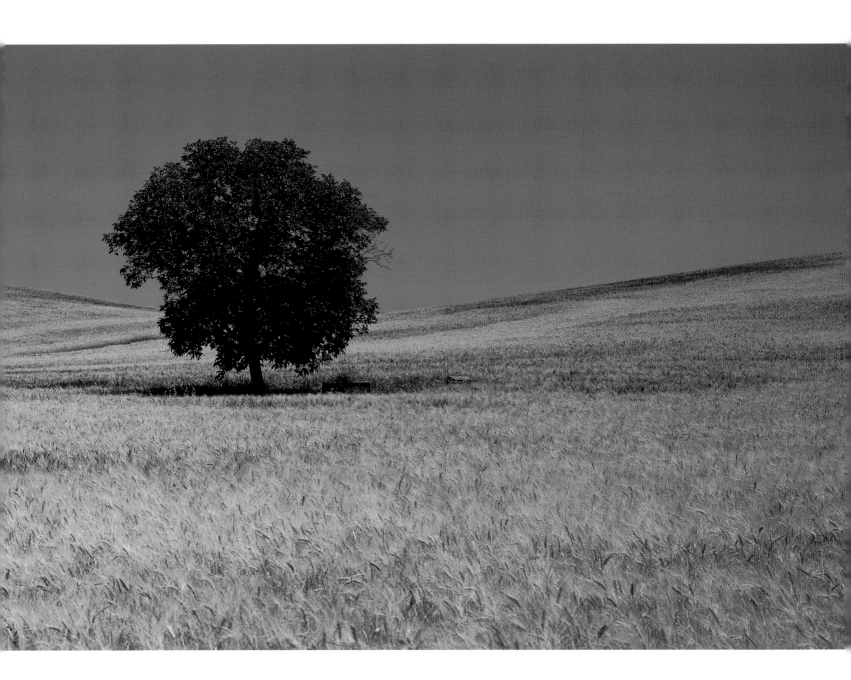

INDEX

Page numbers in *italic* refer to illustrations

SAY CHEESE!

While I was photographing in the Canadian Rockies, this persistent Columbian ground squirrel would not leave my backpack alone so I decided to put him to work. A few well-placed cake crumbs convinced him to start shooting. Now if I could just get him to carry the bags! Camera: Pentax 6x7; lens: 200mm; film: Fuji Velvia 50; exposure: 1/60 sec @ f/8.

ACKNOWLEDGMENTS

I would like to thank the following people for their help in producing this book:

Daniel Lezano, for giving his time to ghost write the book while under tremendous restraints of editing *Photography Monthly* magazine.

My editors, Neil Baber and Ame Verso, with their creative and organizational expertise, managed to put this book together under a tight deadline even while I was away on various photo shoots.

Ali Myer, head of design, for creating not just a 'how to' book, but a great display of well-designed layouts, that is more a showcase of my images.

Ian Kearey, project editor, for organizing the chapters and making the text flow.

Tony Smith International and Pete Huggins, for the use of their studios.

Graham Merritt at Lee Filters, for his continued support and producing my custom warming filter.

Lee Frost, for his insight and vast experience publishing books with David & Charles.

My wife, Kim and children, Jessie and Brandon, who helped decide on what pictures to include in the book.

VIEW MORE OF TOM'S WORK AND INFORMATION REGARDING HIS WORKSHOPS AT: **www.tommackie.com**